Pre-Raphaelites
Beauty and Rebellion

Christopher Newall

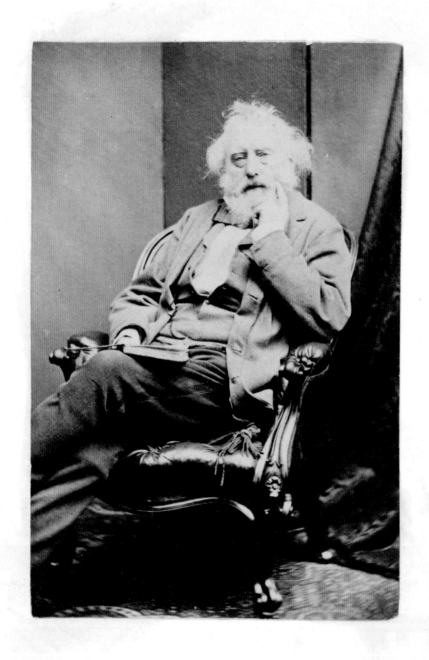

John Miller, Esq.

Photographer
unknown

John Miller, Esq.,
about 1873-6

Albumen print, 8.8 × 5.8 cm
Surrey History Centre

Pre-Raphaelites
Beauty and Rebellion

Christopher Newall
captions compiled by Ann Bukantas

Published by
Liverpool University Press
4 Cambridge Street
Liverpool
L69 7ZU

and

National Museums Liverpool
127 Dale Street
Liverpool
L2 2JH

© National Museums Liverpool and Liverpool
University Press

All rights reserved

ISBN 978-1-78138-303-2

Designed by Carnegie Book Production

Printed and bound by Gutenberg Press Ltd, Malta

Acknowledgements

This catalogue is supported by:
Sotheby's
Mr and Mrs Christopher Gridley
Mr Peter Woods and Mr Francis B Ryan

In addition to Christopher Newall, catalogue contributions from:
Ann Bukantas, Head of Fine Art at National Museums Liverpool,
Dr David Taylor, MA, FSA, and Sandra Penketh, Director of Art
Galleries, National Museums Liverpool.

We would like to express our sincere thanks to the many
colleagues at National Museums Liverpool and in other
museums and galleries nationally who have helped to make the
exhibition and its accompanying publication possible. In
addition, we would like to acknowledge the particularly
generous assistance of: Martin Beisly, Peter Brown, Grant Ford,
Julian Gwyn, Guz Gonzalez, Alex Kidson, Robert Knowles, Rachel
Lang, Dennis Lanigan, Mark Samuels Lasner, Brandon Lindberg,
Fiona Lorimer, Tahitia McCabe, Graeme Milne, Robert Molteno,
Edward Morris, Simon Mullen, Peter and Renate Nahum,
Stephen Newman, Paul O'Keefe, Michael Page, Simon Poë, Julian
Pooley, Geoffrey Prendergast, Guy Schwinge, Joseph Sharples,
David Shiel, Colin Simpson, Margaret Stetz, David Taylor, Julian
Treuherz, Gary Winter, Anne Woodward. We are also indebted to
several very generous private collectors.

The development of the Pre-Raphaelites: Beauty and Rebellion
exhibition was supported in part by a Jonathan Ruffer Curatorial
Research Grant from the Art Fund.

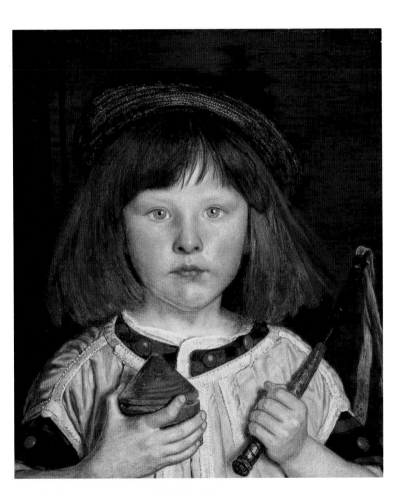

Ford Madox Brown (1821–93)

The English Boy, 1860

(see page 34)
Manchester City Galleries

Contents

Foreword

Liverpool has long been associated with Pre-Raphaelitism. The collections of the Walker Art Gallery, Lady Lever Art Gallery and Sudley House include large numbers of Pre-Raphaelite works, many with iconic status. The visitors they attract, and the numerous national and international requests we receive to lend them to exhibitions, are testaments to Liverpool's significance in the Pre-Raphaelite story. The history of how the city came to have these wonderful collections is multifaceted and fascinating and carries an inspiring message of strong patronage and cultural enlightenment. Looking across the world's major Pre-Raphaelite collections, links to Liverpool can be found, through the works, their past owners and their exhibition histories. From the early days of the Pre-Raphaelite Brotherhood, Liverpool and its collectors exhibited, commissioned, bought and advocated the work of John Everett Millais, William Holman Hunt, Dante Gabriel Rossetti, their associates and followers. There have been many exhibitions and a huge amount published on the subject, yet nothing has focused on Liverpool's role in the movement's history. This publication, accompanying the exhibition at the Walker Art Gallery (12 February–5 June 2016), aims to redress this omission.

The success of Pre-Raphaelitism in Liverpool reflected the town's enlightened approach to *avant-garde* contemporary art, and a support for new art practice dating back to the 18th century. Encouraged by significant figures like the Liberal politician and banker William Roscoe (1753–1831) to understand the importance of cultural philanthropy in a vibrant and progressive town, Liverpool developed a strong tradition of contemporary patronage and collecting. The Liverpool Academy of Art, founded in 1810 with Roscoe's financial assistance, gave artists the opportunity to train and exhibit together. From the 1820s it had a national reputation, with artists from across the country sending works to its exhibitions, hoping to be spotted by regional collectors. Among these, two decades later, were the Pre-Raphaelites, including Millais, Hunt, Rossetti and Ford Madox Brown. The Academy became central to spreading their ideas in the town and Pre-Raphaelite artists or their associates won the Academy's first prize almost every year from 1851 to 1859. This was quite an achievement when in most established circles Pre-Raphaelite art was still considered to be rebellious and challenging. After the Academy's demise in 1867, the role of exhibiting contemporary art fell in 1871 to the new Liverpool Autumn Exhibitions instigated by the Town Council. These annual exhibitions, firstly held in the Liverpool Museum and from 1877 at the purpose-built Walker Art Gallery, cemented Liverpool's reputation as somewhere that loved and collected art. The enlightened guidance of political figures like the art enthusiast and collector Philip Rathbone was instrumental in consolidating Liverpool's place at the forefront of civic collecting.

By the mid-19th century, Liverpool had a large group of successful, newly rich business leaders who were looking to decorate their homes with art and support the institutions that promoted it, and the new railway network enabled artists to visit existing and prospective patrons in the town. In this culturally enlightened atmosphere, many collectors explored the possibilities of recent approaches to art as opposed to simply mainstream fashions. Pre-Raphaelitism appealed to them, and the Scottish, Liverpool-based merchant John Miller was one of its

earliest and most significant collectors. He became an ally to the movement's artists, collecting, promoting and selling their work to his business colleagues. Despite Miller's key role in Pre-Raphaelite history, the detail of his life and business interests has been little known. New research by Ann Bukantas included in this book at last fills in this detail, revealing an accomplished businessman who was far more than just a 'Liverpool tobacco merchant', as he is usually described. For the first time we can actually look upon Miller's face, thanks to David Taylor's work on the Lushington family archive at the Surrey History Centre, which will undoubtedly bring forward many more new insights into the Lushingtons' extraordinary social circles. Other notable Liverpool collectors of Pre-Raphaelite art included George Rae and Frederick Leyland, John Bibby, George Holt, William Imrie, and William Hesketh Lever. Through the articles of the critic Frederic Stephens, and from sale catalogues, letters and diaries, we can visualise their picture displays, imagine their dealings with the artists, and, ultimately, appreciate their contemplation of these beautiful pictures.

A number of these collectors gave special attention to the Liverpool school of Pre-Raphaelite painters. Miller again was an important advocate, giving financial support to one of the group, William Davis. Davis's work and that of Daniel Alexander Williamson, William JJC Bond, John Edward Newton, Alfred William Hunt, James Campbell, Joseph Worrall, William Windus and John Ingle Lee echoed the Pre-Raphaelite founding principles of truth to nature, bright colours and immaculate detail, yet had a unique local character. Their beautiful studies of the rural landscapes surrounding the Liverpool region – North Wales, the Lake District, Cheshire – appealed to the town-dwelling collectors. This local group was acclaimed by the founding Pre-Raphaelite artists but received mixed reviews from established critics so their careers were inevitably difficult. Again, new research brings us to a closer understanding of their lives, their successes and their disappointments. This is especially true for John Ingle Lee (formerly recorded as John J Lee).

The art historian Christopher Newall has worked with us to select this exhibition and produce the catalogue. His proposal to look at Pre-Raphaelite history through a Liverpool lens has taken some time to come to fruition but he has remained patient and enthusiastic throughout the whole process. We want to give our sincere thanks to him for working with us in such a generous way to achieve the project. We are also grateful to the individuals and organisations who have helped us in our research and who have so generously lent to the exhibition. Their support has been immeasurable. Special thanks also go to the funders who have helped us realise this publication: the Art Fund, Sotheby's, Christopher and Petra Gridley, Francis Ryan and Peter Woods. Their help and encouragement has made a huge difference to the project.

Past colleagues at National Museums Liverpool have carried out exemplary work on Liverpool art institutions and collectors and their achievements should be applauded here. We want especially to mention Edward Morris's research, with Emma Roberts, on the Liverpool Academy, and Julian Treuherz's study of Rossetti and George Rae. Former Curator of British Art, Laura MacCulloch, uncovered new information on Worrall, and research by Joseph Sharples in documenting the architects, designs and interiors of Liverpool and Wirral merchant homes has greatly increased our understanding of local collectors' taste. Finally, no publication on the Pre-Raphaelites and Liverpool would be complete without mention of the ground-breaking work of Mary Bennett, also a former Curator of British Art at the Walker. Mary's monographic exhibitions on Ford Madox Brown, John Everett Millais and William Holman Hunt held at the Gallery in 1964, 1967 and 1969 were central to the rediscovery of Pre-Raphaelite art in the modern period and remain unsurpassed in scale and perceptiveness. Her work on local painters and patrons revealed other threads of the Pre-Raphaelite story. We hope that this exhibition will build on these achievements and provide an expanded context for our own Pre-Raphaelite collection and contribute to a new understanding of works with Liverpool associations elsewhere. At the same time, we hope it will be a catalyst for further exploration, especially on the subject of the Liverpool collectors whose patronage and collecting acumen provided Liverpool with such a remarkable artistic legacy.

Sandra Penketh
Director of Art Galleries
National Museums Liverpool

John Everett Millais (1829-96)

Isabella, 1848-9

Oil on canvas, 103 × 102.8 cm

Walker Art Gallery, National Museums Liverpool

Exhibited at the 1884 Liverpool Autumn Exhibition

The Florentine merchant brothers opposed their apprentice Lorenzo's love for their sister Isabella, and murdered him. Isabella found his body, cut off the head and buried it in a pot of basil. The story is from a poem by John Keats. This was Millais' first Pre-Raphaelite painting and as such is a painted manifesto of the Brotherhood's aims. The bright colour and flat picture space were inspired by early Italian painting. The natural light is a deliberate rejection of the dramatic contrast of light and dark he learnt at art school. Millais includes several symbols to add meaning to the scene such as the hawk tearing at a feather, Isabella's blood orange and the passion flower above her head. The letters 'PRB' on her stool indicate Millais' recent membership of the Pre-Raphaelite Brotherhood.

The Liverpool art world

Christopher Newall

Liverpool's mercantile prosperity, meshed with the innate cultural open-mindedness that distinguishes the city, has allowed arts of all kinds to flourish and be welcomed. Extraordinary intellectual and cultural advances were made in all of the towns of northern England in the period. The history of 19th-century Liverpool is marked by a willingness on the part of its citizens to depart from conventional patterns of thought and by a general disaffection with the London-based establishment. The lawyer and banker William Roscoe, who rose from humble circumstances as the son of a market gardener and inn-keeper to a position of wealth and influence (although in 1816 he was spectacularly cast down by the failure of the bank of which he was a partner), is a prime example of a Liverpool man who was always generous to causes in the town of his birth, but also determined to pursue his own strongly held principles and convictions. As a non-conformist Unitarian who also served as Liverpool's Member of Parliament, Roscoe denounced the trade in African slaves which had shamefully operated from Liverpool since the 1740s and made a speech in the House of Commons that speeded its prohibition throughout the British Empire in 1807. From the late 18th century into the early 19th, Roscoe followed his antiquarian interests by collecting books and assembling a vast collection of paintings, drawings and prints at his house Allerton Hall, Woolton, which included the group of medieval Italian paintings that were acquired in 1819 by the Liverpool Royal Institution and which in 1948 passed to the Walker Art Gallery.

From a young age, Roscoe poured his energies into establishing a succession of artists' associations in Liverpool where exhibitions might be held and to provide a forum for debate about artistic matters.[1] The story of the successive societies, schools and exhibition spaces that were launched in the late 18th and early 19th centuries commences around 1769 when the Liverpool Society of Artists began to meet. This led in 1774 to an exhibition of contemporary paintings which counts as one of the first to be set up in any English provincial town. In 1783 the Society of Artists was succeeded by the Society for Promoting Painting and Design in Liverpool which again benefited from Roscoe's enthusiastic support. Both these early associations offered drawing classes to their members and acquired casts and prints for students to copy. Furthermore, they staged displays of members' works to set before critics and collectors. The Society of Artists operated from rooms in John Street; the latter association first from Rodney Street and later in Lord Street. The Society of Artists' exhibitions were restricted to members' work but the successor institution staged two exhibitions, in 1784 and 1787, which featured works by notable British artists, with paintings on display by Reynolds, Gainsborough, Wright of Derby and Fuseli. A perennial difficulty afflicting all the nascent Liverpudlian art associations was the cost of renting space large enough to stage exhibitions in which a representative collection of recent works might be seen.

1 For a full account of the Liverpool art associations up to and including the Liverpool Academy, see Edward Morris, 'The Academy and Other Art Exhibitions, 1774-1867', in Edward Morris and Emma Roberts, *The Liverpool Academy and Other Exhibitions of Contemporary Art in Liverpool 1774-1867*, Liverpool, 1998.

In 1810, a third and in the event more enduring art association was established, once again with Roscoe's financial and moral support – the Liverpool Academy. This new venture was set in motion at a meeting of artists at Liverpool's Crown and Anchor Tavern. An endowment of £1,600 from Henry Blundell – a local Catholic landowner and friend of Roscoe's – was intended to pay for a custom-built premises, but a £1,000 budget shortfall meant that the building project was not carried through. Instead the Academy operated from various spaces around the town before settling in Old Post Office Place between Church Street and Hanover Street. The Academy exhibitions between 1810 and 1814 featured paintings by Lawrence, Bonington, Turner, Constable, Etty and John Linnell. To encourage London-based artists to contribute, the Academy undertook the costs of transporting works to Liverpool and paid for their return if they remained unsold. In 1814 a competing institution – the Liverpool Royal Institution as it came to be called – was founded with the stated intention of 'promoting the diffusion of Literature, Science and the Arts', and which for a few years eclipsed the Academy. In 1817, however, the Academy was invited to use space in the Royal Institution's premises in Colquitt Street, being allowed to remain an autonomous entity and recommencing annual exhibitions from 1822.

In the late 1820s, '30s and '40s the Liverpool Academy exhibitions assumed national importance and were regarded by artists throughout Britain as offering opportunities for display before munificent patrons in the North West. Prizes were awarded to works regarded as outstanding by the Academy's Council, with sums reserved for painters based in the city. Financial support came from Liverpool's Town Council, from prominent citizens, and from the Liverpool Art Union, instituted in 1834.[2] The increased level of activity and the resulting improvement in Academy finances led to the construction of a new building in Old Post Office Place, designed by John Foster and leased to the Academy by a group of financiers which included John Gladstone, father of the future prime minister. The Academy's period of greatest prosperity was the 1840s when there was such a ready demand for works on display that the organisers felt able to charge commissions on sales. The value of prizes was increased and at the same time

members were encouraged to present works as 'Diploma pieces', creating a collection that was presented to the Liverpool Town Council in 1851, thus forming the nucleus of a permanent and publicly owned collection of contemporary art.[3]

The Liverpool Academy, despite chronic administrative difficulties and disputes about the appointment of officials, had an extraordinary impact in both local and national artistic affairs. Its function as a teaching institution – established at a time before the creation of government funded schools of art and design – helped Liverpool support a thriving art world and – according to the 1851 census – a larger number of professional artists were resident in the town than any other place in Britain outside London.[4] The fact that figures such as William Davis and William Lindsay Windus were each exhibitors at the Academy from 1842, nine and fourteen years respectively before they first sent works to the Royal Academy in London, indicates the allegiance that locally based artists felt for the association. The Liverpool Academy, at least until the mid-1850s, seems to have been imbued with a particular spirit of generosity and open-mindedness to artistic innovation and a zest for works that challenged the artistic status quo. Although run in the interests of its membership and by individuals who might have sought to use the Academy as a cartel to advance their own professional standings – as the Royal Academy in London was seen to do – in fact the Liverpool Academy seems positively to have welcomed new styles and to have encouraged heterogeneous displays of contemporary work.[5]

2 The first such organisation in England. Members of the public bought tickets which would be placed in a draw. The prize was a picture from the exhibition.

3 The ownership of the Diploma collection and its presentation to the Town Council was complicated. See Edward Morris, *Victorian & Edwardian Paintings in the Walker Art Gallery & at Sudley House,* London, 1996, p. 76.

4 See John Seed, '"Commerce and the Liberal Arts" – the political economy of art in Manchester, 1775–1860', in *The Culture of Capital,* edited by Janet Wolff and John Seed, Manchester, 1988, p. 57.

5 The presence of so many names of Pre-Raphaelite or otherwise progressive artists among the lists of Liverpool Academy exhibitors should not disguise the fact, however, that in addition to the indigenous artists who constituted the Liverpool School, the works of many other unremarkable painters were crowded into the autumn displays in Old Post Office Place, as may be judged from the lists of sold works occasionally published in the *Art Journal.*

Ford Madox Brown (1821–93)

The First Translation of the Bible into English: Wycliffe reading his translation of the New Testament to his protector, John of Gaunt, Duke of Lancaster, in presence of Chaucer and Gower, his retainers, 1847–8

Oil on canvas, 119.5 × 153.5 cm

Bradford Museums & Art Galleries

Exhibited at the Liverpool Academy in 1848

Brown's composition here recalls the design of an altarpiece. In its symmetry, clear colours and lack of shadows, the picture shows the influence of early Italian and German Nazarene art, which Brown had studied in Rome. The vivid colours were obtained using a white undercoat. He carefully researched the details such as the costume and furniture from books on medieval history. Wycliffe was a 14th-century theologian and reformer. John of Gaunt and his family sit on the right – the sleeping child was based on studies of Brown's daughter Lucy. The figures on the steps to the left are the writers Geoffrey Chaucer and John Gower.

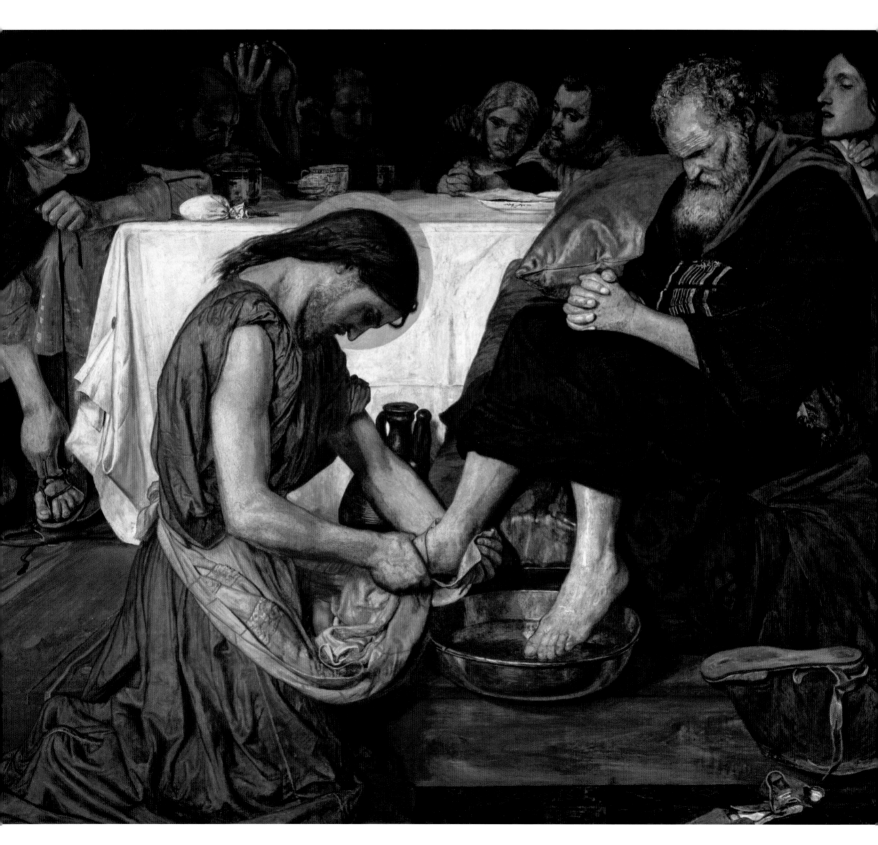

Ford Madox Brown (1821–93)

Jesus washing Peter's Feet, 1852–6

Oil on canvas, 116.2 × 132.7 cm

Tate, London. Presented by subscribers, 1893

Exhibited at the Liverpool Academy in 1856 as *Christ washing Peter's Feet*

This painting won the £50 prize at the Liverpool Academy in 1856. A reviewer writing in *The Liverpool Courier* said 'The Prize picture is not without merit, but we fear this cannot be said of those who awarded the prize.' The artist William Lindsay Windus had proposed it as that year's winner. Brown's subject is set at the Last Supper, as Jesus washes the feet of the disciples. He places the viewer at eye level, as if kneeling to witness the humble act. It is thought that the critic FG Stephens sat for the head of Jesus. Brown's modern, realistic approach to the subject matter attracted the ire of many commentators, who felt the picture had too little dignity for the theme, crude colouring, and was over-complicated and melodramatic. The painting was re-worked over a number of years before being purchased by the Leeds collector Thomas Plint.

From the early 1850s several of the London-based Pre-Raphaelites came to regard the Liverpool Academy as the provincial exhibition venue of choice, frequently sending works there that had previously been exhibited at the Royal Academy.[6] This was especially useful in the case of works that had failed to sell in London, but was also an arrangement which owners of paintings commissioned directly or purchased at the Academy often accepted. The timing of the exhibitions in London and Liverpool was well calculated to permit such a transfer, with the Royal Academy summer exhibition opening each year in May and the Liverpool Academy in September.

A number of Ford Madox Brown's works were shown for the first time in Liverpool, including the watercolour *Oure Ladye of Saturday Night* (Tate), sent to the north-western venue after its rejection by the Royal Academy in 1847.[7] In due course Brown showed some of his most significant works there, including in 1848 *The First Translation of the Bible into English* (page 11) and in 1849 *King Lear* (Tate). Both were previously shown at the 'Free Exhibition of Modern Art' in London.[8] In 1856 he showed six works in Liverpool including *Christ washing Peter's Feet* (page 13), *The Last of England* (Birmingham Museums Trust) and *An English Fireside, in the Winter of 1854–5* (page 48), with the former awarded the Academy's annual prize.

William Holman Hunt, like Brown, exhibited at the Liverpool Academy even from a time before the establishment of the Pre-Raphaelite Brotherhood, showing a subject from Dickens's *The Old Curiosity Shop* there in 1847 (page 18). It was however in the years 1851 and 1853 that Hunt twice won the Academy's annual prize of £50 – for the works *Valentine rescuing Sylvia from Proteus* (page 44) and *Claudio and Isabella* (inside front cover). In its commentary on this double commendation the *Art Journal* concluded: 'The Liverpool Academy has a decided *penchant* for pre-Raffaelitism'.[9] Each had previously been shown at the Royal Academy, as were Hunt's succeeding Liverpool exhibits, *The Light of the World* (Keble College, Oxford) and *The Scapegoat* (page 14), in 1854 and 1856 respectively. Hunt only allowed smaller and more personal paintings to be given their first outing in Liverpool, even though he shared Brown's distaste for the Royal Academy. Amongst such exhibits was *The Haunted Manor* (Tate), shown following Hunt's reworking of it in 1856.

6 See Morris, *Victorian and Edwardian Paintings*, p. 5, and Mary Bennett, 'A Check List of Pre-Raphaelite Pictures Exhibited at Liverpool, 1846–67, and Some of Their Northern Collectors', *Burlington Magazine*, CV (November 1963, pp. 486–95).

7 Also called *Oure Ladye of Good Children*. Other paintings by Brown first exhibited in Liverpool were *View from Shorn Ridgway, Kent* (National Museum of Wales, Cardiff) in 1852, *Heath Street, Hampstead (The Butcher Boy)* (page 31) in 1857, and *Hampstead – A Sketch from Nature* (Delaware Art Museum) also in 1857.

8 An improvised exhibition held in the St George's Gallery at Hyde Park Corner to which Brown and Rossetti both sent work.

9 *Art Journal*, 1853, p. 267.

William Holman Hunt (1827–1910)

The Scapegoat, 1854–5

Oil on canvas, 87 × 139.8 cm

Lady Lever Art Gallery, National Museums Liverpool

Exhibited at the Liverpool Academy in 1856 and purchased by William Hesketh Lever in 1923

The Liverpool Academy catalogue recorded that Hunt's scene was painted at 'Oosdoom [the Biblical Sodom], on the margin of the salt-encrusted shallows of the Dead Sea.' Hunt stayed for two years in the Holy Land in pursuit of authentic backgrounds for his biblical paintings. *The Scapegoat* refers to an Old Testament ritual in which a goat was driven out into the wilderness carrying with it the sins of the congregation, represented by the scarlet cloth on its horns. Despite praising the picture as powerfully painted, with rich and beautiful colouring, *The Liverpool Mercury*'s reviewer in 1856 commented: 'Here is another unfortunate subject, having a world of labour expended over nothing that interests or gratifies the taste of the beholder.'

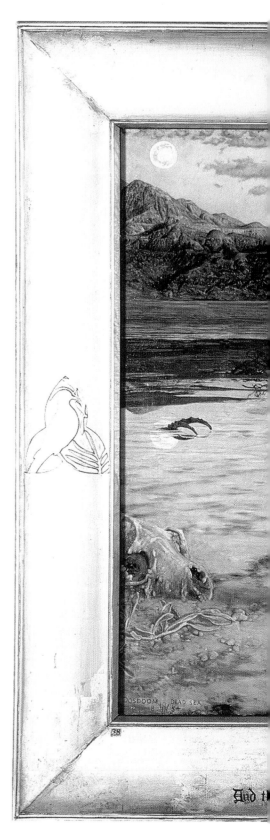

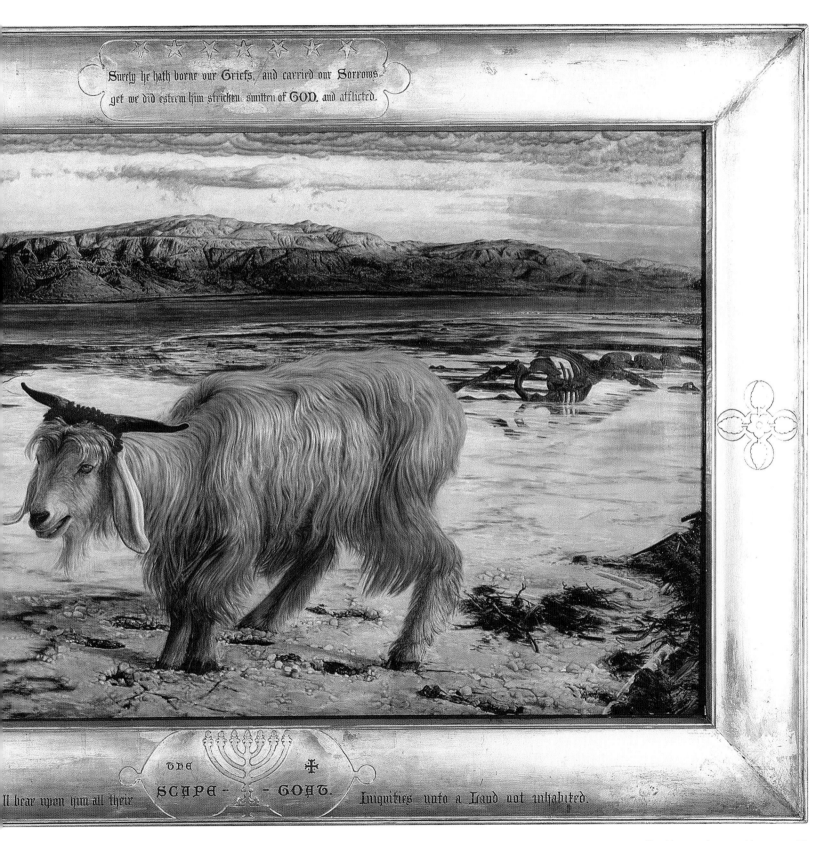

Surely he hath borne our Griefs, and carried our Sorrows:
yet we did esteem him stricken, smitten of GOD, and afflicted.

THE
SCAPE - GOAT.

Il bear upon him all their Iniquities unto a Land not inhabited.

John Everett Millais (1829–96)

Pizarro seizing the Inca of Peru, 1846

Oil on canvas, 128.3 × 172.1 cm

Victoria and Albert Museum. Bequeathed by Henry Hodgkinson, 1897

Possibly the version exhibited at the Liverpool Academy in 1846

This complex, dramatic painting by the 16-year-old artist represents the Spanish conquistador Franscisco Pizarro capturing Atahualpa, the Inca emperor, in 1532. Millais' brother-in-law, the actor John Wallack, posed for Pizarro whilst John Millais, his father, sat for the priest and other figures. The Royal Academician Edward Goodall loaned the ornaments used in the scene. *Pizarro* was the first picture Millais exhibited. It was shown at the Royal Academy in 1846, where it was praised by critics, despite being badly positioned and therefore difficult to see. Holman Hunt thought it 'more like the work of an artist in his prime.' This picture, a smaller rendering of it, or a sketch, featured in the Liverpool Academy's exhibition that year, and John Miller certainly acquired a small version which was included in the 1858 sale of his collection.

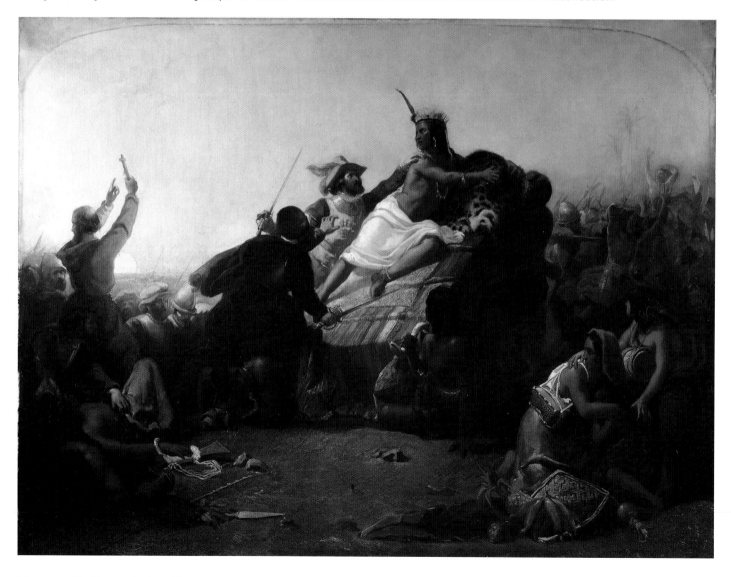

Henry Mark Anthony (1817–86)

Nature's Mirror, about 1854

Oil on canvas, 128 × 197 cm

Wolverhampton Arts & Museums

Exhibited at the Liverpool Academy in 1854 and winner of the £50 prize for best picture

The Manchester-born landscape artist Anthony was a close associate of the Pre-Raphaelites. He was awarded the Academy's prize with this landscape in 1854. The *Liverpool Mercury* upheld it as a scapegoat for all the perceived faults of Pre-Raphaelitism – as mere servile copying of nature at the expense of selection, atmosphere and feeling. It had been better received earlier in the year at the Royal Academy.

John Everett Millais preceded Brown and Hunt as a Liverpool exhibitor, his first work there having been *Pizarro seizing the Inca of Peru* (page 16) in 1846 when the artist was just 17 years old.[10] Millais's next Liverpool exhibit, *The Huguenot* (Makins Collection), was the prize-winner in 1852, and was followed in 1854 by the modern-life moral subject *Wedding Cards – Jilted* (page 50), bought at the exhibition, or lent to it, by the Liverpool collector John Miller. Millais established himself as one of the most consistent Liverpool exhibitors, continuing to show there even after his election as a member of the Royal Academy in 1863.

The Liverpool newspapers' incipient hostility to the Academy's support for Pre-Raphaelite art was referred to in 1856 when Windus wrote to Rossetti to explain why he had decided not to show *Burd Helen* (page 51) there after its first outing in London:[11] 'I have not sent it to the Liverpool exhibition, as I heard there was an intention to write it down in the local press, which, although powerless for good in matters of art, possesses peculiarly the faculty of annoyance and irritation, and remarkable skill in discovering and rubbing upon tender places'.[12] That same year, the response of the Liverpool press to Brown's prize-winning with *Christ washing Peter's Feet* (page 13) was as vicious as anything Windus himself might have feared. However, the following year an even more fraught dispute arose when Millais's *The Blind Girl* (inside front cover) appeared at the Liverpool Academy. Miller had recently bought the painting from the dealer Ernest Gambart and presumably hoped it would appreciate in value as a result of a favourable reception in Liverpool. His expectations were fulfilled as the painting was awarded the annual prize but also provoked a storm of criticism and virulent protest at what had come to be seen as the Academy's predisposition towards Pre-Raphaelitism. A conservative faction believed that a more deserving candidate in 1857 was Abraham Solomon whose pictorial drama *Waiting for the Verdict* (Tate) was shown that year, and so finally battle-lines were drawn on the issue of Pre-Raphaelitism and its legitimacy as the acknowledged *avant-garde* art form of the day. The row raged on through the following winter, with the Liverpool-born artist Alfred William Hunt attempting to persuade John Ruskin to lend his support to the Pre-Raphaelite cause as the critic had done in 1851 in relation to Pre-Raphaelite works at the Royal Academy.

10 Or possibly a sketch for the finished painting, c.f. Mary Bennett, *PRB Millais PRA*, exhibition catalogue, Walker Art Gallery, Liverpool, 1967, p. 22.

11 In the event it was shown at the Liverpool Academy three years later.

12 Quoted in Ford M Hueffer, *Ford Madox Brown: A Record of his Life and Work*, London, 1896, p. 110.

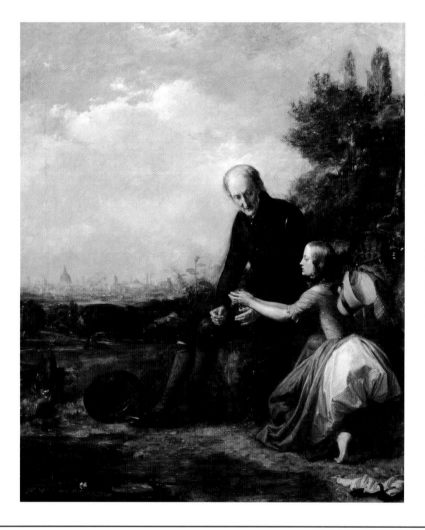

William Holman Hunt (1827–1910)

Little Nell and her Grandfather, 1845

Oil on canvas, 76.5 × 63.5 cm

Museums Sheffield

Exhibited at the Liverpool Academy in 1847 as *The first stoppage of Little Nell and her Grandfather, on their departure from London*

The subject is taken from Charles Dickens's novel *The Old Curiosity Shop* which tells the story of the orphaned Nell Trent. To provide for her, Nell's grandfather becomes a gambler. She leads him out of London in order to save him. In this early work, the student Hunt shows them resting on their journey by a pool of water, with the temptations of London far in the distance – the view is from Highgate Hill. In 1907, Hunt confessed in a letter to the Walker's curator Edward Dibdin that he had accidentally used salad oil in the sky.

Ruskin's reply to Hunt's letter was disappointingly hesitant: 'I've been noticing that row for a long time – and if it had not been about a Millais picture, should have had a finger in pie long ago – But I don't know how'.[13] Later, Ruskin expressed resignation: 'Let the Liverpool people buy whatever rubbish they have a mind to; and when they see, which in time they will see, that it <u>is</u> rubbish, and find, as find they will, every Pre-Raphaelite picture gradually advance in influence and in value, you will be acknowledged to have borne witness all the more noble and useful, because it seemed to end in discomfiture; though it will <u>not</u> end in discomfiture'.[14]

Resentment of the favourable reception that had been given to works by Brown, Hunt and Millais had been building for a while. In due course the matter spilled over into the London periodicals, with William Michael Rossetti writing letters on the subject to the *Athenæum* in December 1857 and to the *Spectator* in January 1858. In this last, Rossetti summarised the position of the Liverpool Academy in its support for Pre-Raphaelitism but also stated candidly that 'the

13 Quoted in Christopher Newall, *The Poetry of Truth – Alfred William Hunt and the Art of Landscape*, exhibition catalogue, Ashmolean Museum of Art, Oxford, 2004, pp. 10–11. This undated letter is among the Violet Hunt Papers at Cornell University.

14 Ruskin's letter to AW Hunt, which Hunt sent on for publication in the letters column of the Liverpool newspaper *The Albion* and which appeared on 11 January 1858, is given as an appendix in HC Marillier, *The Liverpool School of Painters*, London, 1904, pp. 260–1.

Liverpool press, and a large section, at any rate, of the Liverpool public, dislike Pre-Raphaelitism, and the Academy is severely taken to task for its selections' – leading to the resounding declaration 'We cannot hesitate to say that, in all such cases, the course adopted by the Liverpool Academy is right, and the only right one [...] Pre-Raphaelite art is the vital and progressive art of the day'.[15] Shortly afterwards the *Art Journal* paraded its conservative credentials by publishing a bitter notice concerning the dispute with reference to WM Rossetti's letter.[16] The civic indignation that was felt in certain quarters led the Town Council to withdraw the annual subsidy of £250 that until then had been used to pay the rent on the Academy's premises. This left the institution nursing debts that eventually became unmanageable.

There was mounting concern in the later 1850s that what had been seen as a north-western beacon of support for Pre-Raphaelitism might collapse. In 1856, Windus explained to DG Rossetti how endangered the Liverpool-based Pre-Raphaelites felt: 'We have succeeded thus far, but more by our enthusiasm in the cause than by our numbers, and we require all the assistance that the Pre-Raphaelite Brothers can give by sending us pictures to maintain our position'.[17] This was a period when interesting paintings by the Pre-Raphaelite circle were in increasing demand from an expanding range of exhibition venues in London and the provinces and for tours such as that which was shown successively in New York, Philadelphia and Boston in 1857–8, thus exacerbating the problem of getting good pictures for display. On 10 June 1858 a meeting in London was addressed by Holman Hunt who, as George Price Boyce noted in his account of the occasion, 'mooted the subject which was the cause of the gathering, viz., the importance of supporting the old Liverpool Academy'.[18] Those attending included the painters John Brett, Burne-Jones, RB Martineau, Prinsep, Stanhope and Henry Wallis, and the critic FG Stephens, as well as Boyce. All present except Wallis concurred with Hunt's view and a list was made of the artists who were prepared to send to Liverpool the following September, with Boyce himself offering two works and three more on behalf of his sister Joanna.

The Liverpool Academy exhibition of 1858 was one of the most remarkable in its history with many of the London artists fulfilling their determination to send good works. Brown was the prizewinner with *Chaucer reading the 'Legend of Custance' to Edward III* (inside front cover), a painting first exhibited in 1851 but which was at that time still on the London art market. Holman Hunt sent *Rienzi* (page 27), like Brown's *Chaucer* a work from some years previously, and from the collection of Mrs John Gibbons (where it was apparently little appreciated and kept in a cupboard).[19] Millais was represented by *Autumn Leaves* (page 23), which once belonged to John Miller but had been sold in May 1858 to the dealer Ernest Gambart. Most remarkably, Rossetti made his debut at the Liverpool Academy in 1858 with three superb watercolours: *Dante's Dream at the Time of the Death of Beatrice* (Tate), of 1856, which had been first exhibited at the Russell Place Pre-Raphaelite Exhibition in 1857; *The Wedding of St George and the Princess Sabra* (Tate), of 1857; and *A Christmas Carol* (Fogg Museum of Art, Harvard University), of 1857–8.

15 WM Rossetti's letter to the *Spectator* of 2 January 1858 appears as Appendix II in Marillier, *The Liverpool School of Painters*, pp. 262–4.

16 'Pre-Raffaelism – The friends and professors of this, the most forbidding mechanism of the art have always been most tenderly sensitive. It has been asserted that the Liverpool Academy is too favourable to pre-Raffaellite art; whereon Mr Rosetti [*sic*] writes in defence of his injured order to the journal in which such a denouncement was hazarded, that it is true that last year, to Mr Millais's "Blind Girl" was awarded the prize of £50; and that, in some previous years also, prizes have been so awarded. To go no farther, this is an admission that the Liverpool Academy has bestowed a very liberal share of patronage on the pre-Raffaellite section of the profession [...] If the pre-Raffaellites have held a *petit comité* on this subject, their decision, as evidenced by thus thrusting their champion into the arena, is wrong – they should be satisfied with the notoriety which they achieve by their works; and if the Liverpool Academy award all their prizes to the pre-Raffaellites, they have an unquestionable right to do so, but as to whether they are right to do so or not, is another question'. (*Art Journal*, 1858, p. 29). (See Morris, *The Liverpool Academy and Other Exhibitions*, pp. 10 and 18, notes 65 and 66.)

17 Quoted in Hueffer, *Ford Madox Brown*, p. 110.

18 *The Diaries of George Price Boyce*, edited by Virginia Surtees, Norwich, 1980, p. 24.

19 See Dianne Sachko Macleod, *Art and the Victorian middle class*, Cambridge, 1996, p. 420.

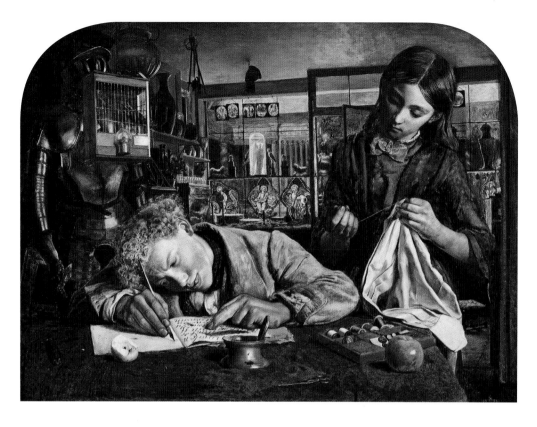

Robert Braithwaite Martineau (1826–69)

Kit's Writing Lesson, 1852

Oil on canvas, 52.1 × 70.5

Tate: Presented by Mrs Phyllis Tillyard 1955

Exhibited at the Liverpool Academy in 1852

'Verily the P. R. B.'s are coming thick upon us' warned the *Liverpool Mercury* reviewer before appraising Martineau's 1852 entry, *Kit's Writing Lesson*, which took its subject from Dickens' *Old Curiosity Shop*. Whilst Martineau was praised for his attention to reality, his painting was used as an example of what was perceived as risky with Pre-Raphaelitism: the exclusion of atmosphere, the lack of distinction between foreground and background, and for including things that '…do not look agreeable in art… Art should always combine beauty with truth… [or]… we shall occasionally see art degraded to a state of hardness and ugliness which we should deplore.' (*Liverpool Mercury*, 14 December 1852, p. 5)

The first two were lent from the collections of Rossetti's Leeds patrons Ellen Heaton and Thomas Plint, while the third was for sale at 80 guineas and was subsequently bought by James Leathart of Gateshead. Rossetti's paintings and drawings were seldom seen in public exhibitions in London and never at the Royal Academy, so although he was not present at the London meeting in June his willingness (even his deliberate intention) to participate in the Liverpool exhibitions was an extraordinary event.[20] It is not immediately clear why Rossetti should have departed from his usual professional pattern but Liverpool may have appealed to him as a place to show his works simply because he was unknown there personally and might therefore feel emotionally detached from an experience that taxed him, but it may also have been out of friendly feeling towards his patrons in the North West, notably George and Julia Rae, and to support an association which they cared about.

Among the Pre-Raphaelite followers who sent works to Liverpool in the late 1850s were the aforementioned Boyce, with two works in 1858, one of which was *Heath Side – Surrey – An Autumn Study* (untraced). John Brett was represented by the two Alpine subjects *The Wetterhorn, Wellhorn and Eiger* (page 21) and *The Glacier of Rosenlaui* (Tate) in 1857 and 1858 respectively, and *The Stonebreaker* (page 26) in 1858. In subsequent years he was represented by *Val d'Aosta* (Lord Lloyd-Webber collection) and *The Hedger* (page 29).

20 Rossetti had previously exhibited in public in London at the Free Exhibition at Hyde Park Corner in 1849, at the exhibition of the National Institution held at the Portland Gallery in 1850, at an exhibition of sketches and drawings held in the gallery of the Old Water-Colour Society in the winter of 1852, and at the Pre-Raphaelite exhibition at Russell Place in 1857. He did not send works to the American touring exhibition of British art in 1857-8. Rossetti subsequently sent works to the Liverpool Academy in 1861, 1862 and 1864.

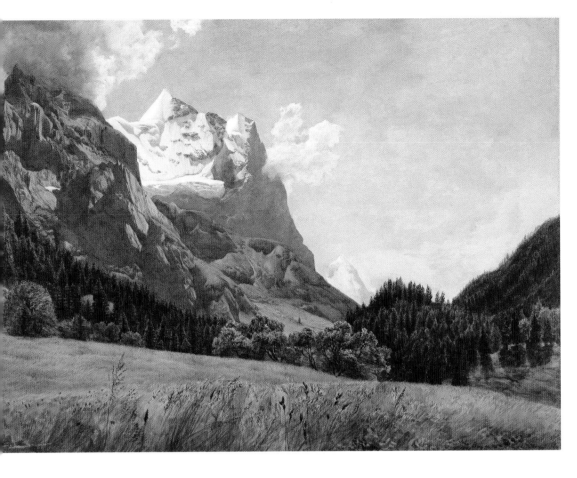

John Brett (1831-1902)

The Wetterhorn, Wellhorn and Eiger, Switzerland, 1856

Watercolour on paper, 25.6 × 36.1 cm
Private collection
Exhibited at the Liverpool Academy in 1857

In this watercolour, Brett took up with a passion John Ruskin's clarion call for painters to work directly from nature. Enthused by the critic's recently published Volume IV of *Modern Painters* (subtitled 'Of Mountain Beauty'), Brett travelled to Switzerland where he met John William Inchbold, who was applying his own fastidious technique to representing the Alpine landscape. Inchbold's work and the natural beauty that surrounded him inspired in Brett the revelation that he had previously only 'fooled and slopped' and would henceforth attempt to paint what he could see.

John William Inchbold (1830-88)

The Lake of Lucerne – Mont Pilatus in the Distance, 1857

Oil on panel, 35.5 × 48.8 cm
Victoria and Albert Museum. Bequeathed by the artist, 1888
Almost certainly the work exhibited at the Liverpool Academy in 1860 as *Above Lucerne*

As someone whose main pre-occupation was landscape painting, the country's geology provided Inchbold with rich subject matter, although Ruskin was not complimentary about the work he produced there. To the left of the lake is the base of Mount Rigi. The cloud-covered Pilatus stands across the water. This picture has been applauded as representing the end of the artist's truly Pre-Raphaelite work, but at the same time as one of the finest examples of their influence on him.

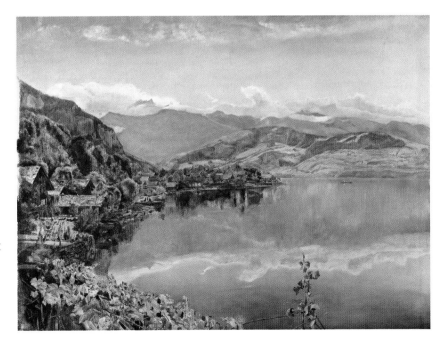

Edward Burne-Jones made his debut in Liverpool in 1859 with an extraordinary pen and ink drawing, *The Wise and Foolish Virgins* (private collection), then fresh from his studio and probably already the property of Thomas Plint. Michael Halliday showed *The Blind Basket-maker* (Lord Lloyd-Webber collection) in 1858. John William Inchbold sent the Swiss landscape subjects *The Jungfrau from the Wengern Alp* (untraced) and *Above Lucerne* (page 21) in 1857 and 1860 respectively. Robert Braithwaite Martineau exhibited his modern-life subject *The Lesson – "Try and Remember"* (Musée d'Orsay, Paris) in 1856. Thomas Seddon followed *The Great Sphinx of the Pyramids at Ghizeh* (page 25), exhibited in 1855, with *The Valley of Jehosophat* (Tate) in 1856. John Roddam Spencer Stanhope – who had attended the June meeting – sent *View of the Bay at Budsum* (untraced) in 1858, and exhibited each year subsequently, including *The Wine Press* (see page 80) in 1861. Finally, Joanna Wells, who as her brother GP Boyce had promised, offered three of her paintings of female heroine subjects in 1858 and a landscape – *A Homestead on the Surrey Hills* (untraced) – in 1859.

The 1858 exhibition at the Academy was the first to find itself in competition with a new association, the Liverpool Society of Fine Arts, which had been set up at the time of the ructions over Millais's *The Blind Girl*. It had the support of a group of London-based artists antipathetic to Pre-Raphaelitism, including Edward Armitage, WP Frith, JC Horsley and EM Ward. The Society was administered by men from the Liverpool business community who claimed financial competence at a time when the Academy, which was run by its members who were artists and patrons, was wracked by charges of incompetence and corruption. At rooms in Queen's Hall in Bold Street, the Society showed generally conservative works – conventional landscapes, sentimentally treated animal subjects, and genre scenes – until 1862. In December 1858, in his comments on the two exhibitions in an article in the *Spectator*, WM Rossetti characterised the Academy's display as fresh, enterprising and individualistic, whereas the Society he regarded – on the basis of its first exhibition – as fusty and old fashioned, with a tendency towards the meretricious and commercial.[21] In 1861 the *Art Journal* compared the exhibitions of the two Liverpool associations, drawing the conclusion that 'one [the Society] is, perhaps, better calculated to gratify the general public, the other [the Academy] more likely to give pleasure to the artist and those who are advanced in a knowledge of Art'. The periodical lamented the schism that had occurred, especially at a time when there was a downturn in mercantile profits as a result of the outbreak of war in the United States in April, and with an expected consequence of reduced spending on art. The journal's writer felt that it was 'most unlikely that either of them will yield an income sufficient for its support [as] the one is in debt, [while] the other has expended nearly all its savings; and no result can be looked for except that which must be judged prejudicial to the patrons and the profession'.[22]

However, even when the Liverpool Academy had apparently seen off the challenge of the Society of Fine Arts, the likelihood of the institution surviving was being openly discussed. In October 1859 Alfred William Hunt wrote to his future wife Margaret Raine: 'The Liverpool Academy is on its last legs undoubtedly', while two months later on 4 December, presumably having just attended a committee meeting, Hunt expostulated: 'Such a collection of featherbrains I never saw met for serious business before – with <u>some</u> exceptions of course'. The following day he reported further that 'there is a meeting of the Academy to <u>wind up</u>. We have lost 300 at best this season & already have diminished our capital below the sum of our engagements, i.e. we have not 1000£ left and still have 6 quars at 200 a quar to run. So we must shut up & let the rooms to save ourselves'.[23] Things were steadily becoming more difficult, although in fact the eventual demise of the Liverpool Academy was not until 1867. It is clear that as an institution the Academy was divided in its view as to what type of contemporary painting it should support at a time when the art world in both London and Liverpool was ever more factionalised. This was an issue that could not be ignored simply because the Academy depended for publicity and revenue on the work of London-based Pre-Raphaelites.

21 See Morris, *The Liverpool Academy and Other Exhibitions*, p. 12. The article was published in the *Spectator* on 4 December 1858, p. 1276.

22 *Art Journal*, 'The Liverpool "Academy" and "Society"', 1861, p. 317.

23 The three letters are quoted in Newall, *The Poetry of Truth*, p. 12. The letters are among the Violet Hunt Papers at Cornell University.

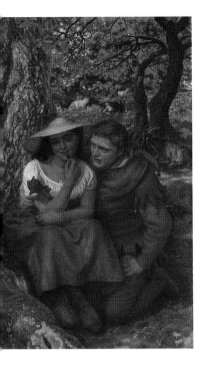 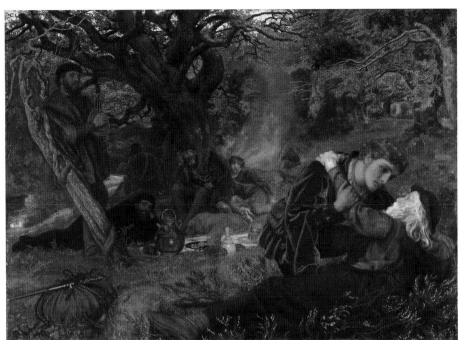 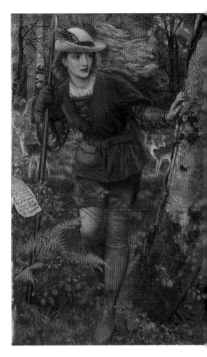

Arthur Hughes (1832–1915)

As You Like It, about 1872/3

Oil on canvas, centre 71 × 99 cm;
wings each 71 × 45.8 cm

Walker Art Gallery, National Museums Liverpool

Exhibited at the 1873 Liverpool Autumn Exhibition as *The Love making of Orlando and Touchstone*. The Liverpool collector Joshua Sing owned the painting and bequeathed it to the Walker in 1908

Hughes has painted three scenes from Shakespeare's play, set in the Forest of Arden, where the court has fled after being exiled by the Duke's brother. On the left the fool Touchstone woos the dull-witted Audrey. In the centre Orlando comforts his aged servant Adam whilst Amiens sings to the Duke and his courtiers. On the right the Duke's daughter Rosalind, disguised as a boy, discovers her name carved on a tree by Orlando. Hughes was part of the Pre-Raphaelite circle in the 1850s. In the 1860s and '70s he turned to romantic medieval subjects, often with musical associations.

John Everett Millais (1829–96)

Autumn Leaves, 1856

Oil on canvas, 104.3 × 74 cm

Manchester City Galleries

Exhibited at the Liverpool Academy in 1858. In the collection of John Miller and sold posthumously in 1881

*Not in exhibition

An article published in the Liverpool newspaper *The Porcupine* in 1866, by which time the Academy was about finally to expire, took the view that the 'immediate cause of the collapse was the then new pre-Raphaelite movement, which became a source of disaster to the Academy, through the activity of a few interested busy-bodies and a small knot of local *dilettanti*. These oppositionists clamoured as if pre-Raffaelism was one of the seven deadly sins'.[24]

One final attempt was made to bring the two Liverpool art associations together. Complicated negotiations took place but the constitutions of each made them incompatible. In 1863 the Academy closed and gave up the tenancy of the rooms in Old Post Office Place. The Society mutated into the Liverpool Institution of Fine Arts and staged two exhibitions, in 1863 and 1864, in the Academy's vacated premises. The most remarkable features of these latter exhibitions were two paintings by Frederic Leighton, *Salomé Dancing* (private collection) and *Jezebel and Ahab* (Scarborough Museum and Art Gallery). The Liverpool Academy itself held two further exhibitions, in 1864 and 1867, in the gallery of the picture dealer John Griffiths. Entry to these was restricted to Academy members and Pre-Raphaelite associates, amongst whom was Rossetti, who sent his 1863 oil *Fazio's Mistress* (Tate).

Liverpool's art scene was thus sadly depleted. As the town's economy gradually returned to previous levels of activity after the conclusion of the American Civil War in April 1865, the vacuum left by the failed Academy was filled in part by picture dealers and commercial galleries.[25] Something more was required, however, and in 1873 Andrew Barclay Walker announced his intention of providing a fitting picture gallery for the town of which he was mayor. The Walker Art Gallery opened in 1877, providing a venue in the first instance for the Liverpool Autumn Exhibition of contemporary art, which had inherited the mantle of the Liverpool Academy's autumn show, and which had been instituted by the Liverpool Town Council in 1871. From the start, members of the

Gallery Committee were conscious of the importance of securing works by the earlier generation of Pre-Raphaelite artists although acquisition budgets were tight and money had to be found from a variety of sources. Clearly, this campaign of acquisition had begun too late for there to be many opportunities for the purchase of Pre-Raphaelite paintings directly from the artists in question (although in 1880-1 the Walker succeeded in acquiring Rossetti's large oil *Dante's Dream* (page 25) having been encouraged to negotiate for its purchase by the young Liverpool journalist and author T Hall Caine). Otherwise, Pre-Raphaelite paintings came to the Gallery through diverse routes. In 1884 Millais's *Isabella* (page 8) was bought with money from the Walker's own resources, while in 1891, with the Gallery Committee under the passionate leadership of the merchant Philip Rathbone, Holman Hunt's *Triumph of the Innocents* was acquired partly with money raised by public subscription. Other significant paintings came to the Walker as a result of the generosity of Liverpool citizens. John Brett's *Stonebreaker* (page 26), which had once been owned by the Liverpool lawyer Thomas Avison and lent by him to the Liverpool Academy in 1858, was presented to the Walker by Mrs Sarah Ann Barrow in 1918. These key acquisitions were to set the scene for the acquisition of Pre-Raphaelite works at the Walker for decades to come.

24 Quoted in Morris, *The Liverpool Academy and Other Exhibitions*, p. 7. The original article was published on 27 October 1866, p. 352.
25 Including the aforementioned Griffiths, whose shop was in Church Street, and the Manchester-based firm of Thomas Agnew & Sons, which had opened a Liverpool branch, in Dale Street, in 1860.

Dante Gabriel Rossetti (1828–82)

Dante's Dream, 1871

Oil on canvas, 216 × 312.4 cm

Walker Art Gallery, National Museums Liverpool

Displayed in the Liverpool Autumn Exhibition at the Walker Art Gallery in 1881, and bought for the Gallery's collection

*Not in exhibition. On display at the Walker Art Gallery

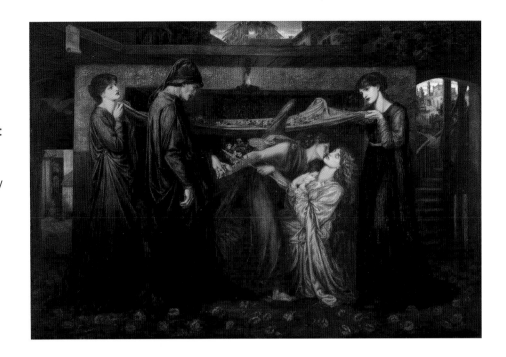

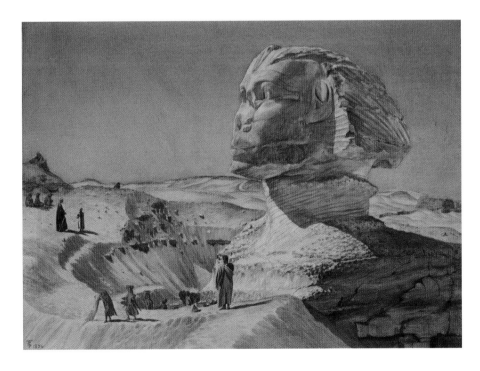

Thomas Seddon (1821–56)

The Great Sphinx of the Pyramids of Ghizeh, 1854

Watercolour and bodycolour on paper, 25 × 35.2 cm

Ashmolean Museum, Oxford. Presented by Miss H. M. Virtue-Tebbs, 1944

Exhibited at the Liverpool Academy in 1855

Seddon visited Egypt with Holman Hunt. He arrived late in 1853 and remained into the following year. Seddon stayed at Giza to paint the pyramids, but also made studies of other sites, including this representation of the Sphinx. During the visit, excavations were being undertaken by a group led by the French archaeologist Auguste Mariette. Seddon was to die of dysentery in Cairo in 1856.

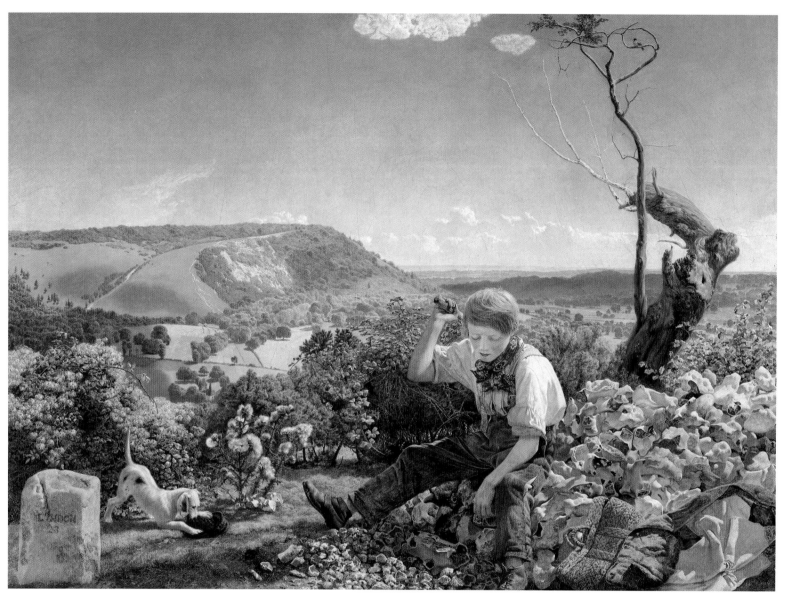

John Brett (1831–1902)

The Stonebreaker, 1857–8

Oil on canvas, 51.3 × 58.5 cm

Walker Art Gallery, National Museums Liverpool

Exhibited at the Liverpool Academy in 1858

This detailed landscape typifies Pre-Raphaelite 'truth to nature', as advocated by John Ruskin, whose writings influenced Surrey-born Brett. Plants, trees and rock formations are painted with scientific accuracy. The landscape is Box Hill near Dorking, Surrey. The stones are flints. The plants, all botanically identifiable, tell us that Brett was working in August or September. He painted it outdoors and wrote to his sister that: 'I can only work on it in sunny days – I hope it will look sunny.' Breaking stones for road mending was an unskilled job, often given to paupers. Brett may have had a symbolic meaning in mind: the bullfinch (sitting in the tree) traditionally symbolises the soul.

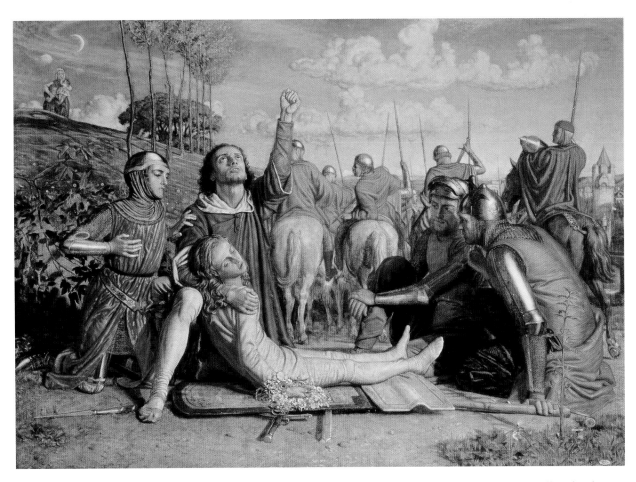

William Holman Hunt (1827–1910)

Rienzi vowing to obtain justice for the death of his young brother, slain in a skirmish between the Colonna and Orsini factions, 1848-9, retouched 1886

Oil on canvas, 86.4 × 121.9 cm

Private collection

Exhibited at the Liverpool Academy in 1858 as *Rienzi*, and later in the collection of Thomas Clarke of Allerton Hall, Woolton

*Not in exhibition

Cola di Rienzi was an heroic figure in medieval Italy who led a popular uprising. During a fight with the Orsinis, his brother was killed accidentally by his family's allies, the Colonna. A new edition of a novel about Rienzi was published in 1848, at which time there was political unrest in Italy and the Chartists were protesting in London. Hunt wrote that this awakened in him a revolutionary spirit that he wished to capture in a picture. *Rienzi*, therefore, combines historic and modern themes. The open-air setting (primarily Hampstead Heath) is the young artist's reaction to Ruskin's call to study nature, while the weaponry was painted, for accuracy, at the Tower of London. Dante Gabriel Rossetti sat for the face of Rienzi, and Millais and William Michael Rossetti for the Colonna knight on the left. This was Hunt's first exhibited painting bearing the initials 'PRB'.

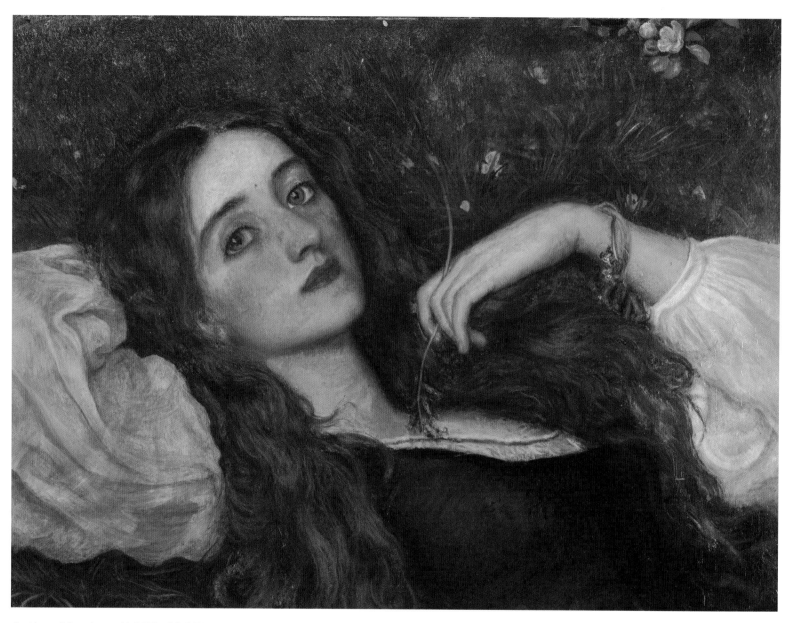

Arthur Hughes (1832–1915)

In the Grass, about 1864–5

Oil on board, 26.5 × 35.6 cm

Museums Sheffield

**Exhibited at the Liverpool Academy in 1865,
lent by George Rae**

This is Hughes' second version of this subject. He had been part of the Pre-Raphaelite circle in the 1850s, but this painting reflects his turn in the 1860s and 1870s towards more romanticised themes. The sitter is probably the artist's wife, Tryphena Foord, whom he married in 1855. At the time of its exhibition at the Liverpool Academy in 1865, the *Liverpool Daily Post*'s reviewer noted that Rae had commissioned the picture from Hughes and that he was lending it to the Academy to oblige the artist. Another review, also in the *Daily Post*, proclaimed the painting 'remarkable' and 'a fine study of the "fashionable" hair and complexion.'

John Brett (1831–1902)

The Hedger, 1860

Oil on canvas, 90 × 70 cm

Private Collection

**Exhibited at the Liverpool
Academy in 1860**

In *The Hedger*, which Brett worked on in
woodland in Kent, he marries rustic figures with
naturalistic landscape. This may be his response
to negative reactions to an earlier painting, *Val
d'Aosta* (Lord Lloyd-Webber collection),
principally a landscape scene which Brett had
difficulty selling. He was perhaps also
influenced by Ruskin, who had bemoaned the
lack of English spring subjects in his 1858
Academy Notes. At the Liverpool Academy *The
Hedger* was accompanied by a quotation from
'The Revulsion', a poem by Brett's friend
Coventry Patmore:

In dim recesses Hyacinths droop'd,

And breadths of Primrose lit the air

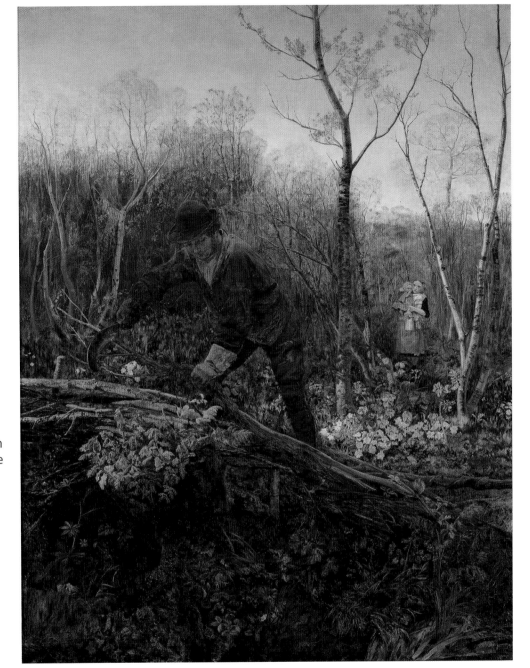

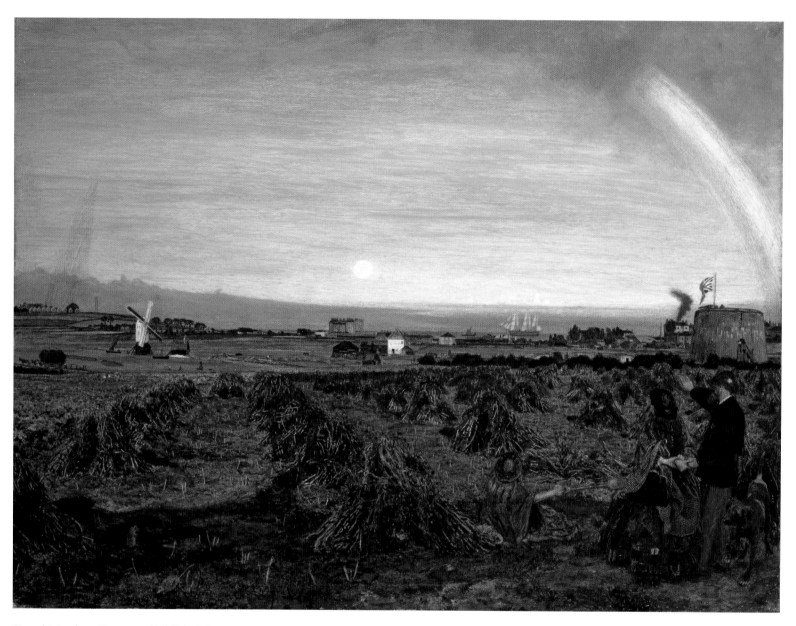

Ford Madox Brown (1821–93)

Walton-on-the-Naze, 1860

Oil on canvas, 31.7 × 42 cm

Birmingham Museums Trust

Exhibited at the Liverpool Academy in 1860

Brown himself appears here as the man surveying the panoramic landscape. With him are his wife Emma and their daughter Catherine. He and his family stayed in Walton-on-the-Naze on the Essex coast in August 1859. Brown recorded in his picture account book that he painted this scene, which combines the worlds of work and leisure, on the spot. The tower to the right is the famous Martello Tower, and Walton Mill is in the distance to the left.

Ford Madox Brown (1821-93)

A Study on the Brent at Hendon, 1854-5

Oil on board on mahogany, 20.3 × 24.8 cm

Tate: Presented by F. Hindley Smith 1920

Exhibited at the Liverpool Academy in 1856

This was one of three small landscapes painted for quick sale, although Brown put much effort into them. It was painted outdoors, then finished in the studio.

Ford Madox Brown (1821-93)

Heath Street, Hampstead (The Butcher Boy), 1852-6

Oil over pencil on canvas, 22.8 × 30.8 cm

Manchester City Galleries

Exhibited at the Liverpool Academy in 1857 as
Hampstead - a Sketch from Nature

This sketch was made in connection with Brown's painting *Work* (Manchester City Galleries).

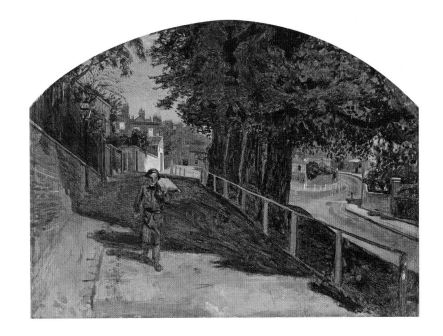

Arthur Hughes (1832–1915)

The Woodman's Child, 1860

Oil on canvas, 61 × 64.1 cm

Tate: Presented by Mrs Phyllis L. Holland 1958

Exhibited at the Liverpool Academy in 1860

This genre scene was commissioned by the Gateshead collector James Leathart, together with a companion picture. The model for the young girl, who is painted with extreme tenderness, is probably the artist's daughter Emily. In accordance with Pre-Raphaelite ideals, Hughes said that he did not make any studies for the painting. The landscape setting is executed with extreme fidelity to nature, and the overall composition illustrates Hughes' extraordinary sense of colour evident in his works of the 1850s and 1860s.

George Price Boyce (1826–97)

At Sonning Eye, Oxfordshire, 1860

Watercolour and pencil on paper, 27 × 55.6 cm

Private collection

Exhibited at the Liverpool Academy in 1862

The hamlet of Sonning Eye is on the river Thames in Oxfordshire. According to an inscription on the back of the picture, Boyce painted this scene at 'forenoon' in August 1860. The representation of a particular time of day, and the detailed motifs of red bricks, the cottage, trees and water, are highly characteristic of his work. Likewise the inclusion of various elements to suggest movement – the figure, ducks in the water and cats on the fence, are favourite pictorial devices for Boyce.

William Holman Hunt (1827–1910)

The Sphinx, Gizeh, looking towards the Pyramids of Sakhara, 1854

Watercolour on paper, 25.2 × 35.2 cm
Harris Museum and Art Gallery, Preston
Exhibited at the Liverpool Academy in 1856

Hunt travelled to Egypt early in 1854, *en route* to Palestine. His travelling companion was Thomas Seddon. According to a letter he wrote to Millais, Hunt was unimpressed by the Pyramids, thinking them ugly. The Sphinx held his interest more, and he resolved to finish this watercolour despite having been interrupted by desert storms. Compared with Seddon's view of the monument (page 25), Hunt's study presents the colossal form as if it were a natural phenomenon eroded by the sand-laden winds. The foundations of the Sphinx had recently been uncovered by French-led excavations.

Ford Madox Brown (1821–93)

The English Boy, 1860

Oil on canvas, 39.6 × 33.3 cm
Manchester City Galleries
Exhibited at the Liverpool Academy in 1860

The young boy, brandishing his whip and top, is the artist's eldest son, Oliver Madox Brown (1855–75), then aged five. The setting is thought to be the family home in London. Brown painted *The English Boy* for the patron Thomas Plint, a Leeds stockbroker. The picture has been identified as being based on a portrait by Holbein of *Edward VI as a boy* (National Gallery of Art, Washington DC) which Brown probably knew through an engraving.

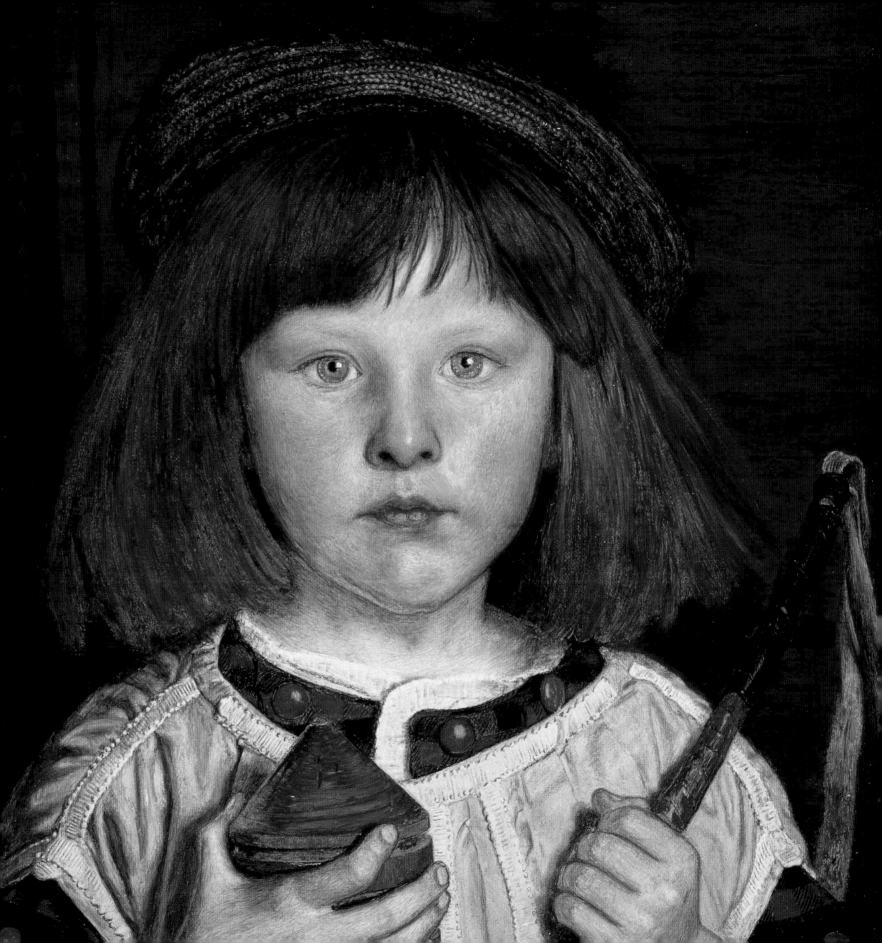

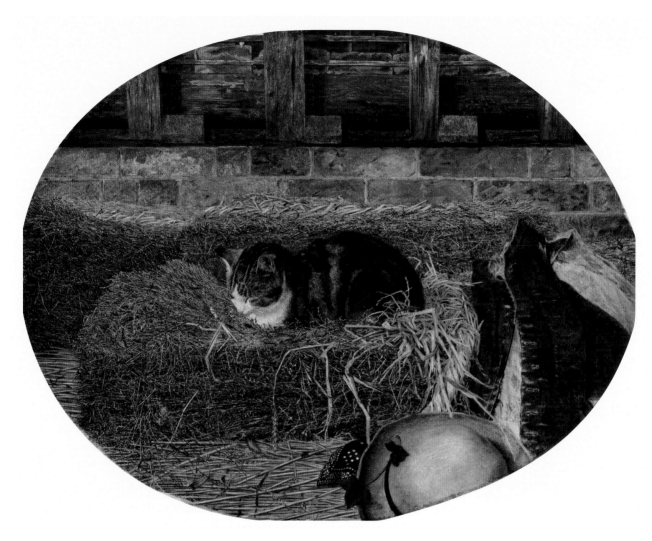

Rosa Brett (1829–82)

The Hay Loft (also known as Catnap), 1858

Oil on canvas, 27 × 34.7 cm

Private collection

Exhibited at the Liverpool Academy in 1858

The discarded clothing in this seemingly innocent image of a snoozing cat suggests that less than innocent activities may be unfolding elsewhere in the barn. Brett's meticulous detail and luminous colours reveal a Pre-Raphaelite influence. Animal and bird studies were a particular skill of Brett's. She had her own cat, Bunny, and her work demonstrated a sensitive insight into the character and physical form of animals. When this work was displayed in Liverpool in 1858 – her first exhibition – the self-taught Brett used the masculine pseudonym 'Rosarius'. Her brother was the artist John Brett.

George Price Boyce (1826–97)

From the Windmill Hills, Gateshead upon Tyne, 1864–5

Watercolour on paper, 28 × 40 cm

Tyne & Wear Archives & Museums, Laing Art Gallery, Newcastle upon Tyne

Exhibited at the Liverpool Academy in 1865 as *From the Windmill Hills, Gateshead-on-Tyne*

Newcastle upon Tyne can just be seen in the background of Boyce's view. At one point there were some ten windmills on this elevated site. Boyce uses his signature red brickwork to enhance the effects of the light from the setting sun in this composition. The tranquil countryside provides respite from the industrialised town in the distance. This was one of Boyce's later Pre-Raphaelite-influenced works.

William Holman Hunt (1827–1910)

Il Dolce Far Niente, 1859–66, retouched 1874–5

Oil on canvas, 99 × 82.5 cm
Private collection
Exhibited at the Liverpool Autumn Exhibition in 1875

Hunt's intention here was to paint a figure of full proportions with, as he wrote, no 'didactic purpose' – the title suggests the sitter is pleasantly doing nothing. He used more than one model. At the 1867 Royal Academy exhibition, reception to the picture was hostile, with Hunt criticised for frivolity. *Il Dolce* changed hands many times. It was included in a Birmingham auction of oil paintings in the possession of Mr Marsden of King Street Galleries, London, advertised in the *Liverpool Mercury* on 11 February 1879. By 10 March 1879 the London dealer Arthur Tooth – presumably having acquired it – was advertising it in the *Sunderland Daily Echo and Shipping Gazette.* These provincially placed advertisements correspond to an existing gap in the picture's provenance, but also demonstrate the dealers' keenness to target enthusiastic buyers in the north of England.

John William Inchbold (1830–88)

The Chapel, Bolton, 1853

Oil on canvas, 50 × 68.4 cm
Northampton Museums and Art Gallery
Exhibited at the Liverpool Academy in 1853

On exhibition, this painting of Bolton Priory in the Yorkshire Dales was accompanied by a quotation from Wordsworth's poem 'The White Doe of Rylstone': 'The gentler work begun / By nature, softening and concealing / And busy with a hand of healing.' Inchbold shows the Priory late on a summer afternoon. With its close observation of nature, the painting marks Inchbold's shift towards the Pre-Raphaelite style.

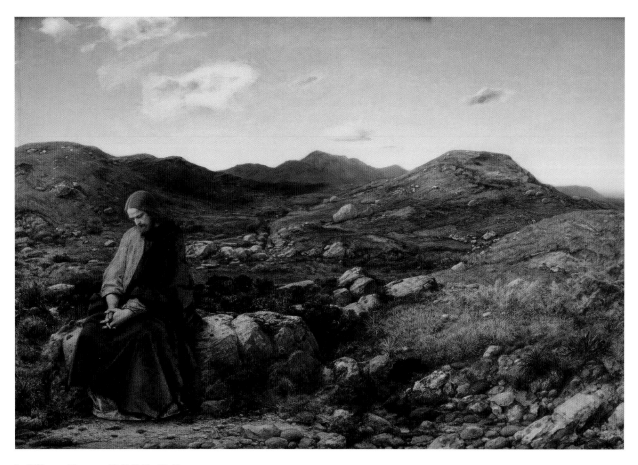

William Dyce (1806–64)

Man of Sorrows, about 1859

Oil on millboard, 39.3 × 49.5 cm

Scottish National Gallery, Edinburgh. Purchased with the aid of the National Heritage Purchase Grant, (Scotland) 1981

Exhibited at the Liverpool Academy in 1861

It is thought that Dyce used the Scottish landscape as the setting for his portrayal of Christ and he was criticised by FG Stephens for taking such a liberty. Dyce represents Jesus in a vulnerable and naturalistic emotional state rather than the traditional 'Man of Sorrows' depiction exposing the wounds of the Crucifixion - indeed, the palms of His hands are hidden. The painting was exhibited in Liverpool with a title drawn from Luke 4: 1–2 : 'And Jesus was led by the Spirit into the / Wilderness, and in those days / He did eat nothing'. The *Liverpool Mercury*'s review described Dyce's 'Christ in the Wilderness' as 'a beautiful painting, and one which cannot fail to command attention.' The picture is probably a companion piece to *David in the Wilderness* (page 41).

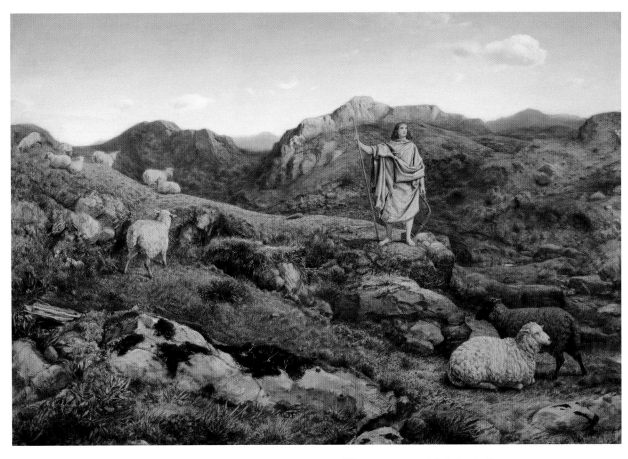

William Dyce (1806-64)

David in the Wilderness, 1860

Oil on millboard, 39.3 × 49.5 cm

Scottish National Gallery, Edinburgh. Purchased with the aid of the National Heritage Purchase Grant, (Scotland) 1981

Exhibited at Liverpool Institution of Fine Arts in 1867

This work was probably conceived as a companion piece to *Man of Sorrows* (page 40). As with that picture, the landscape, with its almost photographic degree of accuracy, appears to be Scottish. Aberdeen-born Dyce was a devout Christian and produced a number of religious subjects. He sought to portray biblical figures as real people with whom an audience could identify.

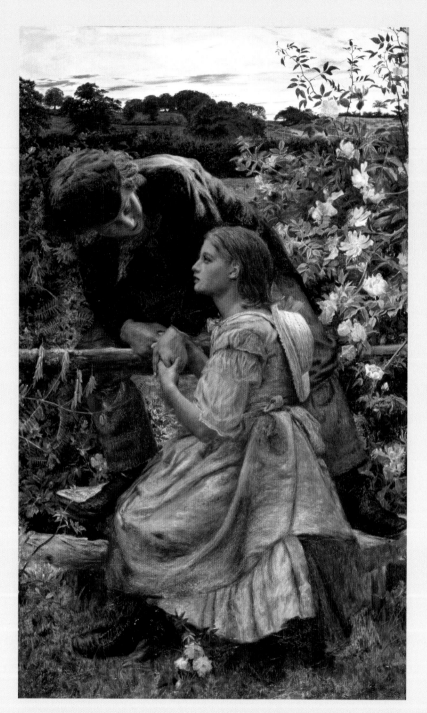

Frederick Smallfield (1829–1915)

Early Lovers, 1858

Oil on canvas, 76.4 × 46.1 cm
Manchester City Galleries
Exhibited at the Liverpool Academy in 1859

Smallfield studied at the Royal Academy in the 1840s with some of the Pre-Raphaelites, but did not show their influence until late in the 1850s. He was best known for his watercolours. The genre picture *Early Lovers* illustrates Thomas Hood's ballad 'Time of Roses'. The verse accompanied the painting at the 1859 Liverpool Academy exhibition. At the Institution of Fine Arts at the Portland Gallery in London the same year, the painting was proclaimed by one reviewer as the best in the show.

Albert Joseph Moore (1841–93)

Study of an Ash Trunk, 1857

Watercolour on paper, 30.3 × 22.9 cm

Ashmolean Museum, Oxford. Purchased, 1959

**Exhibited at the Liverpool Academy in 1858 as
*An Ash Trunk &c.***

The young and precocious Albert Moore had not yet entered
the Royal Academy Schools when he painted this study, which
adheres faithfully to Ruskin's promotion of fidelity to nature.
Together with this watercolour, Moore exhibited another work,
Wayside Weeds – an equally down-to-earth subject – in
Liverpool in 1858.

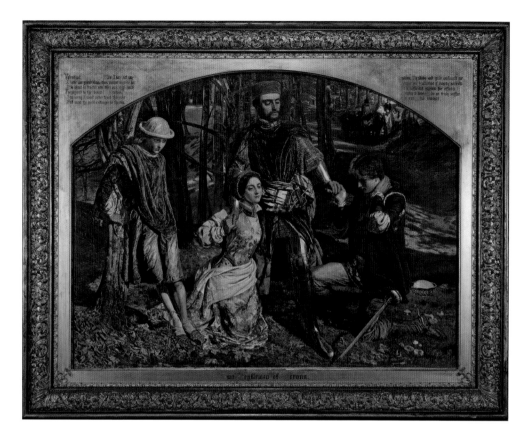

William Holman Hunt (1827–1910)

Valentine rescuing Sylvia from Proteus, 1850–1

Oil on canvas, 100.2 × 133.4 cm

Birmingham Museums Trust

Exhibited at the Liverpool Academy in 1851 as *Valentine Rescuing Sylvia from Proteus, and reproaching him for his falsity*. Winner of the £50 prize

*Not in exhibition

Ford Madox Brown (1821–93)

Windermere, 1855

Oil on canvas, 17.5 × 49.2 cm

Lady Lever Art Gallery, National Museums Liverpool

Exhibited at the Liverpool Academy in 1857. The painting was owned by George Rae and purchased from his executors by William Hesketh Lever in 1917

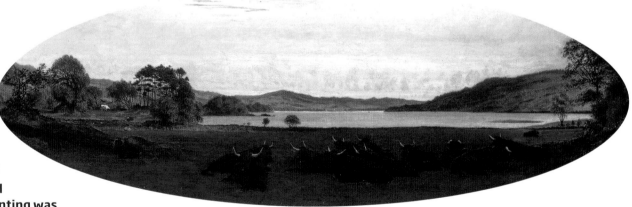

In March 1848, Brown first met Rossetti and came into contact with nascent Pre-Raphaelite ideas. In September he visited the Lake District and his diary records that he spent four hours a day for six days labouring on this small canvas. Two versions were painted, both based upon this first study. He completed and signed this study seven years later in 1855. The sky was also cut down and the slip frame designed which transforms it into an oval picture, concentrating the image in the same way he had employed oval or round shapes in his major 1850s paintings. The view is from the north end of Lake Windermere, looking south.

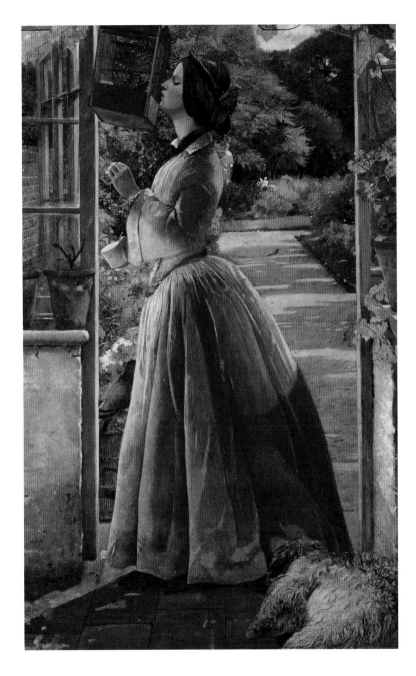

Walter Howell Deverell (1827–54)

A Pet, 1853

Oil on canvas, 83.8 × 57.1 cm

Tate: Purchased 1911

Exhibited at the Liverpool Academy in 1853

Deverell was among a wider circle of painters under the Pre-Raphaelites' influence. At the 1853 Liverpool exhibition this painting was captioned with a quote from William Broderip's *Leaves from the Note Book of a Naturalist*: 'But after all, it is very questionable kindness to make a pet of a creature so essentially volatile.' *A Pet* was one of a group of paintings derided by the *Liverpool Mercury*'s critic: '…some strange attempts at the pre-Raphaelite style. Although we have given all due encouragement to real merit under the new school, we by no means intend to encourage every extravagance that artists may perpetuate under this name… [they are] stiff, ungraceful and crude in colour.' Hunt and Millais helped to support Deverell when he was mortally ill by buying *A Pet* from the exhibition for £80 (or guineas).

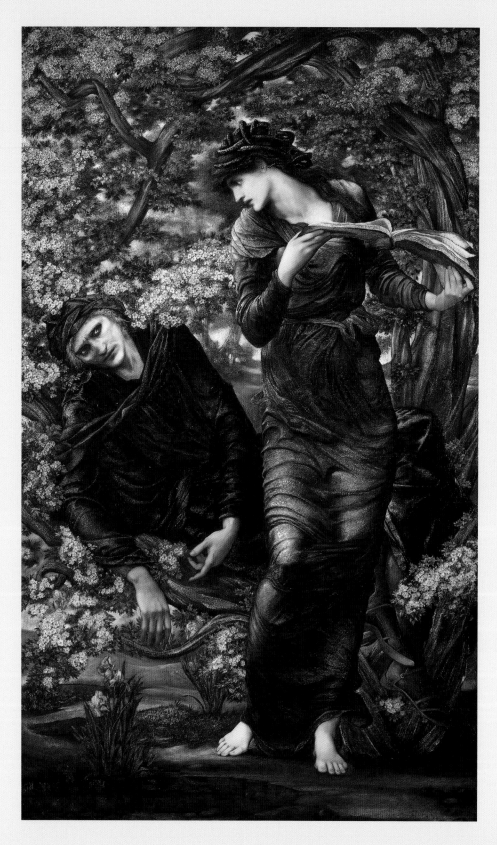

Edward Burne-Jones (1833–98)

The Beguiling of Merlin, 1873-7

Oil on canvas, 186 × 111 cm

Lady Lever Art Gallery, National Museums Liverpool

Owned by Frederick Leyland, and later by William Hesketh Lever

In this scene from the Arthurian Legends, with which the artist was enthralled, Merlin falls into a deep sleep under the enchantment of Nimue, the Lady of the Lake. The intensity between the two figures may be read as a reflection of the artist's own private life. The model for Nimue was Mary Zambaco, a medallist and sculptor. She was one of Burne-Jones' admirers and became his mistress. The writer Oscar Wilde described this painting as being 'full of magic'.

The Liverpool patrons

Christopher Newall

In a series of articles in the *Athenæum*, published between 1875 and 1887, the critic Frederic George Stephens gave vivid accounts of works of art that he had seen in private collections in Liverpool and Birkenhead. As he had previously done for the art patrons of Newcastle and Gateshead-on-Tyne, Stephens offered the readership of this modestly intellectual, London-based literary magazine glimpses of the extraordinary collections that were being assembled in the north-western conurbation. He indicated the passion with which these men and women, who were generally people who had risen to wealth and influence in a generation, and did not come from family backgrounds in which collecting art was part of an inherited culture, approached the process of acquisition.

Stephens occasionally referred to paintings by Old Masters – for example works by Tintoretto, Velasquez and Rembrandt belonging to Frederick Leyland,[1] Netherlandish landscapes belonging to Anna Maria Heywood of Norris Green,[2] works attributed to Murillo and Veronese belonging to Alfred Fletcher of Woolton,[3] and the remarkable accumulation of antique statuary at Ince Blundell Hall.[4] Other collections described included works by French 19th-century artists, generally of the more conservative type, for example that of Grant Morris of Woolton.[5] As might be expected, however, the majority of the works that Stephens

documented were by British artists, and with a clear preponderance for paintings and drawings of the second and third quarters of the 19th century. The writer had been one of the founding members of the Pre-Raphaelite Brotherhood in 1848 and although he seems never to have contemplated a professional career as a painter his appreciation of contemporary art – and especially Pre-Raphaelitism – was undoubted. How he persuaded collectors to admit him to their houses and likewise to recommend him to others who owned works of art of quality can only be imagined.

Among the Liverpool collectors of Pre-Raphaelite art of the first generation was John Miller.[6] From Lanarkshire, Miller appears to have moved to Liverpool as a young man to advance his business interests through trade in goods from North America including cotton and timber. No other figure of his generation was so intent upon fostering the arts in the city, nor did any other patron appear so well liked by the painters and critics who were his friends. Ford Madox Brown, who met him in the course of a visit to Liverpool in September 1856, vividly recalled 'This Miller [as] a jolly kind old man with streaming white hair, fine features & and a beautiful keen eye [...] A rich brogue, a pipe of Cavendish & smart rejoinder with a pleasant word for every man, woman, or child he meets, is characteristic of him. His house is full of Pictures even to the kitchen, many pictures he has at

1 See *Athenæum* 2869, 21 October 1882, pp. 534–5.
2 See *Athenæum* 2864, 16 September 1882, pp. 375–6.
3 See *Athenæum* 2970, 27 September 1884, p. 408.
4 See *Athenæum* 2864, 16 September 1882, p. 375. Most of the collection now belongs to National Museums Liverpool.
5 See *Athenæum* 2968, 13 September 1884, pp. 340–1.

6 More information about Miller and all the other Liverpool and Birkenhead patrons and collectors here discussed comes from Macleod, *Art and the Victorian middle class*, and its very useful Appendix 'Major Victorian Collectors'. For new information on Miller, see Ann Bukantas, 'John Miller of Liverpool', p. 74 in this publication.

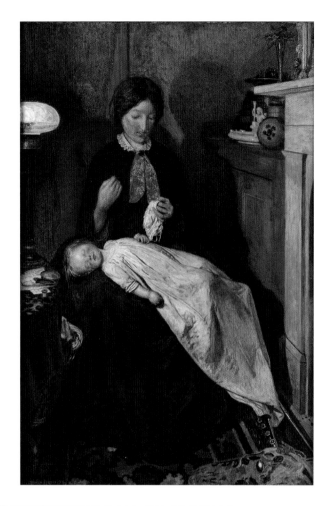

Ford Madox Brown (1821–93)

Waiting: an English Fireside in the Winter of 1854–5, 1851–5

Oil on oak panel, 30.5 × 20 cm

Walker Art Gallery, National Museums Liverpool

Exhibited as *Waiting* at the Liverpool Academy in 1856. The picture was acquired by John Miller, and was later owned by his son Peter

This was Brown's first contemporary scene. Begun in 1851–2 as a domestic subject, he later altered it to a topical one representing an officer's wife awaiting his return from the Crimean War. On the table he added a miniature portrait of a soldier and some letters. The setting is a middle-class room. The figures are portraits of Brown's wife Emma and daughter Catherine. They are painted as if a Madonna and child, with an intensity that suggests the holiness of domestic life.

all his friends houses in Liverl & his house in Bute also filled'.[7] William Michael Rossetti likewise described Miller as 'one of the most cordial, large-hearted, and lovable men I ever knew'.[8] Much of Miller's collection was dispersed by the time of Stephens's visits to the North West in preparation for the *Athenæum* articles so there is no detailed account of what was to be seen at his successive addresses in Liverpool or at his country house, 'Ardencraig', on the Isle of Bute. Miller, who was in his fifties by the time the Pre-Raphaelites appeared on the scene, was nonetheless bowled over by the progressive works displayed at

the Liverpool Academy in the early 1850s.[9] The artists to whom he attached a particular allegiance – Brown, Millais and Holman Hunt – were those whose style of painting was shown to advantage in the late summer exhibitions there. The former was represented in Miller's collection by the subject *Waiting – An English Fireside, in the Winter of 1854–5* (page 48), bought directly from the artist while they were together in 1856 for £84.[10]

7 *The Diary of Ford Madox Brown*, edited by Virginia Surtees, New Haven, 1981, p. 189.
8 WM Rossetti, *Dante Gabriel Rossetti as Designer and Writer*, London, 1889, p. 15.
9 Miller's insatiable appetite for paintings had led him previously to acquire works by an earlier generation of artists including Constable and Turner, and all of these were displayed in Miller's houses alongside masterpieces by the Pre-Raphaelites.
10 The purchase was referred to in an entry in Brown's diary for 27 September 1856. See Surtees, *The Diary of Ford Madox Brown*, p. 190.

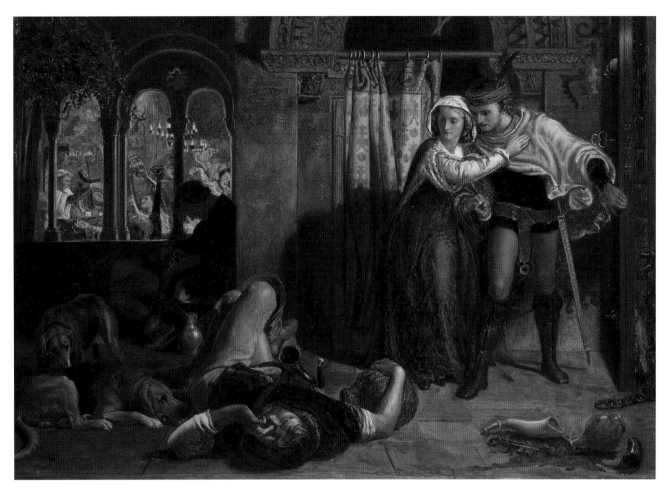

William Holman Hunt (1827–1910)

The Flight of Madeline and Porphyro during the drunkenness attending the revelry (The Eve of St Agnes), 1847–57

Oil on panel, 25.2 × 35.5 cm

Walker Art Gallery, National Museums Liverpool

This is an episode from John Keats' poem *The Eve of St Agnes*, about two eloping lovers. Begun before the Pre-Raphaelite Brotherhood was founded in 1848, the picture shows Hunt's early interest in medievalism, naturalistic detail and moral teaching. He contrasts innocent young love with the debauched castle guests. Hunt exhibited a larger version of the painting at the Royal Academy in 1848. It began as an outline drawing of the bigger picture. In the 1850s Hunt finished it for his Liverpool patron John Miller.

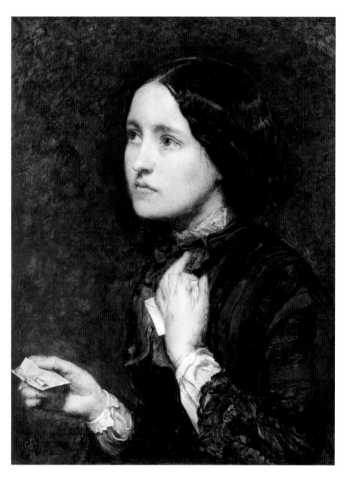

John Everett Millais (1829–96)

Wedding Cards: Jilted, 1854

Oil on panel, 22.2 × 16.5 cm

Private collection

First exhibited at the Liverpool Academy in 1854 as *The Wedding Cards*. Formerly in the collections of John Miller and William Hesketh Lever

This portrait is now thought to be one of a small group of 'heads' that Millais painted in the spring of 1854. He had fallen in love with Ruskin's wife Effie and was interested in representing themes of emotional crisis through his paintings. Wedding cards were given out to the friends of recently married couples to announce they were 'at home' to receive congratulatory visits. Millais' focus upon the young woman's gesture, her ringless left hand symbolically clasped to her heart, together with her sad expression, suggest all is not well. The painting was lent by Miller to the 1857 exhibition of Pre-Raphaelite art at Russell Place in London, and the following year was included in the sale of his art collection.

In addition to two important early paintings by Millais, Miller owned one of the artist's undoubted masterpieces, *The Blind Girl* (inside front cover), which as has been seen was the object of controversy when shown in Liverpool in 1857, and *Autumn Leaves* (page 23). More intimate than either of these, although perhaps less conspicuous when shown at the Liverpool Academy in 1854, was Millais's charming *Wedding Cards – Jilted* (page 50). By Hunt, Miller had the reduced replica of *The Eve of St Agnes* (page 49) which he had commissioned, and *The Haunted Manor* (Tate).

Miller was the greatest supporter of the indigenous school of painters in Liverpool, many of whom were his personal friends and attended his weekly gatherings at which matters to do with art were discussed. In 1850 he assisted the young William Lindsay Windus by sponsoring him on a trip to London to see the summer exhibitions, and in 1856 he acquired the artist's first Pre-Raphaelite work, *Burd Helen* (page 51), although he sold it two years later.[11]

11 Miller owned the painting at the time of the Royal Academy summer exhibition of 1856 where it was first shown, as indicated by a letter from Rossetti to William Allingham written in May of the year, in which he praised the work and concluded: 'It belongs, I hear, to your friend Miller' (See *The Correspondence of Dante Gabriel Rossetti Volume 2 – The Formative Years, 1835-1862 – II. 1855-1862*, edited by William E Fredeman, Cambridge, 2002, p. 127). In 1858, it was bought by Thomas Plint, but was subsequently owned by FR Leyland. In addition to buying and then selling paintings and drawings when opportunities for profit occurred, Miller may have regarded himself as an art agent and perhaps expected to be rewarded when he made introductions which led to commissions, as for example when he brought FR Leyland and Rossetti together in 1865.

William Lindsay Windus (1822–1907)

Burd Helen, 1856

Oil on canvas, 84.4 × 66.6 cm

Walker Art Gallery, National Museums Liverpool

Exhibited at the Liverpool Academy in 1864. Passed through the collections of John Miller, Frederick Leyland and John Bibby

Pregnant by her callous lover, Burd Helen ran alongside his horse disguised as a pageboy. The story is from a Scottish border ballad. Verses from this are written on the frame. In 1850 Liverpool-born Windus was encouraged by the Liverpool collector John Miller to visit London and see the Pre-Raphaelite paintings at the Royal Academy. *Burd Helen*, his first picture revealing their influence, was praised by Rossetti and the critic Ruskin at the Academy of 1856, and was bought by Miller. Two years later Ruskin criticised Windus's picture *Too Late* (page 109). Devastated, Windus became a recluse. Both paintings share tragic sexual themes concerning the 'fallen woman', a favourite Pre-Raphaelite subject.

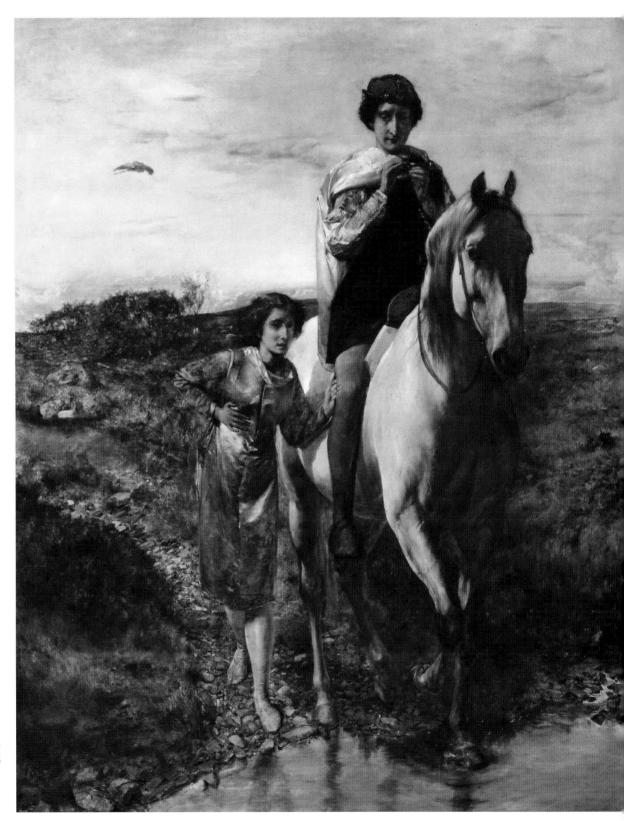

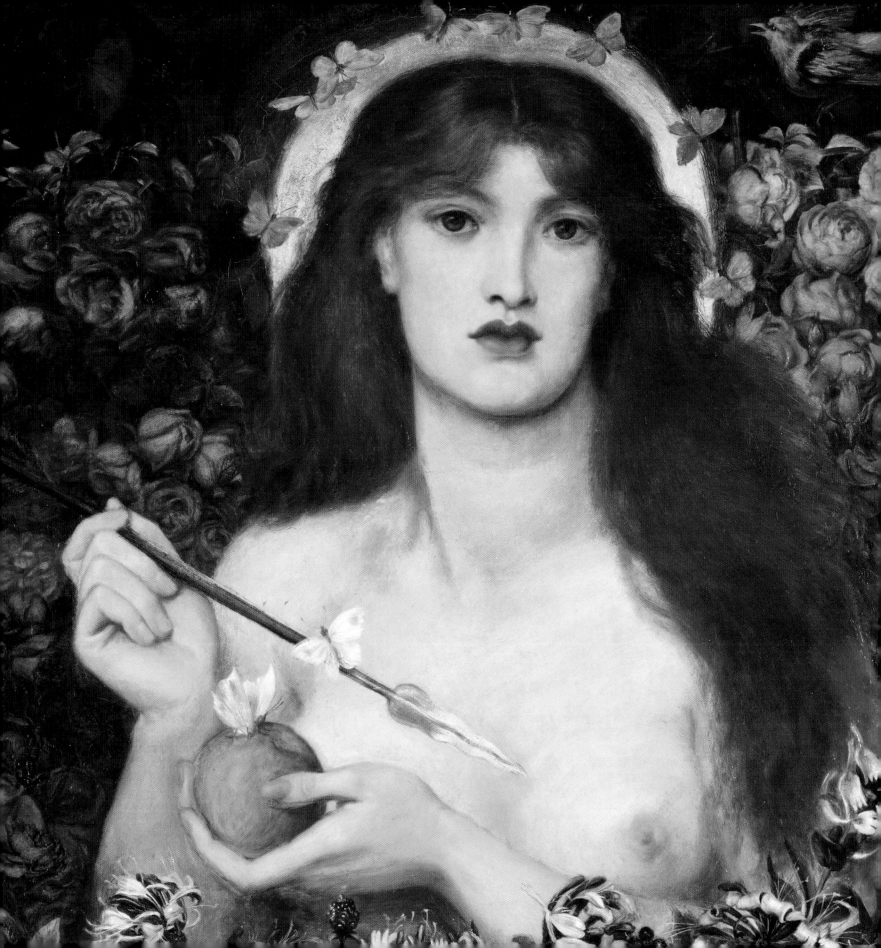

Dante Gabriel Rossetti (1828-82)

Venus Verticordia, about 1863-8

Oil on canvas, 98.1 × 69.8 cm
Lent by the Russell-Cotes Art Gallery & Museum,
Bournemouth

The title, 'Venus, turner of hearts', derives from Latin
literature. Venus, the goddess of love and beauty,
turned women's hearts towards virtue. Rossetti
interpreted it in the opposite sense, to mean turning
men's hearts away from fidelity. This is evident in a
sonnet Rossetti wrote for the picture. The roses,
honeysuckle, apple and nude figure emphasise the
theme of love and sexuality. He went to much trouble
to acquire the flowers in order to paint from nature.
Rossetti was among the first artists to initiate the
Victorian revival of the nude. A smaller – and censored
– watercolour version of the painting was owned by
George Rae and then William Hesketh Lever. Rossetti
masked the nudity with drapery at Rae's request – Rae
thought her too voluptuous 'for a respectable old
timer like me'.

Ford Madox Brown (1821–93)

The Coat of Many Colours (Jacob and Joseph's Coat), 1866

Oil on canvas, 108 × 103.2 cm

Walker Art Gallery, National Museums Liverpool

Commissioned by George Rae in 1864 for 450 gns, and later owned by William Coltart whose widow Eleanor presented it to the Walker Art Gallery in 1904

This composition was first drawn in 1863 for an illustrated Bible. The story comes from the *Book of Genesis*. A quotation is given on the upper part of the frame. Resentful of their father's favouritism for Joseph, his brothers sold him into slavery and told their father Jacob that he had been killed by a wild beast. Brown shows the deceitful brothers, Jacob's despair and the suspicion felt by his youngest son, Benjamin. The Pre-Raphaelites strove to give Biblical pictures an authentic Middle Eastern flavour. Brown had never visited the Middle East so he copied the landscape from a watercolour painted near Jerusalem by the artist Thomas Seddon. He took the costumes from illustrations of Assyrian and Egyptian examples.

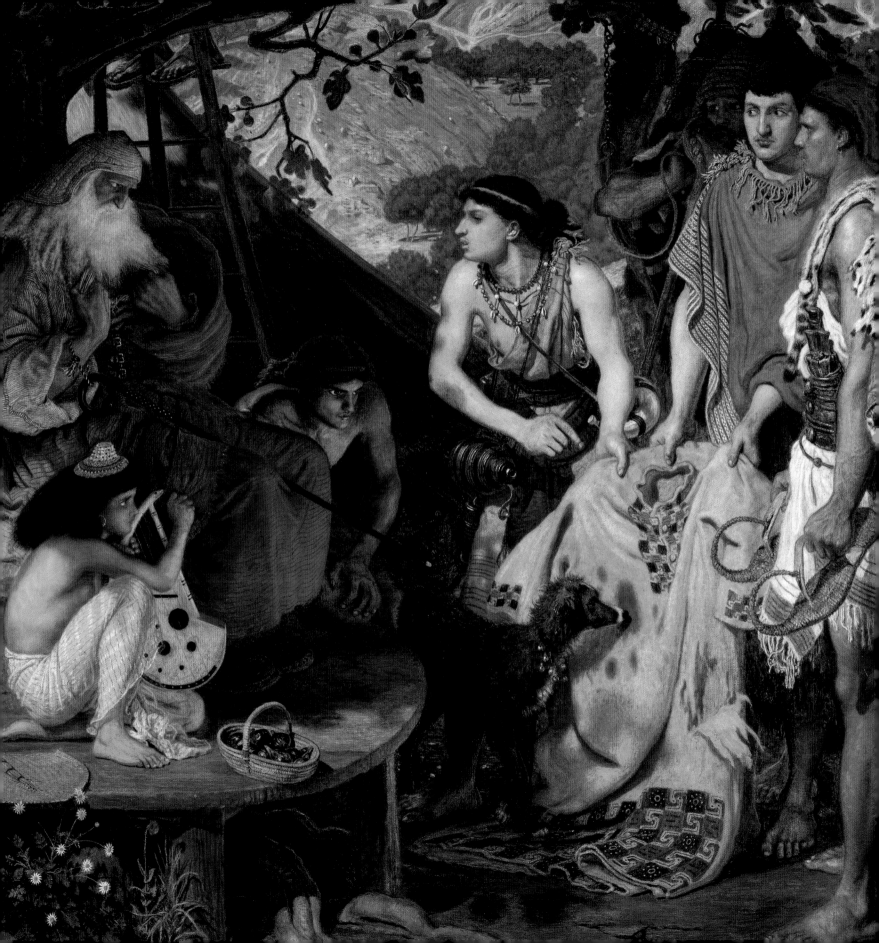

According to HC Marillier, it was Miller who recommended William Davis to paint landscape.[12] He owned a large number of his works, invited him on painting expeditions to Bute, and effectively ensured his livelihood. In addition, Miller attempted to give direction to the affairs of the Liverpool Academy where the Liverpool artists gathered and exhibited, serving as president of the Council. His affable personality and his generosity made him a welcome figure in wider artistic circles, as may be judged from the invitation he received in 1858 to join the Hogarth Club in London as a 'non-artistic' member.

Certain artists seem disproportionately well represented across the spectrum of the Liverpool collections, and one can only imagine how individuals might have gained a particularly favourable local reputation by exchanges of opinion between friends or through neighbourly competition to display new acquisitions. Millais and Brown were frequent contributors to the exhibitions of the Liverpool Academy, and the latter seems to have made a special effort to advance his reputation and make friends in the city when things were hard in London – as indicated by a Micawberish diary entry for 23 September 1856: '[having] made up my mind to go & try my luck at Liverpool, went & bought a ready made coat & trousers for 3 guineas, & all arrangements being complete for swelling it'.[13] Dante Gabriel Rossetti appears never to have visited Liverpool but was always welcoming to visitors from the North West to his house in Chelsea and was on terms of particular friendship with Miller and George and Julia Rae. He was represented in at least ten collections in Liverpool and Birkenhead and with four particular patrons – John Bibby, the Raes, and FR Leyland – owning a total of 60 or more of his paintings and drawings between them, he was thus, in numerical terms, the most widely represented artist among those who were not indigenous to those places. John Bibby came of a family of ship-owners in Liverpool, and the collection at his house in Sefton Park was described by Stephens.[14] The nine works by Rossetti that he owned came directly from the artist, or, in later years, from the dispersal sales of fellow collectors (including that of Leyland, at whose 1892 sale Bibby bought *La Pia de' Tolomei* [University of Kansas, Lawrence, Kansas]).

The most remarkable of the Liverpool collectors of Rossetti was, however, the banker George Rae, so much so that in 1872 he had cause to write a jocular complaint to the artist – 'It is a grand thing to be the owner of more "Rossettis" than "any other man": but it has its drawbacks. The number of persons who desire to see them is increasing. (There are four coming tomorrow, for example: but of course Saturday is a half-holiday.) Well – I think of having a Catalogue printed. I must either do this, or allow my wife to be walked off her legs, or talk herself into chronic hoarseness, in performing her part of show woman'.[15] This glimpse into the domestic life of George and Julia Rae gives some clue to their public-spirited generosity in allowing people access to their treasures. The catalogue referred to lists 19 paintings and drawings by Rossetti. Amongst these was a unique accumulation of the artist's watercolours of the 1850s which the Raes had begun to acquire from as early as 1862, commencing with the purchase of *The Wedding of St George and the Princess Sabra* (Tate) and continuing in 1864 with the addition of six further drawings, including *The Blue Closet* (Tate), bought from William Morris at a time when he sought to raise capital for his expanding decorating business. Later, Rae commissioned from Rossetti a series of oils showing female figures imbued with erotic allure. The first of these was *The Beloved* (Tate), a subject inspired by the 'Song of Solomon'. This was succeeded as an acquisition by *Sibylla Palmifera* (Lady Lever Art Gallery). A watercolour replica of the subject *Venus Verticordia* (page 53), which in the original version shows the goddess bare-breasted, was adapted at Rae's request on the grounds that 'the oil painting struck me as just a trifle too voluptuous in face &c. for a respectable old timer like me',[16] as he explained to Rossetti in 1864. Rae may have come to wish that all his negotiations with Rossetti could have been as simple as the deals conducted in 1862 and 1864, as from that time forward the delivery of works commissioned became ever more fraught and subject to delay.

12 Marillier, *The Liverpool School of Painters*, p. 100.
13 See Surtees, *The Diary of Ford Madox Brown*, p. 188.
14 *Athenæum*, 27 September 1884, pp. 408-9. John Bibby was the third of three successive generations of his family with the same name, and he and his father have been confused in historical accounts.
15 Quoted Julian Treuherz, 'Aesthetes in Business: The Raes and D.G. Rossetti', *Burlington Magazine*, CXLVI, January 2004, pp. 13-19.
16 Ibid., p. 14.

Stephens was spellbound by the Rae collection, describing what he saw in two long pieces which commenced the series of articles in the *Athenæum*.[17] In his opening remarks about works by Rossetti he regretted that the artist was so little known, and expressed the view that in the Rae pictures 'a new vein of inspiration is here to be seen, together with a gorgeous and masterly mode of painting and a splendid order of colouring, [...] and an unbounded luxury of invention'.[18] In Stephens's view, the Raes' collection was especially remarkable because it represented the rare and intense early watercolours which were the product of Rossetti's unique pictorial inventiveness in its formative stage, but these were accompanied by paintings from the period of the painter's transition into Aestheticism and his invention of an art which elicits a subliminal response upon the spectator's imagination. Furthermore, because much of the correspondence between Rossetti and Rae survives,[19] information exists about how each regarded the works that were entering the collection, and even how they should be displayed. Julian Treuherz has quoted from a particularly interesting letter in which Rossetti recommends a hanging scheme in which the 1850s drawings were to be placed frame-to-frame,[20] and thus calculated to achieve an effect of overwhelming decorative richness.

A further letter from Rae to Rossetti, sent upon the receipt of *The Beloved* in March 1866, offers a glimpse of the close-knit character of the Liverpool art community and the kind of exchanges that took place between patrons and painters. On the occasion described, Miller had been to the Raes' house to see Rossetti's work and 'was enraptured by it'. Leyland had accompanied him, but although according to Rae 'he admired the work very much, [it was] not with the warm and practised discrimination of old Mr Miller'. Among the painters who saw the new work, 'Poor [William] Davis looked at the picture for half an hour without uttering a word, but he sighed every now and then and left in a depressed state of mind'.[21] In 1879

the Raes moved to Redcourt in Birkenhead, a house designed by Edmund Kirby, and where the paintings and drawings in their collection must have been seen to advantage. Late in life, George Rae reminisced about how the experience of seeing Pre-Raphaelite works at the Liverpool Academy in the 1850s, and specifically Millais's *The Huguenot* (Makins Collection), which was shown in 1852, had formed his taste. His first purchase was of a watercolour entitled *Among the Thames Willows* (untraced) by George Price Boyce in 1860, but only a year after this tentative beginning he bought Ford Madox Brown's landscape masterpiece *An English Autumn Afternoon* (Birmingham Museums Trust). Another remarkable work of art from the Pre-Raphaelite orbit belonging to the Raes was Edward Burne-Jones's pen-and-ink drawing *The Wise and Foolish Virgins* (private collection), which they bought from the Plint sale in 1862 and which three years previously had been shown at the Liverpool Academy.

Miller and Rae were both Scots who moved to Liverpool at a time when the city was experiencing exponential economic growth. The consequent opportunities for enrichment led to previously unimaginable standards of living and, as has been seen, the chance to commission and collect works of art. Miller's first and second wives are shadowy figures whose roles in the formation of the collection are unclear;[22] conversely, Julia Rae can be recognised as sharing her husband's enthusiasm for picture collecting. Even more clearly identifiable as someone who expressed her own taste in the choice of paintings to buy was Ellen Coltart. In the course of two marriages (her first husband, Jonathan Tong, a yarn agent in Salford, died in 1881, after which she married her long-term admirer the iron merchant William Coltart), Ellen (or Eleanor as she seems to have been renamed by the time of her second marriage) made purchases directly from artists, at London exhibitions and in later years from the dealers Thomas Agnew. Stephens visited the Coltarts' house Woodleigh at Claughton cum Grange, Birkenhead, and wrote with enthusiasm about Rossetti's watercolour replicas *Lady Lilith* (Metropolitan Museum of Art, New York) and *The Borgia Family* (Victoria and Albert Museum).

17 See *Athenæum*, 2501, 2 October 1875, pp. 443–5, and 2502, 9 October 1875, pp. 480–2.
18 *Athenæum*, 2501, 2 October 1875, p. 444.
19 In the University of British Columbia and at the Lady Lever Art Gallery.
20 Treuherz, *Burlington Magazine*, CXLVI, p. 16, fig. 14.
21 The letter's full text is quoted Ibid., p. 17.

22 For new information on Miller's wives, both of whom were called Margaret, see Ann Bukantas, 'John Miller of Liverpool', p. 74 in this publication.

Dante Gabriel Rossetti (1828–82)

Monna Vanna, 1866

Oil on canvas, 88.9 × 86.4 cm

Tate: Purchased with assistance from Sir Arthur Du Cros
Bt and Sir Otto Beit KCMG through the Art Fund 1916

Owned by William Blackmore and then George Rae

Alexa Wilding, a favourite model of Rossetti's, sat for this
decorative, Venetian-style picture celebrating women's
beauty. Rossetti considered it to be one of his best works.
It was commissioned by Rossetti's patron William
Blackmore, who lived near Ellesmere Port, but in 1869
Blackmore sold it to George Rae – the Raes owned several
examples of Rossetti's 'beauties', which FG Stephens
included in his 1875 description of Rae's collection in *The
Athenaeum*.

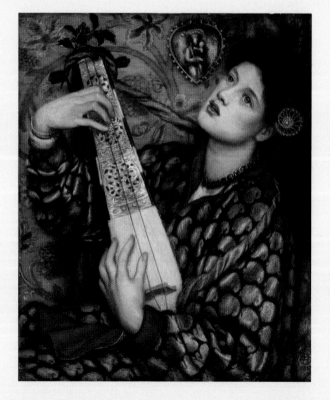

Dante Gabriel Rossetti (1828–82)

A Christmas Carol, 1867

Oil on canvas, 46.4 × 39.4 cm

Private collection

**Owned by George Rae and then William
Hesketh Lever**

Rossetti's Christmas subject was modelled by a laundress
named Ellen Smith whom he had encountered in a Chelsea
street in 1863. She became one of his 'stunners', posing
for a number of works. The painting has a loosely medieval
style. The woman's ornate accessories and the instrument
she plays in such an exaggerated fashion had appeared in
other paintings. The Virgin and Child are represented in
the ornament behind the sitter. This was Rossetti's second
painting under this title – in 1858 he exhibited a
watercolour of the same name at the Liverpool Academy.
That earlier interpretation of *A Christmas Carol* was an
elaborate three-figure composition featuring at its centre
Rossetti's muse, Elizabeth Siddal (Fogg Museum, Harvard).

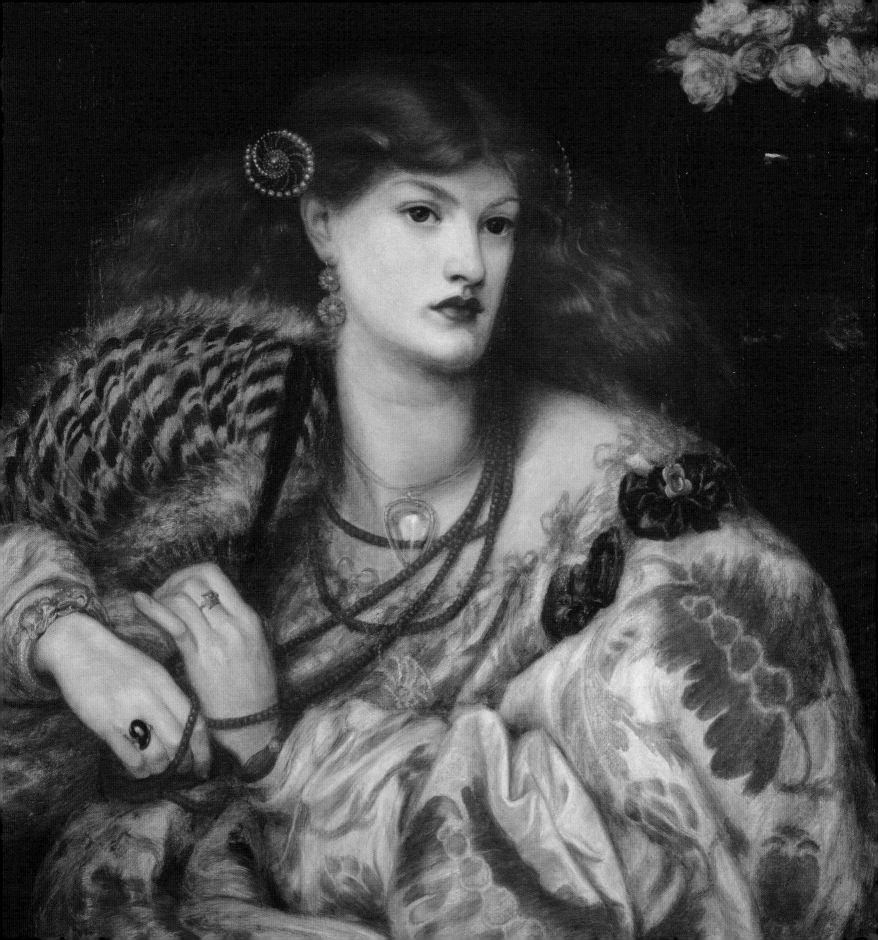

By Burne-Jones were the two watercolours *The Annunciation* (Lord Lloyd-Webber collection) and *Green Summer* (unlocated), and by Simeon Solomon *The Mystery of Faith* (page 61). Ellen and William Coltart's breadth of taste and openness to the innovations of Aestheticism, and their direct contact with painters (as explained by AG Temple in his article describing the collection),[23] are demonstrated by their possession of two of Albert Moore's most challenging works. *A Wardrobe* (Johannesburg Art Gallery) of 1867 represents Venus undressing, but in an image shorn of all mythological trappings. As extraordinary in its indifference to apparent anachronism and equally free of moralistic narrative is the painting which Stephens described as 'A Music Party' but which Moore called *A Quartet* (private collection) in which four ancient musicians play violins and a 'cello, attended by three toga-clad females. Shortly after being widowed for the second time, in 1903, Ellen Coltart gave the oil version of Ford Madox Brown's *The Coat of Many Colours* (page 54) to the Walker Art Gallery (the painting had been commissioned by George Rae and was in his collection until 1875), and at the end of her life Thomas Armstrong's *The Hayfield* was bequeathed to the Victoria and Albert Museum in London.

In the second half of the 19th century, by which time Liverpool's population had risen to about half a million, there was an impulse on the part of those who could afford it to move away from the commercial epicentre, with families migrating out into the suburbs of Everton and Toxteth, and with the development of '*rus in urbe*' schemes such as Sefton Park, where Liverpudlian plutocrats lived in grand free-standing houses surrounded by trees and expanses of water and in a style loosely modelled on the terraces and villas that John Nash had earlier created in London's Regent's Park. People of wealth required ever larger houses in which to accommodate their families and servants, and in which works of art and fine furniture were displayed. This familiar pattern of urban development satisfied a wish for cleaner air and more open space and was at the same time dependent upon improved systems of transportation so that there was

easy access to parts of the city where business offices and trading houses were situated. In the same period, Liverpool and London became more closely connected, in both social and commercial terms and with transport links well established.[24] Business enterprises in Liverpool were increasingly integrated with those of other cities of the North and with London, with the consequence that wealthy Liverpudlians were increasingly likely to have houses in London, which in some cases became their principal family homes and to which their collections might be transferred, or where they might amass.

Frederick Richards Leyland exemplifies this new breed of Liverpudlian oligarch. Born into dire poverty (his mother hawked pies in the streets of Liverpool and was deserted by Leyland's father, who was a shipping clerk),[25] at a young age he was taken on as an apprentice at the Bibby Line. There, by sheer ruthless determination and with astonishing rapidity, he first became manager and designer of the steamships that formed the fleet and then in 1873 took control of the company, transforming it into the hugely lucrative and pre-eminent carrier of passengers and goods in the Mediterranean and the North Atlantic. Leyland lived at Speke Hall from 1867 and subsequently at Woolton Hall, both of which houses stood close to Liverpool, but also from 1869 in a lavish mansion in London – 49 Prince's Gate – and for the most part the gems of his collection, works by Rossetti, Leighton, Moore and Burne-Jones, as well as paintings by Old Masters, were displayed there. Stephens saw the collection at Woolton Hall in 1882, and had clearly also been to the house in Prince's Gate (where he had had the opportunity to study anew Rossetti's *Proserpine* [Tate]). At Woolton was hung the oil version of Brown's *The Entombment* (Lord Faringdon collection), commissioned by Leyland in 1868 although begun two years earlier. Also hanging in a room designed by Robert Adam was Burne-Jones's series of canvases showing *Night* and *Day* and four more of the seasons of the year (all unlocated), previously seen at the Grosvenor Gallery exhibition of 1878.

23 *Art Journal*, 1896, pp. 97-101.

24 The Liverpool & Manchester Railway had opened in 1830 and established a major transport thoroughfare which led through Liverpool from all parts of the United Kingdom and connected with Ireland and transatlantic shipping routes.

25 See Ibid., p. 442.

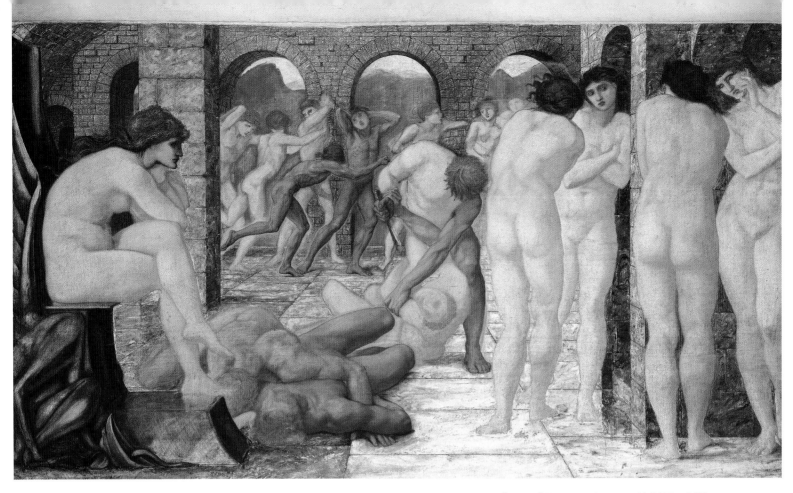

Edward Burne-Jones (1833–98)

Venus Discordia, 1873

Oil on canvas, 128.2 × 209.8 cm

Ar fenthyg gan / Lent by Amgueddfa Cymru – National Museum Wales

Owned by Frederick Leyland

Venus Discordia was developed from one panel of an unfinished triptych illustrating the Fall of Troy. It shows the goddess Venus, left, watching a scene of carnage fuelled by the four vices which stand to the right: Anger, Envy, Suspicion and Strife. In its treatment of the figures and the architectural setting, the painting demonstrates Burne-Jones's study of Renaissance art during his third and final visit to Italy.

Simeon Solomon (1840–1905)

Mystery of Faith, 1870

Watercolour on paper, 51.3 × 38.8cm

Lady Lever Art Gallery, National Museums Liverpool

Owned by William Coltart

Dante Gabriel Rossetti (1828-82)

The Blessed Damozel, 1875-9

Oil on canvas, 111 × 82.7 cm, plus predella 36.5 × 82.8 cm

Lady Lever Art Gallery, National Museums Liverpool

Owned by Frederick Leyland, then William Hesketh Lever

The Blessed Damozel is based on a poem Rossetti wrote at the age of 19 about a lady who died young and was separated from her earthbound lover. The couple prayed to be re-united after death. The painting corresponds to the first verse of the poem which describes the woman in Heaven with lilies in her hand and stars in her hair. Rossetti's model was Alexa Wilding. The painting originally belonged to Frederick Leyland and hung in the living room of his London house next to *Proserpine* (Tate), among extravagant gilt furniture. The voluptuous frame may have been designed to match the overall style of the room. Lever, who in the latter part of his life had become a keen collector of Pre-Raphaelite art, bought the painting in 1922.

James Abbott McNeill Whistler (1834–1903)

Speke Hall No 1, 1870

Etching and drypoint with pen and pencil,
22.4 × 14.9 cm

Walker Art Gallery, National Museums Liverpool

This is Mrs Frances Leyland outside the Leylands' family home, Speke Hall.

Leyland was undoubtedly focused in his interest in art on the London circle of painters associated with Pre-Raphaelitism and the subsequent Aesthetic movement and showed little interest in the Liverpool-based painters who he may have regarded as provincial. He did, however, own three works by Windus, including the two paintings for which the artist is best remembered, *Burd Helen* (page 51) and *Too Late* (page 109).

Leyland's many paintings and drawings by Rossetti, who he had approached in the first place in December 1865 on the recommendation of Miller and with whom a correspondence survives from 1866 until days before the artist's death in 1882,[26] were mostly bought by direct negotiation. A genuine friendship seems to have existed between the two – perhaps surviving because Rossetti was sufficiently intimidated by Leyland not to resort to his usual delaying tactics and obfuscation or only doing so within bounds, and as each sank into personal situations that were ever more solitary, their mutual affection seemed to intensify.

26 See *The Rossetti-Leyland Letters – The Correspondence of an Artist and his Patron*, edited by Francis L Fennell Jr, Athens, Ohio, 1978.

The painter Val Prinsep, who was the patron's son-in-law and who had known Rossetti since the 1850s, believed that this was 'the one real friendship of [Leyland's] life'.[27] However, with Leyland, the old joviality with which art matters were conducted by Miller and Rae was replaced with something more hard headed. Described by Margaret Macdonald as 'a ruthless and ambitious man, impatient, quarrelsome, and unforgiving: [but also] hardworking, meticulous, just, [and] a generous patron and friend',[28] artists as well as rivals in business had much to gain from him but also needed to be on their guard. His friendship with Whistler, to whom he had been introduced by Rossetti, is recorded in charming chalk studies of the Leylands' children, made while the American was staying at Speke Hall in around 1873, and by an engraving of Speke made when he was rediscovering the techniques of etching and drypoint (page 63), in which he was supposedly encouraged by Leyland.[29] The stupendous, Hispanic-style portrait of Leyland, *Arrangement in Black* (Freer Gallery of Art, Washington DC), was the outcome of a friendship that was hugely productive, even if undertaken on Whistler's part in search of "golden guineas". As is well known, the connection between the two men came to a spectacular end in February 1877 in the course of an acrimonious dispute about the commission for the 'The Peacock Room' in Prince's Gate, with accusations and insults exchanged, and in which barrage Whistler's painted satire *The Gold Scab* (California Palace of the Legion of Honor, The Fine Arts Museums of San Francisco), of 1879, was the concluding salvo.

A distinction may be drawn between the patrons and collectors who had contact with the artists whose works they acquired and others who took a more impersonal approach by buying works at auction or from dealers. In the Liverpool context, there was a gradual shift from a direct engagement between painters and patrons and the kind of friendly and supportive relationship exemplified by John Miller, towards an attitude that was more rapacious on the part of the buyer, through to a situation whereby the plutocrat might remain detached and with little sense of needing to participate in or even to understand the creative process. Huge accumulations of art were made by men such as Humphrey Roberts, whose fortune derived from timber trading and the development of the Mersey docks, and who lived in Waterloo in Liverpool and London. Stephens described Roberts's collection in the *Art Journal*,[30] sometimes specifying the Royal Academy exhibition where paintings had been purchased, but also identifying works by William Davis and AW Hunt among members of the Liverpool School and suggesting that Roberts may have had a particular affection for artists associated with his home city. The ship-owner and marine insurer George Holt, similarly, seems to have preferred to buy paintings from exhibitions or from dealers' stock rather than by commission or direct contact. This may be judged from the variety of types of work and subjects of the works that he had in his collection at Bradstones, West Derby,[31] which included paintings by an earlier generation of landscape painters such as Augustus Wall Callcott, William Linnell and Thomas Creswick. In addition, Holt owned paintings by Ary Scheffer and Auguste Bonheur among other European artists, and the overall impression given is of a conservative and unadventurous taste out of sympathy with Pre-Raphaelitism. However, in 1887 he bought a reduced version of William Holman Hunt's *The Finding of the Saviour in the Temple* (page 65), and in the last years of his life demonstrated a particular affection for the work of John Melhuish Strudwick, to whom he may have been introduced by fellow Liverpool ship-owner and patron William Imrie.[32]

27 See Val Prinsep 'The Private Art Collections of London – The Late Mr Frederick Leyland's in Prince's Gate', *Art Journal*, 1892, pp. 129–34.
28 *James McNeill Whistler,* exhibition catalogue by Richard Dorment and Margaret F Macdonald, Tate Gallery, London, 1995, p. 155.
29 Ibid., p. 159.

30 *Art Journal*, 1888, pp. 121–4.
31 As described by FG Stephens in *Athenæum,* 16 September 1882, pp. 376–7. The Holts subsequently moved to Sudley House, Aigburth, which has been preserved as a museum collection and example of the style of decoration and scale of houses lived in by the Liverpool patrons.
32 See Morris, *Victorian and Edwardian Paintings*, p. 18.

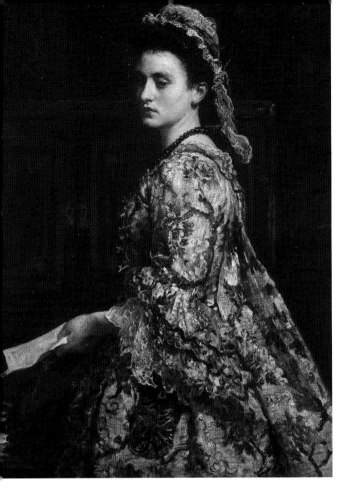

John Everett Millais (1829–96)

Vanessa, 1868

Oil on canvas, 112.7 × 91.5 cm

Sudley House, National Museums Liverpool

Owned by George Holt

Millais employed detail and bold colours to attain a high degree of realism, as can be seen in this painting. The subject wears a painstakingly depicted 18th-century brocade gown. *Vanessa* is a fancy portrait of an artists' model posing as the lover of the writer Jonathan Swift. There is a companion to this painting, entitled *Stella* (Manchester City Galleries). Both pictures were enthusiastically received. Millais was commended for his use of colour and his rendering of flesh tones.

William Holman Hunt (1827–1910)

The finding of the Saviour in the Temple, 1862

Oil on canvas, 45.5 × 70.2 cm

Sudley House, National Museums Liverpool

Owned by George Holt. Exhibited in the Liverpool Autumn Exhibition in 1904

Hunt visited the Holy Land in 1854-5 in search of authentic Biblical settings. Disappointed, he took the architecture for the temple from the Alhambra Court of the Crystal Palace at Sydenham, recently designed by Owen Jones. Hunt carefully researched Old Testament customs for accuracy and to bring Christ to life for a modern audience. Religious symbols in the painting and on its frame add meaning to Hunt's narrative. His attention to detail was recognised. The *Manchester Guardian* wrote: 'No picture of such extraordinary elaboration has been seen in our day.' There is a large version of the painting at Birmingham Museum and Art Gallery.

John Melhuish Strudwick (1849–1937)

Circe and Scylla, 1886

Oil on canvas, 99.7 × 69.8 cm

Sudley House, National Museums Liverpool

Owned by George Holt

In 1890 George Holt decided he wanted a painting by Strudwick and purchased this subject, taken from Greek mythology as retold by the Roman author Ovid. The enchantress Circe was jealous of the maid Scylla, with whom her favourite, the sea deity Glaucus, had fallen in love. Circe poisoned the stream in which Scylla bathed, turning her into a sea monster. Strudwick represents Circe squeezing her potion into the water as Scylla prepares to step into it. Following his acquisition of this work, Holt commissioned three more paintings directly from Strudwick.

Holt's correspondence with Strudwick reveals his sympathy for the artist and interest in his highly individual artistic purpose, and the relationship between the two men led to the assembling of a group of Romantic figurative works by him all of which remain at his former home, Sudley House.

Last among this representative group of Liverpool and Birkenhead patrons comes William Hesketh Lever, later Lord Leverhulme, whose wealth derived from soap manufacture and who collected voraciously in the years around the turn of the 20th century. His house, Thornton Manor in Cheshire, was packed with an extraordinary miscellany of 18th- and 19th-century paintings, watercolours of the Early English School and the Victorian period, together with sculpture, ceramics and furniture. Lever had a polymathic enthusiasm for works that had originally been made for aristocratic settings and which displayed sumptuous richness of decoration and meticulous craftsmanship. He was 20 years younger than Leyland, 34 years younger than Rae, and more than half a century younger than Miller, and although in certain respects he inherited the mantle of their patterns of collecting, the sheer scale and rapidity of acquisition that he led made it impossible to exercise the same degree of care in the selection of objects or to be in direct communication with artists as they had been. Lever's wealth allowed him to buy artworks *en masse,* amongst the most significant of which were the purchases, on three occasions, of collections put together by the occasionally unscrupulous watercolourist and dealer James Orrock.

In the museum that Lever formed, the Lady Lever Art Gallery at Port Sunlight, there is a signal absence of works by artists who might be regarded as challenging or *avant-garde* from the first two decades of the 20th century.[33] He started collecting on a significant scale in the mid-1880s, purchasing Victorian genre pictures to advertise his company's product, Sunlight Soap, with paintings such as William Powell Frith's *The New Frock* (Lady Lever Art Gallery). As he grew in wealth and experience as a collector, he bought works by leading Victorian artists such as Millais, Leighton and Luke Fildes. By the 1890s he was buying more historic examples of British fine and decorative art. At the turn of the century Lever started to exhibit items from his collection in the buildings of his model village at Port Sunlight. This led eventually to his development of the Lady Lever Art Gallery to house and display the best of his personal collection. At the opening ceremony, Lever's intentions in founding the Gallery were stated clearly, when he said, "Art can be to everyone an inspiration".[34]

Lever's collecting may be seen as an early manifestation of the revival of interest in the achievements of the Pre-Raphaelites, for he took his opportunity to acquire works by Millais, Rossetti, Holman Hunt and Burne-Jones as they emerged onto the market from the collections of their first or second owners. Both Burne-Jones's masterpiece *The Beguiling of Merlin* (page 46) and Rossetti's *The Blessed Damozel* (page 62) had previously belonged to Leyland, the former subsequently belonging to the Duchess of Marlborough and the latter to Lady Inchiquin, before Lever had his opportunity to acquire them in 1918 and 1922 respectively. Holman Hunt's *The Scapegoat* (page 14) – certainly the most conspicuous and arguably the greatest Pre-Raphaelite painting in the North West – passed through a series of collectors' and dealers' hands until 1923 when Gooden & Fox bought it for Lever for £4,830. Likewise he acquired many paintings by Millais (although nothing by him entered the collection that can genuinely be described as Pre-Raphaelite). One of the few artists – himself a Pre-Raphaelite revivalist – from whom Lever bought directly, was John William Waterhouse.

Over a period of about 60 years, coinciding with the consummation of Merseyside's economic expansion and the amassing of huge wealth by an astute and energetic group of citizens, an extraordinary number of important and beautiful works of art were brought to both Liverpool and Birkenhead.

33 Augustus John's portrait of Lever of 1920 is one of the few works that might be described as modernist. It was cut up on the sitter's instruction, so offended was he by it, leading to a public row between patron and painter in the tradition of the Whistler-Leyland dispute, although played out with less acerbic wit. The different parts of the canvas were reunited in 1954. See Edward Morris, 'Paintings and Sculpture', *Lord Leverhulme - A Great Edwardian Collector and Builder,* exhibition catalogue, Royal Academy of Arts, London, 1980, p. 58.

34 Viscount Leverhulme, *Viscount Leverhulme / by his son*, London, 1927, p. 288.

William Holman Hunt (1827–1910)

Harold Rathbone, 1893

Oil paint on panel, 23.1 × 17.8 cm

Walker Art Gallery, National Museums Liverpool

Exhibited in the Liverpool Autumn Exhibition in 1894

Harold Rathbone was a member of the prominent Liverpool merchant family. His father Philip chaired the committee that ran the Walker Art Gallery. Harold studied at the Slade School of Art and became a pupil of Ford Madox Brown. In 1894 Harold founded the Della Robbia Pottery Company, in Birkenhead, which produced ceramics in an art-nouveau style. This portrait may have been the outcome of contact between Rathbone and Hunt in 1890–91, when he organised the public subscription to buy Hunt's *The Triumph of the Innocents* for the Walker Art Gallery.

It is unfortunate that so much of the art that arrived in the North West was in due course dispersed, with sales of collections taking place as the first generation of patrons died in the late 19th century and with gathering pace on behalf of their descendants in the years before and after the First World War. There was a gradual lessening of personal commitment to the place where commercial success had led in turn to the opportunity to collect, with the notable exception of Lord Leverhulme and family.

Patterns of taste and acquisition were by no means restricted to contemporary artists of the British School, or indeed only to paintings and drawings, as Stephens's articles in the *Athenæum* make clear. However, the intellectual engagement and open-mindedness of the Liverpool men and women who loved art, tested in their dealings and friendships with contemporary artists and testified to by the extraordinary galaxy of works they possessed, made them exceptional in their generation.

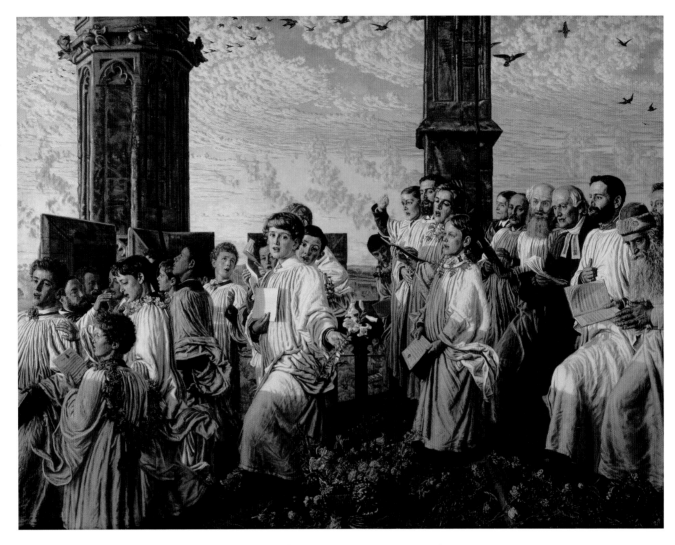

William Holman Hunt (1827–1910)

May Morning on Magdalen Tower, 1890

Oil on canvas, 154.5 × 200 cm

Lady Lever Art Gallery, National Museums Liverpool

Exhibited in the Liverpool Autumn Exhibition in 1893 and owned by William Hesketh Lever

This painting shows the ceremony of greeting the sun on May Morning from the top of the tower of Magdalen College, Oxford. Hunt aimed to create a modern religious and symbolic subject, linking contemporary Christian worship with ancient times. He has included a Parsee, an Indian sun worshipper, from the Indian Institute at Oxford. The beaten copper frame was designed by the artist. The figures are portraits of the President, fellows and choristers of the college, though some of the boys were not choir members – they were included simply for their appearance.

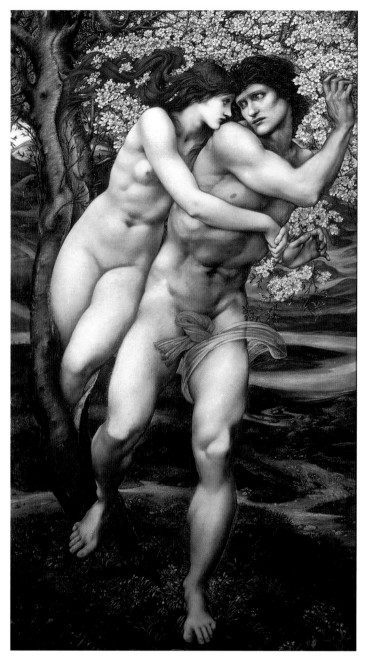

William Holman Hunt (1827–1910)

Rt. Hon. Stephen Lushington, D. C. L., 1862

Oil on canvas, 81.9 × 64.8 cm

National Portrait Gallery, London. Given by the sitter's granddaughter, Miss Susan Lushington, 1912.

Exhibited at the Liverpool Institution of Fine Arts in 1863

Lushington (1782–1873) was a judge and a retired politician. His fourth son Vernon became a good friend of John Miller's and was close to a number of the Pre-Raphaelites. Vernon commissioned this portrait of his father from Hunt. The Lushington family were very well connected in literary and artistic circles.

Edward Burne-Jones (1833–98)

The Tree of Forgiveness, 1881–2

Oil on canvas, 195.5 × 106.7 cm

Lady Lever Art Gallery, National Museums Liverpool

Owned by William Imrie and William Hesketh Lever

*Not in exhibition. On display at Lady Lever Art Gallery

'My quaint old Liverpool friend': Vernon Lushington and John Miller

Dr David Taylor, FSA

In 1856 or 1857 Ford Madox Brown wrote to John Miller commending to him a newly qualified barrister, Vernon Lushington. Miller replied, 'I will be glad to know young Lushington when he comes down... as a number of the bar congregate frequently at No. 9.'[1] Around the same time, Brown himself wrote to the Liverpool artist William Davis:

> To try and assist you to get more known Vernon Lushington from whom I have a letter along with yours, desired to be introduced to Mr Miller chiefly to become acquainted with Windus & yourself & thought you will find him I doubt not a valued friend & each year increase in powers & influence, He is indeed exceedingly loved by his friends.[2]

After his first visit to Miller's home in August 1857, Lushington wrote back to Brown:

> One line to thank you for the hearty welcome I have received from your friend Mr John Miller... he received me with wonderful cordiality & bad me make his house my own. I am going to dine with him on Sunday. It gives me a new spurt in life to see & hear such a fine old fellow...[3]

A decade later, Lushington reported to his wife that he had just been visited by "old Mr Miller my quaint old Liverpool friend – to whom 10 years ago I took a letter of introduction from Madox Brown, the Pre-Raphaelite painter. We have been steady friends, he & I, ever since & talked infinite law & art together."[4] Their long friendship had drawn the young barrister into the circle of the Liverpool Pre-Raphaelites and their collectors.

Until recently knowledge of Vernon Lushington was largely restricted to brief references in the autobiographies and letters of his better known contemporaries, including in Georgiana Burne-Jones' *Memorials of Edward Burne-Jones* in which he is recorded as the man who had introduced her late husband to Rossetti, an act which changed the course of his life.

The recent emergence of a large collection of Lushington family papers has provided an opportunity to know more of this man and to assess his central role in the intellectual and cultural history of the second half of the 19th century. The archive has also revealed the only known photographs of John Miller (pages 2 and 79) and his daughter Maria.[5]

Lushington was born on 8 March 1832 in London, the son of the distinguished lawyer Dr Stephen Lushington (page 70). In 1865 Vernon married Jane Mowatt, who was later painted both by Rossetti[6] and Arthur Hughes, most famously with her three daughters in the latter's *The Home Quartet* (private collection). Following his Call to the Bar in 1857 Lushington took an interest in maritime and shipping law. His time as a naval cadet in his late teens had laid a foundation for this and he was later appointed Secretary to the Admiralty. His choice of working in law on the Northern Circuit, focusing on the newly

1 Miller's home, 9 Everton Brow. NAL. MSL/9951/14/72/43.
2 Princeton University, Janet Camp Troxell Collection of Rossetti Manuscripts. CO189. Box 8. Folder3]
3 NAL. MSL/1995/14/59/1-4.
4 Surrey History Centre. SHC 7854/3/5/3/6a–b.
5 The Lushington archive is now held at the Surrey History Centre, Woking – reference 7854. See David Taylor *'Under the Cedar', The Lushingtons of Pyports. A Victorian family in Cobham – and elsewhere in Surrey*, Grosvenor House Publishing, 2015.
6 Rossetti's portrait of Jane Lushington is now with Tate.

emerging industrial centres of Manchester and Liverpool, may have been influenced by links with Liverpool's Rathbone family. William Rathbone IV was a committed opponent to slavery and probably knew Lushington's father through their shared commitment to abolition. In Manchester, Lushington frequently stayed with the novelist Elizabeth Gaskell's family. In Liverpool, his clients included newly rich men such as the ship-owner Frederick Leyland.

Lushington's interest in the Pre-Raphaelite Brotherhood and their circle developed whilst he was studying law at Cambridge University. He wrote to Brown as early as 1856, telling him that he had recently visited the Tottenham house of the collector Benjamin Windus, where, "behind two other pictures I discovered 'The Last of England'." Lushington described the painting at length and encouraged Brown to exhibit it.

> I think it could not fail to hand well & receive due notice, and for this reason. That its subject is one a real life & of 19th century life...it is a subject characteristic of our time. I wish all you Pre-Raphaelites would give yourselves up to the work of recording things memorable amongst us now God knows, today is interesting enough.[7]

Lushington's appreciation of Brown's picture, and Rossetti's *Dante's Vision of Beatrice* (Tate) was later published in *The Oxford and Cambridge Magazine* which was produced by William Morris and others in 1856. His friendship with John Miller, and with the artists in the Pre-Raphaelite circle, was furthered through his membership of the Hogarth Club in London. Founded in April 1858, the exhibiting society and social club was formed as a result of a sustained campaign by Brown, Rossetti and their circle to establish exhibiting associations which would give them independence from the Royal Academy. The Liverpool painters Campbell, Davis, Hunt, and Windus readily gave their support for the Club, which they hoped would assure them of an exhibition space and sales in London.[8]

Always enthusiastic in introducing new friends to Miller, in January 1858 Lushington wrote from Liverpool to the Pre-Raphaelite sculptor Thomas Woolner:

> I have just come back from smoking a pipe with our friend Mr Miller...he will be just delighted, if you will come and see him, 'come straight' he says to 9 Everton Brow and take up your bed there. There you shall see Turners, Millaises, Winduses almost as many as you will, and one of the heartiest of human kind that now walk on terra firma.[9]

Together, Miller and Lushington also enjoyed visits to Leyland and Rae, to dine and to see their pictures. Lushington's reports back to his wife offer tantalising glimpses into their homes and lives:

> Mr Leyland is a client of mine... Lately he has been under proper influence buying Turners & Rossetti's & Jones's & Solomons; and so he has a number of beautiful pictures. But of all the things I saw, nothing struck me so much as a Venetian Mirror! I can't describe it, except that it had like a bound book most lovely clasps & clamps of gilt brass work full of bird's & beats, & even huntsmen. Unlike anything I have ever beheld.[10]

On 20 August 1867 Lushington wrote to Jane:

> Tomorrow evening I dine out with a gentleman hitherto a stranger to me – Mr Rae, a banker – to see some Pre-Raphaelite pictures – He is one of their chief patrons, - has a good many Rossetti's &c - Old Mr Miller is at the bottom of this.[11]

His letter the following day gives an evocative description of Rae's lifestyle:

> I enjoyed my trip out last night. Old Mr Miller put on his black tail coat – a rare thing for him, & he & I & Mr Rae, all three crossed the river & then up in a fly to Mr Rae's house which is in Claughton. The whole house is a den of Pre-Raphaelite things. He has no carpets, only Moorish rugs & mats.

7 National Art Library [NAL], MSL/1995/14/59/1-4.
8 Deborah Cherry, 'The Hogarth Club: 1858-1861", *Burlington Magazine*, Vol. 122, No. 925. (April 1980), pp. 236-44.
9 Amy Woolner, 'Thomas Woolner, R.A. Sculptor and Poet. His Life In Letters.' (Chapman and Hall Ltd., 1917).
10 National Art Library [NAL], SHC 7854/3/5/3/5a-d.
11 National Art Library [NAL], SHC 7854/3/5/4/20a-c.

William Davis
(1812–73)

The Flock,
about 1855

Oil on canvas, 32 × 49 cm

Peter and Renate Nahum

The Flock was at one time owned by Vernon Lushington, a friend of John Miller's who spent time in Liverpool whilst working in law on the 'Northern Circuit'. Lushington's father Stephen was painted by Holman Hunt (page 70).

Then the furniture on the ground floor is all carved Indian work. And the walls are hung with Rossetti, Stanhope, Madox Brown, Davis, & the rest: - many of them very beautiful, & the whole forming a very fine collection. On our arrival sherry was handed round in Pre-Raphaelite glasses… Then besides we had some pianoforte music & some singing & I finished the evening by discussing Trade Unions with Mr Rae, who of course - thought they were ruining the country.[12]

In March 1869 Lushington was back in Liverpool, writing to his wife:

Then I sallied out for walk to see some friends - Old Mr Miller first of all. I found him in his little dark office with the wall all hung with drawings by a Mr Ensor whom he helps to find a purchaser now &

then. He presently showed me a drawing 'Romeo & Juliet' by Madox Brown - Poor fellow said he, he wants money. He did it for Mr Graham… but for some reason Mr Graham wd not have it so it was thrown back on Mr Brown's hands, - who in despair sent it to Mr Miller to try & sell it for him price £105. Mr Miller cdn't find a purchaser so sent Brown out of his own purse an instalment of £40 - 'And now' said he to me, 'you shall have it if you like for £60: & Brown poor fellow, will be delighted' - But I was prudent, my dear.[13]

Lushington's friendship with the Pre-Raphaelites and their circle continued into his old age. In 1882 he attended Rossetti's funeral and in 1910 Holman Hunt's widow asked him to be a pall bearer at her husband's funeral in St Paul's Cathedral - an invitation which, with regret, Lushington declined due to his poor health. Two years later, Lushington himself died.

12 National Art Library [NAL], SHC 7854/3/5/4/22a-d.

13 National Art Library [NAL], SHC 7854/3/5/6/4a-d.

John Miller of Liverpool

Ann Bukantas

The Liverpool merchant John Miller is one of the best known of the Pre-Raphaelites' patrons and collectors. His enthusiasm for buying and selling art was sometimes to bolster his own collection and at other times to sustain the artists he supported, particularly William Davis. Our knowledge of Miller comes largely from the diaries and letters of the London and Liverpool Pre-Raphaelites: Ford Madox Brown and William Windus were close friends, and amongst his regular correspondents. But new research for this exhibition means that it is now possible to flesh out Miller's earlier life, including his Scottish origins, together with the business dealings that provided the means for his collecting.[1]

Miller was one of the many Scottish immigrants in Liverpool in the 19th century whose business acumen contributed to the town's economic growth.[2] He was the fourth child of John Miller and Ann Meek,[3] and was probably born in Barony, Lanarkshire, in 1796.[4] His father, and possibly Miller's uncle George, had business interests in Jamaica prior to returning to Lanarkshire as landed proprietors.[5] George, who died in 1808, left £1,000 to his nephew John, perhaps the sum that would help Miller to establish himself in Liverpool.[6] Miller's widowed mother remarried in 1809.[7] By 1815, following the end of the Napoleonic Wars, and perhaps with locally gained experience behind him, a 19-year-old Miller would have been ready to seize the international opportunities that the North West port offered.

Although the year of his arrival in Liverpool cannot be established, the young entrepreneur was certainly in business in the town by 1819, under the partnership Cannon, Miller & Co. with another Scot, the merchant David Cannon.[8] They had interests in several ships and from 1820 traded regularly with David Crichton, a Scottish merchant and shipbuilder in Pictou, Nova Scotia – Miller made several visits to Canada. The partners were involved in trading goods – including timber, cotton, mackerel and salt – and in the building and selling of ships. Their co-dependent business arrangement, with Crichton often in debt to his Liverpool partners, was a sometimes brittle one – Crichton once accused Miller of challenging him to a duel, which the latter denied. The Anglo-Canadian relationship weathered the peaks and troughs of

1 This short essay does not aim to reprise the already widely published information about Miller, other than where corrections are necessary.
2 By 1871, only Newcastle's population had a greater proportion of Scots-born immigrants. John Belcham and Donald M Macraild, 'Cosmopolitan Liverpool' in *Liverpool 800, Culture, Character & History*, edited by John Belcham, Liverpool, 2006, pp. 351–5.
3 John Miller (b. 1759?–d. 1798–by 1801), Ann Meek (b. 1770). She was a daughter of the well-known John Meek of Campfield, (1738–1802), a surgeon and a founder of the Falkirk Banking Company. They married on 6 June 1791. Scotland's People, O.P.R. Marriages 479/00 0080 0408 FALKIRK. Ann's sister Janet married John's brother George (John Miller of Liverpool's uncle).
4 Miller's siblings were all born in or around the parishes of Old Monkland and Barony, Glasgow: Agnes (b. 1792); George (1793–1864); James (b. 1794); Mary Rennie (b. c. 1795). Scotland's People; Ancestry.co.uk; family trees provided by Miller's descendants. Miller's birth has not yet been traced in the Scottish record. His daughter Augusta, writing to Ford Madox Brown, makes reference to her father's 79th birthday: letter, 28 May 1875, gives Miller's birthday as 79 last Sunday, suggesting a birth date of 23 May 1796. National Art Library, Victoria & Albert Museum, Ford Madox Brown Papers, Box 13, MSL/1995/14/66/86.
5 Official documents, including his 1791 marriage record to Ann Meek (see Fn.3), record John Miller Senior as 'late of the Island of Jamaica'. The exact nature of the Millers' business in Jamaica is, as yet, unknown. In Lanarkshire, John and George Miller were associated with estates at Gartcraig and Frankfield. The marriage registry record for the second marriage of 'our' Liverpool John Miller gives his father John Miller Snr's occupation as 'Merchant'.
6 1808, Miller, George (Reference SC36/48/2 Glasgow Sheriff Court Inventories). www.scotlandspeople.gov.uk.
7 To James Davidson, on 3 March 1809. Scotland's People, O.P.R. Marriages 685/01 0530 0304 Edinburgh.
8 Miller's senior by some 13 years, Cannon was born in Kells, Kirkudbright, in 1783 and died in Rock Ferry in 1866. He died a wealthier man than Miller, who was one of the executors of his estate – it was proved at under £45,000.

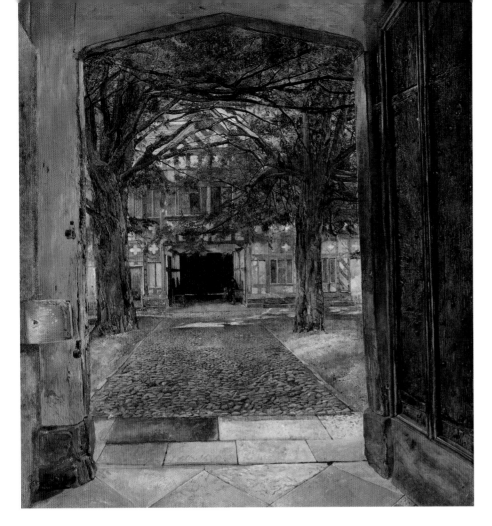

James Campbell (1828–93)

The Courtyard at Speke Hall, 1854

Oil on canvas, 50.2 × 43.4 cm

Walker Art Gallery, National Museums Liverpool

Probably owned by John Miller

Speke Hall near Liverpool, dating from the 16th century, was a favourite subject for artists. This is a view from the door in the south front back, between the great yew trees. In the 1860s Speke became the home of the collector Frederick Leyland. This painting was previously attributed to William Davis. On stylistic grounds it is now thought to be by James Campbell, who also painted under the influence of the Pre-Raphaelites.

several financial crises, but ultimately it ended in dispute in 1834, although the Liverpool partners continued business in Canada.[9] By 1835, Miller, a ship-owner and commission agent, was sufficiently established to have become chairman of the North American Colonial Association. In this office he gave evidence, at length, to the British government's Select Committee on Timber Duties, describing himself as one of the largest importers in Liverpool for some years. His testimony gives a detailed insight into his business and the wider concerns of the timber trade.[10] Miller is usually referred to as a tobacco merchant, but the evidence for this seems absent, both in these early years and later on. He certainly smoked (a pipe of Cavendish tobacco, according to FM Brown[11]) and there are engaging references in his various letters to Brown of Miller sending supplies of 'the weed', via his family, to his London friends, but this may simply be because the favoured types were readily available in Liverpool.

In 1822, during the early years of his partnership with Cannon, Miller had married Margaret Muirhead. Settling in the developing Everton district of Liverpool,

9 See Julian Gwyn, 'Nova Scotia's Shipbuilding and Timber Trade: David Crichton of Pictou and his Liverpool Associates, 1821–1840', *Canadian Papers in Business History 2* (1993), pp. 211–33; and Meghan P Hallett, 'The Davison Family of Pictou and Wallace: A Case Study in Maritime Enterprise', MA Thesis, 1998, Saint Mary's University, Halifax, NS.

10 *House of Commons Papers* (Google Books/Harvard College Library), Reports from Committees, Sixteen Volumes, 15, Timber Duties, Session 19 February–10 September 1835, Vol XIX.

11 Surtees, *The Diary of Ford Madox Brown*, pp. 188–9.

they had ten children between 1823 and 1842.[12] Whilst supporting his growing family and operating what was a demanding and sometimes precarious business, Miller developed an active involvement in the town's art scene that pre-dates his Pre-Raphaelite interests. In late 1838 he was a prominent committee member in the public subscription scheme to commission for Liverpool, from Benjamin Robert Haydon, the large painting *Wellington on the Field of Waterloo* (Walker Art Gallery).[13] In 1839 Miller inspected a stallion which was to be the model for the Duke's horse and it was he who consigned the final commission instalment of £75 to Haydon in 1840.[14] His relationship with the artist continued: Haydon's diary records him painting for Miller *The Highland Lovers*,[15] and in 1846, down to his last few shillings, Haydon asked four men, including Miller, to buy drawings, but found on that occasion 'Miller is too poor.'[16] The posthumous sale of Miller's collection in 1881 included Haydon's *Duke of Wellington*

shewing [sic] George IV. the Field of Waterloo.[17]

Beyond his relationship with Haydon, in 1841 Miller was one of the more generous donors, giving £25, towards the Liverpool Royal Institution's new art gallery, and was acknowledged as a 'donor of valuable pictures'.[18] Between 1840 and 1844 he provided several works for the Liverpool Mechanics' Institution's exhibitions including paintings by Carracci, Rembrandt, Canaletto, Teniers, Gainsborough and Danby.[19] Also in this period, despite the backdrop of a depressed shipping trade and difficult business creditors, Miller built 'Ardencraig', a substantial villa in the popular town of Rothesay on the Isle of Bute's east coast and for the next few years this became his Scottish retreat.[20] Holman Hunt was among the artists who stayed there. According to Miller's obituary, his sons were partly educated on Rothesay.[21] It was also there that Miller's daughters Janet and Margaret married in a double wedding in June 1851.[22]

Miller's artistic activity of the 1840s was a mere rehearsal for the 1850s onwards, when he became fully engaged with the Pre-Raphaelite cause. Having weathered the national financial crash of 1847, by 1854 Cannon, Miller & Co. was trading as Miller, Houghton & Co.[23] It is perhaps no coincidence that Miller's first purchase of a Pre-Raphaelite painting was in 1854, the same year that the company sold the Barque 'Argentinus'

12 They married in Falkirk on 22 October 1822. Margaret Muirhead (1795-1857) was the daughter of Falkirk merchant Peter Muirhead and Janet Buchanan. The Millers' children were: John (b. 1823); Janet ('Jessie') Buchanan (1824-1906); Peter Muirhead (1826-94); Mary Ann Meek (1828-1913); Margaret (1830-1920), who married Donald Currie and became Lady Currie; George John (b. 1832); Augusta ('Gussy') Buchanan (1833-1915), who married Peter Paul Marshall of Morris, Marshall, Faulkner & Co.; Maria Chislett (1836-1929); James (b. 1838); and William (b. 1842). The first eight were baptised at the Scotch Chapel in Gloucester Street, and its successor, the Scotch Secession Church, Mount Street, Liverpool.

13 A previous scheme to paint the subject was commissioned in 1835 by the print-sellers Messrs. Boys., but the project lapsed. The Liverpool painting, completed in 1840, passed through Liverpool Town Hall and Liverpool Collegiate Institution, then back into civic ownership, before its transfer to the Walker Art Gallery in 1969.

14 'Reader, you see I always trusted in God. This day I received 75L. from Miller, the Liverpool merchant, the balance for the Duke, and this has saved me, as it is the link between the two sums: but for this an execution would have entered my house, and the old scenes of horror would have come over again.' (8 June 1840). Tom Taylor (Ed.), *Life of Benjamin Robert Haydon*, London, 1853, Vol. III, p. 140.

15 Taylor, *Life of Benjamin Robert Haydon*, p. 132 (29 March 1840), p. 133 (18 April 1840), p. 135 (11 May 1840).

16 Taylor, *Life of Benjamin Robert Haydon*, p. 305 (23 March 1846). Britain was entering a financial downturn which may have affected Miller's business deals.

17 Catalogue of the sale at Messrs. Branch & Leete, Liverpool, 4-6 May 1881, lot 244. Walker Art Gallery. A version of the painting - probably Miller's - is in the Royal Hospital Chelsea.

18 'Liverpool Permanent Gallery of Art', *Liverpool Mercury*, 17 September 1841, p. 1. British Newspaper Archive (online).

19 Liverpool Mechanics' Institution catalogues 1840, 1842, 1844. Walker Art Gallery.

20 Built 1840. Later that decade Miller's brother George was also using 'Ardencraig', and it was available for summer rental by 1849 according to contemporary newspaper adverts. It was eventually advertised for sale in 1860 and in 1862 was owned by the Marquis of Bute. The house still exists, as holiday flats.

21 *The Buteman and Advertiser for the Western Isles*, 28 October 1876.

22 While Margaret married (later Sir) Donald Currie (1825-1909), who became a major ship owner and art collector, Janet married the merchant Robert Andrew Munn (1825-62).

23 Miller was in this partnership with his son Peter and John Houghton (1812-83).

for over £5,000.[24] He became a fervent collector, buying and commissioning work direct from artists, from fellow collectors or from dealers such as Agnews. The artists Bond, FM Brown, Campbell, Davis, AW Hunt, WH Hunt, Lee, Millais, Rossetti, Tonge and Windus were all represented in his collection. As well as having paintings stacked in his office, his house was 'full of pictures, even to the kitchen. Many pictures he has at all his friends' houses, and his house at Bute is also filled with inferior ones...'[25] Miller regularly corresponded with artists including Brown, Rossetti and Windus over the progress of individual works, and he brokered introductions and sales between artists and potential buyers. He gave financial advances to artists whose coffers were running low; after the deaths of Walter Deverell and William Davis, he threw himself into raising money to support their dependents. He acted as a 'middle-man' for the loan of both artists' and collectors' works to exhibitions, including arranging such mundanities as transport. Miller also held a number of Committee roles.[26] Most famously, he was the congenial host of regular social evenings at his Liverpool home, where artists, his friends and business associates gathered to meet, debate, and to ingest what were, according to Brown and Miller himself, unpalatable, heavy meals of salt beef. Miller was well-liked, with an acknowledged eye for a good painting. George Rae described him as possessing 'warm and practised discrimination.'[27] Only occasionally was his zeal remarked upon with negativity, such as the occasion when Brown felt pressurised into buying a Davis sketch.[28] The overall

favourable picture of him mirrors his business life, in which he was increasingly called upon both locally and in London to arbitrate in commercial disputes, a role that commanded the utmost trust, honesty and respect of the business community, and for which those who possessed these qualities would be in great demand.[29]

Miller's fortunes continued to rise and fall throughout the 1850s and '60s. Despite a busy 1856 which saw him commission Holman Hunt's *Eve of St Agnes* (page 49) and buy Brown's *Waiting: An English Fireside of 1854–5* (page 48) for £85, at the start of 1857 he wrote to Brown that he had had a long bad year and lost a lot of money. By June there were further heavy losses '(£1800 by one failure last week)'.[30] The following 18 months brought more upheaval. Miller seemed in buoyant spirits, writing in May 1857 concerning pictures for the Pre-Raphaelites' exhibition at Russell Place: '...you can have Davis' Windmill and Campbell's Trudgers (page 106), rejected by the R.A.'[31] But on 22 October, Miller's wife Margaret died. In May 1858, Miller sold his art collection (or what must have been at least a substantial part of it), including his Pre-Raphaelite pictures, at Christie's.[32] In June, Miller remarried in Liverpool, to the widow Margaret Cookson.[33] His move to Gloucester Place, Low Hill, dates from around this time. It was this new Mrs John Miller who, in 1864, was the recipient of the gift, from Brown, of his watercolour *King René's Honeymoon*.[34]

24 21 May 1854. Sale of barque Argentinus; PRONI T2713/2/; CMSIED 305035. Public Record Office, Northern Ireland (online). Also in 1854, Miller, Houghton & Co. donated the first church bell to Sharon United Church, built that year in Tatamagouche, Nova Scotia. Ross Bonnyman, 'Sharon United Church: A Brief History' (online); Frank H Patterson, *A History of Tatamagouche Nova Scotia*, Halifax NS, 1917 (archive.org).

25 Brown's diary, 25 September 1856: Hueffer, *Ford Madox Brown*, p. 137.

26 The Liverpool Art Union, The Liverpool Committee of the Art Union Society of Glasgow, and the Liverpool Academy Council, of which he was President in the 1850s.

27 University of British Columbia, Rae to Rossetti, 5 March 1866. Quoted in Treuherz, *Burlington Magazine*, CXLVI, p. 17.

28 Brown's diary, 26 September, 1856: At one of Miller's events Brown was put on the spot by Miller who asked him to buy a sketch off Davis, which he felt unable to refuse. Hueffer, *Ford Madox Brown*, p. 138.

29 I am grateful to Dr Graeme Milne, University of Liverpool, Department of History, for his background information on merchants in 19th-century Liverpool.

30 Miller to FM Brown, NAL, MSL/1995/14/72/1; MSL/1995/14/72/8.

31 Miller to FM Brown, NAL, MSL/1995/14/72/6.

32 The sale comprised 250 lots. Christie and Manson, London, 20–2 May, 1858. Copy of sale catalogue in Walker archive. NB: An earlier John Miller collection sale (Christie's, 21 June 1851) referenced in Macleod, *Art and the Victorian middle class*, p. 452, is erroneous and relates to 'the late John Miller, Esq., of Ballumbi, North Britain.'

33 On 25 June 1858. Margaret Cookson (née Chaplin) (1814–72) was the widow of John Cookson, a cabinet maker. Her father, Martin Chaplin, was a ship builder. Her son Robert Cookson became a cotton broker. He is the Robert referred to in Windus's letter to Miller, 24 February 1868, NAL, MSL/1995/14/133/9.

34 Mary Bennett, *Ford Madox Brown: A Catalogue Raisonné*, New Haven & London, 2010, Volume I, p. 206.

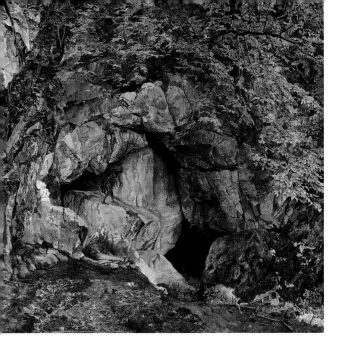

James Campbell (1823–93)

The Dragon's Den, about 1854

Oil on canvas, 40.1 × 40.1 cm

Walker Art Gallery, National Museums Liverpool

Exhibited at the Liverpool Academy in 1854, priced at £30. It was bought by John Miller, one of Campbell's best patrons

Campbell, a Liverpool follower of the Pre-Raphaelites, seems to have abandoned landscape in the mid- to late-1850s, in favour of scenes of everyday life. The location here is a cave called Dunald Mill Hole near Carnforth, Lancashire. The inclusion of a knight peering into the cave may have appealed to the Victorian enthusiasm for tales of medieval chivalry.

The early 1860s brought more financial difficulties amidst the impact of the American Civil War upon trade, although contemporary shipping reports indicate that Miller, Houghton & Co. were at that time involved in shipments including sugar, molasses and coal with the Barbaries[35] and Bermuda. In December 1861 Miller wrote to Brown that he could not meet Rossetti's cash price of £130 for *The Farmer's Daughter*, instead obtaining it in an exchange.[36] 1862 saw the sale by Miller's eldest son John Jnr, a ship-builder and broker, of his art collection (perhaps for economic reasons), many pictures of which 'were personally selected and purchased by John Miller, sen., Esq., from the…artists.'[37] By the mid-1860s, Miller's son Peter had experienced significant money problems, and in 1865, Miller, Houghton & Co. was dissolved.[38] In his final decade, during which time he continued to operate as a commission merchant and ship-owner, Miller's picture dealing, his exhibition loans and the brokering of relationships between patrons and artists continued apace; he sold works to collectors including George Holt, and it was Miller who provided a letter of introduction for FR Leyland to Rossetti – undoubtedly

one of his most enduring legacies.[39] The artist meanwhile noted that the work of Miller's daughters Augusta and Mary, who were both amateur artists, 'shows plainly that your love of art has borne practical fruits in your family.'[40] Miller died in New Brighton on 9 October 1876, four years after his second wife Margaret, his estate proved at under £4,000.[41] The posthumous sale of Miller's pictures was held in Liverpool in 1881[42] and it was from there that a number of now much-loved Liverpool Pre-Raphaelite works, including Campbell's *The Dragon's Den* (page 78), and Windus's *The Outlaw* (page 124), were eventually to make their way into the public domain.

35 The Barbary Coast, northern Africa.

36 Miller to FM Brown, NAL, MSL/1995/14/72/25

37 His art collection sold by JF Griffiths at his gallery in Church Street, Liverpool, 1 July 1862. *Liverpool Mercury*, 27 June 1862, p. 6; 1 July 1862, p. 4. British Newspaper Archive. Catalogue un-located.

38 *The London Gazette*, 29 August 1865, p. 4210.

39 Rossetti to Miller, 9 October 1865, in *The Correspondence of Dante Gabriel Rossetti 3 The Chelsea Years 1863–1872, Vol III 1863–1867*, edited by William E Fredeman Cambridge 2003, p. 336 (65.145). Writing to FM Brown on 1 March 1866, George Rae commented that Miller 'has much influence with Mr Leyland'. George Rae papers, Lady Lever Art Gallery.

40 Rossetti to Miller, 9 October 1865, Fredeman, p. 337 (65.145).

41 Under £4,000 is accurate according to his probate notice. McLeod, in *Art and the Victorian middle class*, however, gives the figure at less than £5,000, as does Andrew Porter in *Victorian Shipping, Business and Imperial Policy*, Suffolk, 1986, p.29, whom she is possibly quoting.

42 The sale comprised 290 lots. Branch & Leete, Hanover Galleries, Liverpool, 4–6 May 1881. Copy of sale catalogue in Walker archive.

Portrait of a collector

Ann Bukantas

Photographer
unknown

John Miller, Esq.,
about 1873-6

Albumen print,
8.8 × 5.8 cm

Surrey History Centre

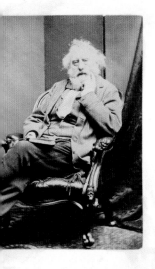

John Miller, Esq.

This recently discovered photograph of John Miller, found amongst the papers of the Lushington family, is, to date, the only located image of the Liverpool merchant and art collector.[1] It was in the possession of Miller's younger friend, Vernon Lushington. The 'streaming white hair' described by Ford Madox Brown after his first meeting with Miller in 1856 is a striking characteristic.[2]

Miller was also the subject of portraits by some of his artist friends. John AP MacBride exhibited a bust of Miller at the Royal Academy in 1848 (No 1424; untraced), almost certainly the same piece shown at the Liverpool Academy the previous year (No 755). A marble bust of Miller (perhaps the same piece) by MacBride was also at the Liverpool Academy in 1850 (No 518), when it was praised in a review in the *Liverpool Mercury*: 'Probably the best specimen of portraiture in sculpture is the one of John Miller, Esq., by McBride. For natural and dignified expression, and for ability in execution, it is a masterpiece of art, which will tend much to raise its author to the high position he evidently aspires to and deserves.'[3]

Just over a decade later, in 1859, the highly-regarded Liverpool artist John Ewart Robertson's portrait of Miller was shown at the Royal Scottish Academy in Edinburgh (No 663; untraced). This is likely to be the same *Drawing in Chalk of John Miller, Esq.* that he exhibited at the Liverpool Academy that year (No 655). One of the most tantalising as yet unlocated pictures of Miller, however, was painted by the Liverpool Pre-Raphaelite John Edward Newton, and called *The Late John Miller amongst his Pictures*. This was included in the Worsley House sale of the collection of the Liverpool solicitor and businessman

Alexander Burnes Anderson in 1879, prior to his bankruptcy in 1880.[4]

In her will of 1938, Miller's granddaughter Margaret Anne Munn states her intention to leave to Frederick Donald Mirrielees 'the large Oil Portrait of his great grandfather John Miller at present at his house 'Garth' near Aberfeldy, Perthshire.'[5] Both the artist and date of this picture are unknown, and the picture remains untraced.

Ford Madox Brown is known to have made a chalk drawing of Miller in 1873 (untraced) which he wrote about in letters to George Rae and to his daughter Lucy Madox Brown. This was described as 'wonderful' by the artist's son.[6] It passed into Miller's hands, and, for a portrait that was admired as a good likeness by his daughters, there is a likelihood that it remained within his family, but is as yet also untraced. Miller's appearance in the Lushington photograph suggests a date of around 1873-6 - the last few years before his death in October 1876 - and it is therefore likely that these are the identical features captured in Brown's drawing.

1 The archive also contains a photograph of Miller's daughter Maria. Surrey History Centre. SHC 7854/3/5/3/6a-b.
2 Surtees, *The Diary of Ford Madox Brown*, p. 189.
3 *Liverpool Mercury*, Tuesday 31 December 1850, p. 5. British Newspaper Archive [database online].

4 No 109 in the sale according to Mary Bennett. A copy of the catalogue believed to have been in Walker Art Gallery files in untraced. Mary Bennett, *Ford Madox Brown: A Catalogue Raisonné,* Volume II, B82, p. 408.
5 Margaret Anne Munn (1852-1946) was Miller's granddaughter. Her parents were Miller's daughter Janet Buchanan Miller (1824-1906) and Robert Andrew Munn (1825-62). Miller's great-grandson Frederick Donald Mirrielees (1881-1940) was the son of Margaret Currie (1854-1925). She was one of the three daughters of Miller's daughter, also Margaret (1830-1920), later Lady Currie, through her marriage to Donald Currie (1825-1909). The Garth was the Currie family home. Copy of MA Munn's Will (Probate Liverpool 16 May 1946) in Walker Art Gallery files.
6 Mary Bennett, *Ford Madox Brown: A Catalogue Raisonné*, Volume II, B82, p. 408.

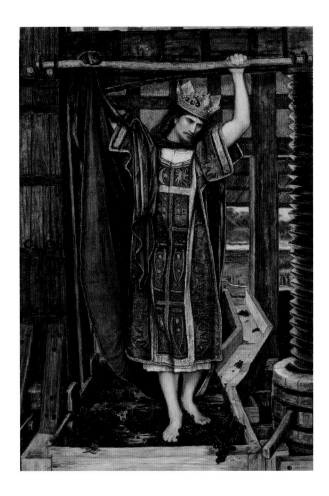

John Roddam Spencer Stanhope (1829-1908)

The Wine Press, 1864

Oil on canvas, 94 × 66.7 cm

Tate: Presented by Sir Henry Grayson Bt 1930

Stanhope exhibited an earlier watercolour subject of this theme (Lanigan Collection) at the Liverpool Academy in 1861, which was acquired by George Rae. The subject is Biblical, from the Old Testament book of Isaiah 63:3: 'I have trodden the winepress alone; and of the people there was none with me.' The artist also recalled seeing French peasants treading wine on a visit to Varennes in his youth.

John William Inchbold (1830-88)

Venice from the Public Gardens, 1862-3

Oil on canvas, 34.3 × 52.1 cm

Private collection, England

Owned by George Rae

Inchbold spent almost two years in Venice from the spring or early summer of 1862 during which time his style changed from being dependent upon minute detail. Instead, atmosphere and light became his preoccupation. He wrote to the Gateshead collector James Leathart that the scene was sunset in the 'Giardini Publico' Venice. When exhibited in London in an exhibition organised by Holman Hunt, the painting met with criticism for being too much like a sketch rather than a finished painting. It was later owned by George Rae.

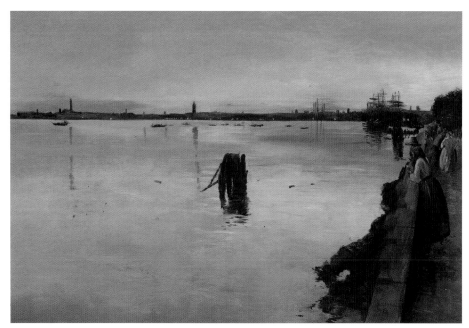

John Melhuish Strudwick (1849-1937)

Love's Palace, 1893

Oil on canvas, 64.7 × 114.9 cm

Sudley House, National Museums Liverpool

Commissioned by George Holt for his collection

Love's Palace was one of several commissions from Strudwick by George Holt of Sudley House. Holt was a major collector of Strudwick's, as was the shipping magnate William Imrie. The painting is an allegory of love based on a poem by the architect GF Bodley. Love is enthroned in the centre of the composition, while the three fates sit on the steps. Around them, as if on a stage, women, knights and *Amorini* – the winged boys – enact love's ups and downs.

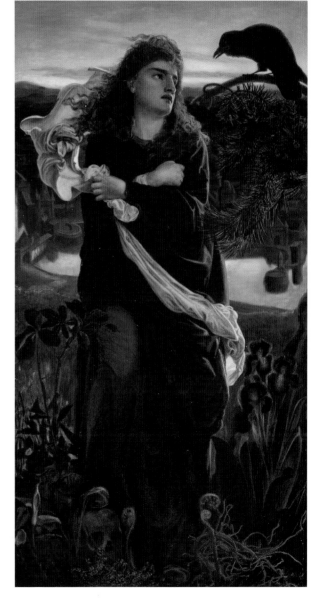

Frederick Sandys (1829-1904)

Valkyrie, 1868-73

Oil on canvas, 74.9 × 40.6 cm

Williamson Art Gallery & Museum, Birkenhead; Wirral Museums Service

Formerly owned by Frederick Leyland, and later by Joseph Beausire

One of Sandys' own wood engravings on the theme of the Norse king Harald Harfagr, made in 1862, inspired this painting. The Valkyrie – a mythical figure connected with the fate of those in battle – is discussing the king's destiny with a raven. Frederick Leyland bought the painting from Sandys for £200, but had to wait several years for its completion. In his 1882 commentary on Leyland's collection in *The Athenaeum,* FG Stephens remarked that 'the still and tragic energy of the legend never had better or fitter exposition than in this fine design.'

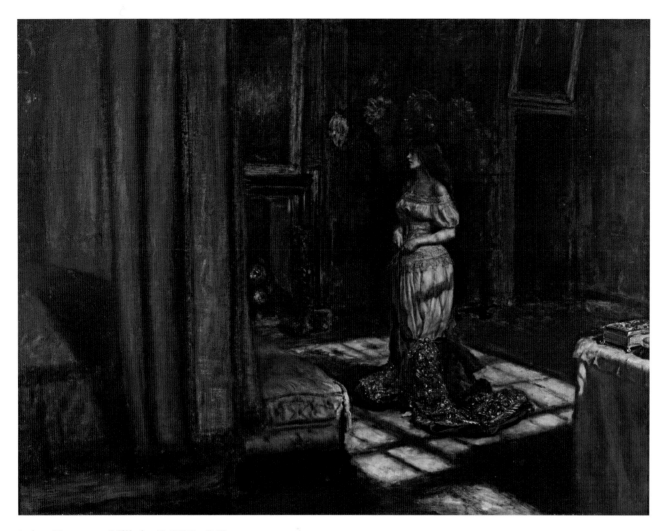

John Everett Millais (1829–96)

The Eve of St Agnes, 1863

Oil on canvas, 117.8 × 145.3 cm

The Royal Collection/HM Queen Elizabeth II

Formerly owned by Frederick Leyland

The artist's wife posed for this scene over three nights in a moonlit room at Knole, near Sevenoaks. It was completed using a professional model. The title refers to the superstition that on St Agnes Eve (20 January), an unmarried girl who had performed certain rites before going to bed would dream about her future husband. The painting was latterly owned by Her Majesty Queen Elizabeth the Queen Mother.

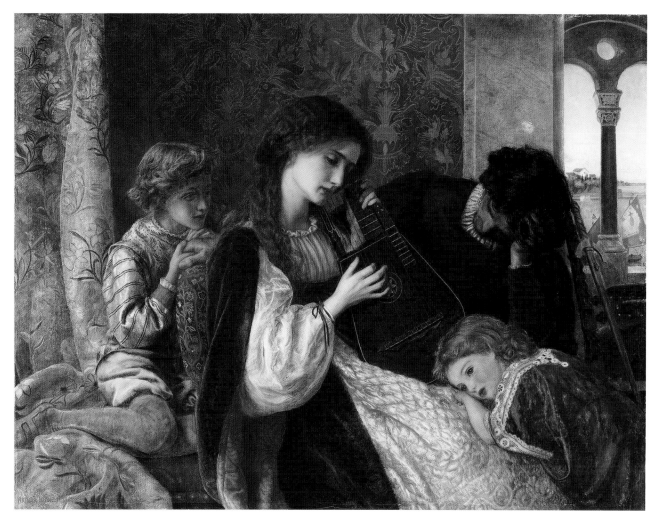

Arthur Hughes (1832–1915)

A Music Party, 1864

Oil on canvas, 58 × 76 cm

Lady Lever Art Gallery, National Museums Liverpool

Exhibited at the Liverpool Academy in 1864, and once owned by George Rae and then William Hesketh Lever

Hughes had visited Italy in 1862 and this painting, in its rich costumes and use of colour, reflects his enthusiasm for art by the Italian masters Titian and Veronese. The artist translated this Italianate influence into a contemporary family scene to attract a Victorian audience, and hopefully a buyer. George Rae bought the painting.

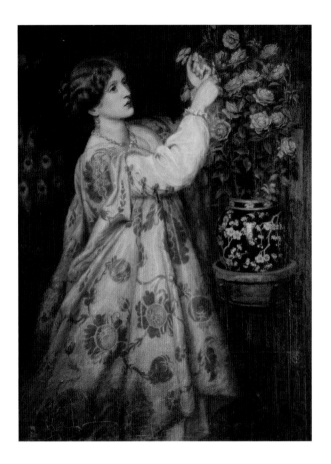

Dante Gabriel Rossetti (1828-82)

Monna Rosa, 1867

Oil on panel, 68.5 × 53.3 cm
Private collection

Commissioned by Frederick Leyland in 1867

In 1867 Frederick Leyland commissioned *Monna Rosa*, a portrait of his wife Frances. This was one of Leyland's first Rossetti works. The fine blue pot in the painting is a ginger jar, for which Rossetti coined the name 'hawthorn pots'. An earlier portrait, also *Monna Rosa*, had been exhibited at the Liverpool Academy in 1862. To coincide with a major British Association event in Liverpool in September 1870, Rossetti's *Mona Rosa* - possibly Leyland's version - was exhibited in a special exhibition at Liverpool Town Hall. All the works exhibited were drawn from local collections.

William Davis (1812-73)

Crafnant Valley, about 1865

Oil on canvas, 35.9 × 53.8 cm
Private collection

Exhibited at the Liverpool Academy in 1865 as *On the River Cravenant*. In George Rae's collection from 1873

The view here is in Snowdonia, from the south-east towards the north face of Mynydd (mount) Deulyn, and from the east bank of the river Geirionydd, which flows into the valley of the river Crafnant. The cattle are Welsh Blacks. The painting is thought to have remained unsold in Davis's studio at his death in April 1873, and was included in his memorial exhibition held at Liverpool Art Club in 1873. This is possibly where the collector George Rae acquired it.

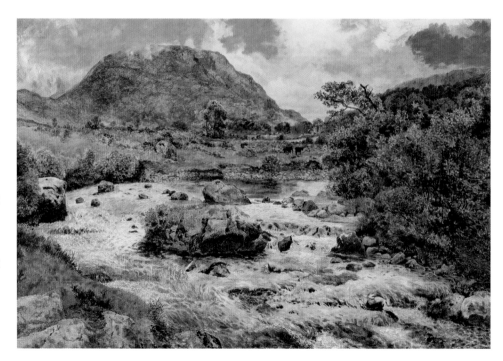

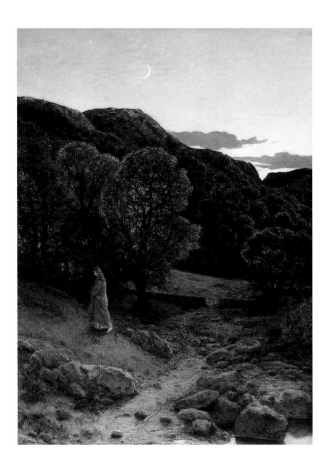

William Dyce (1806-64)

The Garden of Gethsemane, possibly 1850s

Oil on board, 40.8 × 30.5 cm
Sudley House, National Museums Liverpool
Owned by George Holt

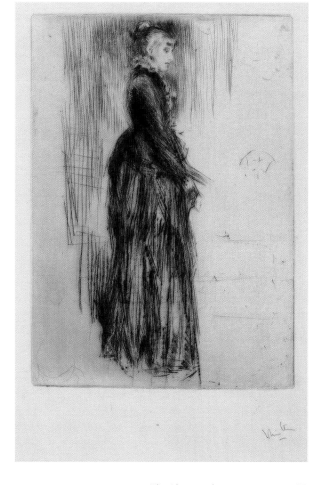

James Abbott McNeill Whistler
(1834-1903)

The Little Velvet Dress, 1873

Drypoint etching, 27.9 × 20 cm
Walker Art Gallery, National Museums Liverpool

The sitter is Mrs Frances Leyland.

William Davis (1812-73)

The Rainbow, about 1858

Oil on canvas, 45.5 × 65.5 cm

Walker Art Gallery, National Museums Liverpool

Exhibited at the Liverpool Academy in 1858

By the mid-1850s Davis began to focus on landscapes. He often found his subjects in the countryside around Liverpool. This picture shows a rainbow over fields near St Helens, east of the city. His paintings were admired by the London Pre-Raphaelites, but not by the writer John Ruskin, or by local art critics who described this picture as 'an offensive daub' when it was exhibited in Liverpool in 1858. Davis rolled up the right side of the canvas to conceal the rainbow, which he felt had caused the criticism. The rainbow was rediscovered in 1972.

The Liverpool school

Christopher Newall

The Pre-Raphaelite Brotherhood was formed in the autumn of 1848 by a group of young artists who had been born or brought up in London. The founding Pre-Raphaelites depended in the first place upon London exhibition spaces, foremost amongst which was the Royal Academy. In the 1850s professional and social connections began to be established between the London-based artists and their contemporaries living away from the capital. Members of the Pre-Raphaelite inner circle such as Ford Madox Brown, William Holman Hunt and John Everett Millais were aware of the opportunities that provincial cities offered as places to exhibit and for the access they gave to potential buyers. The works that they showed were looked at with interest and helped to spark a nationwide momentum in painting towards close detail and bright colour, and a fondness for naturalistic and carefully observed landscape settings. The Pre-Raphaelite works seen at the Liverpool Academy in the 1850s and '60s were powerfully influential upon an indigenous school of landscape and modern-life painters, leading to the establishment of a loosely formed but recognisable Pre-Raphaelite group in the town. However, the style of art devised by the Liverpool painters associated with Pre-Raphaelitism was in many ways a departure from the London-led prototype. Both in stylistic and technical terms, and in a larger sense to do with its purpose, the school of painters that emerged in the North West can be regarded as an artistic grouping in its own right and to a great extent intellectually and artistically detached from London.

Henry Currie Marillier coined the term 'The Liverpool School of Painters' when he thus titled the book that he wrote about the city's painters in 1904.

Whether or not justified in so describing an amorphous and divergent group of progressive artists, the term was presumably endorsed by Edward Rae, son of the patron George Rae, and who was acknowledged as having encouraged Marillier to write his account of how the arts prospered in the North West of England over the century or so up until the demise of the Liverpool Academy in 1867.[1] Marillier was especially interested in the Liverpool artists who may be described as Pre-Raphaelite, and the biographies that he compiled represent a valuable source of information on individuals for whom there might otherwise be little trace. Among the members of the Liverpool School were painters who had been born or raised in the North West or who had migrated there seeking professional opportunities. Some continued to reside in the city and participated in its artistic life, while others departed – either to live in London or to settle in the countryside. Bonds of friendship linked certain individuals within the loose association, while others deliberately abandoned the artistic federation that existed in Liverpool. These artists were not tied together by any particular professional allegiance or common artistic objective, and therefore the question follows as to what stylistic characteristics define or distinguish their approach. The Liverpool artists, who often struggled to earn a living, nonetheless painted in a way that was an authentic expression of their feelings for nature and the landscape and in a way that makes their works compelling to this day.

1 See Marillier, *The Liverpool School of Painters*, p. 9.

William Davis (1812–73)

Junction of the Liffey and Rye near Leixlip, 1857

Oil on board, 20.3 × 30.5 cm

Walker Art Gallery, National Museums Liverpool

Formerly owned by John Miller, and possibly later by George Rae

Dublin-born Davis made his career in Liverpool and became Professor of Drawing at the Liverpool Academy in 1856. Davis was supported almost single-handedly by the collector John Miller for much of his career. He revisited Ireland in 1853 and 1857. This lively sketch dates from his second visit and shows the church tower of Leixlip on the right and the boathouse in the grounds of Leixlip Castle on the left.

William Davis (1812–73)

View on the Liffey near Leixlip, 1857

Oil on board, 20.3 × 30.2 cm

Walker Art Gallery, National Museums Liverpool

Owned by John Miller, William Coltart and possibly by George Rae

This painting is one of several known to have been painted on the second trip Davis made to Ireland in 1857. The view looks downstream from the right bank of the Liffey towards Leixlip, a few miles west of Dublin. Leixlip Castle can be seen, as can the boathouse in the grounds.

Robert Tonge (1823–56)

Wind on Green Corn, near Eastham, about 1853

Oil on board, 31 × 51 cm

Williamson Art Gallery & Museum, Birkenhead; Wirral Museums Service

Exhibited at the Liverpool Academy in 1853 as *Green Corn*

In his 1904 book *The Liverpool School of Painters*, HC Marillier proclaimed Tonge as 'the greatest master of landscape' the school produced. Cornfields and skies were Tonge's passion and he employed low horizons in order to create more space for the sky. This picture belonged to the local collector Joseph Beausire.

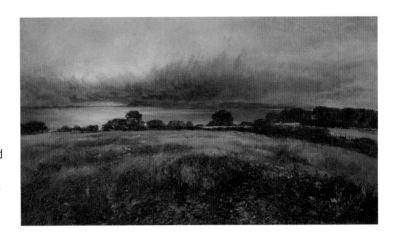

William Joseph Julius Caesar Bond (1833–1926)

On the Ogwen, 1887

Oil on board, 30.4 × 48.2 cm

Walker Art Gallery, National Museums Liverpool

Landscape painting especially was valued as a specialisation among the Liverpool-based artists, whereas at the Royal Academy landscapists were at a severe disadvantage, particularly if they showed a Pre-Raphaelite tendency.

Several of the Liverpool-based artists whose adopted principles allow them to be seen as northern disciples of Pre-Raphaelitism were of an older generation than the London pioneers. William Davis (1812–73) was born and trained in Dublin but moved to England, living in Sheffield in 1837 and settling in Liverpool about five years later. He was 36 when the Brotherhood was formed and therefore beyond his most impressionable years. Davis commenced as a portraitist and painter of still-lifes but later seems to have come under the influence of the Liverpool landscape painter Robert Tonge (1823–56) with whom he made a painting tour in Ireland in 1853. Davis had interesting links with artists in London, notably with Ford Madox Brown and Dante Gabriel Rossetti. The latter admired his Royal Academy exhibit *Early Spring Evening - Cheshire* in 1855. Rossetti, who on several occasions sought to disseminate a wider appreciation of works by Liverpool artists, recommended the painting to Ruskin who had not noticed it at the summer exhibition but then made reference to it in his Supplement to *Academy Notes*, quoting Rossetti as saying that it 'contains the "unity of perfect truth with invention."'[2]

When Ruskin actually saw the painting, which is now untraced, he was disappointed, finding that it lacked 'tact [...] in choice of subject'.[3] Ruskin wrote a letter of criticism of the work to be forwarded by Rossetti but which the latter had the kindness not to send. In this, references were made to Davis's adoption of subjects 'so *little* rewarding your pains and skills as that "ditch and wheatfield"'.[4] In *Modern Painters* IV Ruskin protested against 'duck-pond delineation', which may have been a veiled criticism of Davis although he is unnamed,[5] and it is the case that the artist had a reputation for his preference for aspects of the landscape which the more high minded might consider dreary if not squalid. An anecdote circulated which recalled how Davis was once found sketching a sunken culvert while behind his back lay beautiful scenery.

If Ruskin felt that he had been misled into expressing enthusiasm for Davis's work, others within the London Pre-Raphaelite circle took the artist up with alacrity. Ford Madox Brown had also endured Ruskin's disparagement notably in connection with his Hampstead view *An English Autumn Afternoon* (Birmingham Museums Trust), which he defended against the critic's carping about choice of suitable subject matter by explaining simply that he had painted it 'because it lay out of a back window'.[6]

2 *The Works of John Ruskin*, edited by ET Cook and Alexander Wedderburn, 39 volumes, 1903-12, XIV, p. 30.

3 Ibid., p. 32.
4 Ibid., p. 32, n. 1.
5 Ibid., pp. 30-1.
6 Surtees, *The Diary of Ford Madox Brown*, p. 144.

William Davis (1812-73)

Old Mill and Pool at Ditton, 1860-4

Oil on canvas, 53.5 × 36.5 cm

Walker Art Gallery, National Museums Liverpool

Exhibited at the Liverpool Academy in 1864 as *Old Mill at Ditton*

Ditton Windmill was located to the east of Ditton station. Ditton itself is near Widnes. Davis's inclusion of ducks was a favourite motif of his, yet one that caused the critic Ruskin to accuse him of selecting subjects unworthy of painting. John Miller owned a painting by Davis of the mill, of a different size.

Daniel Alexander Williamson (1823–1903)

Westmorland Hills – Effect before Rain, 1861–5

Oil on board,
23 × 38.5 cm

Private collection, on loan to Williamson Art Gallery & Museum, Birkenhead; Wirral Museums Service

In 1860 Williamson settled in Warton-in-Carnforth, North Lancashire, and painted a group of small landscapes with intense, jewel-like colour, deeply indebted to Pre-Raphaelitism. This undated work could date from around that period.

Brown clearly appreciated the incidental and intimate character of Davis's work, as it formed a parallel with his own search for an authentic representation of the landscape.[7] In 1856 Brown enthused about Davis's Academy exhibit: 'a little landscape by Davis of Liverpool of leefless [sic] trees & some ducks which is perfection. I do not remember ever seeing such an english [sic] landscape, it is far too good to be understood'.[8] A few weeks later Brown met Davis in Liverpool at the house of the collector John Miller, and gave a memorable account of a man for whom life was a struggle but whose 'turn will come',[9] or so Brown hoped. Presumably as a result of Brown's influence, Davis was invited to send works to London for the Russell Place exhibition of Pre-Raphaelite art in 1857, and to the travelling exhibition of British art in the United States in 1857–8.

Davis's landscape subjects were found in the vicinity of Liverpool, either in the open countryside to the north close to Formby, or on the Wirral. On occasions he ventured into North Wales, where the collector George Rae had a country house, or to the Isle of Bute, where John Miller, and subsequently Miller's brother George, had a property. It was Davis's propensity to compose his landscapes so that the more distant elements fill the upper parts of the picture-space, and to allow grassy or watery foregrounds to be seen in expanded perspective. This optical distortion makes whatever appears in the foreground plane disproportionately large – as in, for example, *At Hale, Lancashire* (Walker Art Gallery), where ducks and a seated child occupy the composition's lower register, by contrast causing the distant cottages to appear especially diminutive. Two of Davis's most delicate, closely observed paintings show views of the Liffey in Ireland (page 88). In these, buildings on the river's banks allow some sense of orientation despite the wider landscape being obscured by foliage and the perspective being downward into the surface of the water.[10]

Among his numerous views of windmills is *Old Mill and Pool at Ditton* (page 90) in which a decrepit post-mill is seen against the sky, its angular shapes and clapboard bulk reflected in the surface of a pond. Structures that had served for centuries as vital parts of the agrarian economy inspired Davis to explore the landscape through the means of colour and texture.

In response to the Pre-Raphaelite landscapes of Brown and others, Davis gradually brightened his palette and gave more attention to detail. As the pioneer of a method widely adopted by the Liverpool artists, Davis's technique – as described by the commentator FG Stephens – was to use flake white as a smooth and even ground.[11] Onto this surface he applied transparent or semi-opaque oil colour, diluted with copal and oil, floating the pigments on to the gesso-like surface to create extraordinary gauze-like textures and glazed surfaces which are themselves the bases of more solid areas of paint. All of this seems to have been done quite quickly so that pigments were allowed to run together in coalescent pools or stand in glistening isolation as if held apart by some kind of chemical incompatibility akin to a 'resist' in printmaking. A further account survives of Davis's insisting on a range of different colours being applied in a stippled pattern – 'To paint the field below the windmill [...] place a little orange here, beside it a little grey, then some dark blue next to that, then a touch of vermilion [...] Now, draw the edges of the colours together, so. There are all of these colours in nature if we look for them'[12] as he insisted. Davis's handling of paint became ever freer as his career progressed, with spattered surfaces of paint serving to suggest stems and foliage and with filigrees of line or patterns of dots drawn over with a sable brush to give constant variety of texture.

7 Examples of this type are *Carrying Corn* (Tate), of 1854–5, and *Hampstead from my Window* (Delaware Art Museum), of 1857.

8 Surtees, *The Diary of Ford Madox Brown*, pp. 174–5.

9 Ibid., p. 190.

10 Mary Bennett has deduced the precise topography of each; see *Merseyside: Painters, People & Places – Catalogue of Oil Paintings*, two volumes, Liverpool 1978, pp. 85–6.

11 This account of Davis's instruction to a young artist is given by FG Stephens in 'William Davis, Landscape Painter, of Liverpool', *Art Journal*, 1884, pp. 325–8. Flake white is a densely opaque and very pure white paint made from lead carbonate and zinc oxide, which absorbs other pigments freely but otherwise resists discolouration.

12 Quoted in Marillier, *The Liverpool School of Painters*, p. 112.

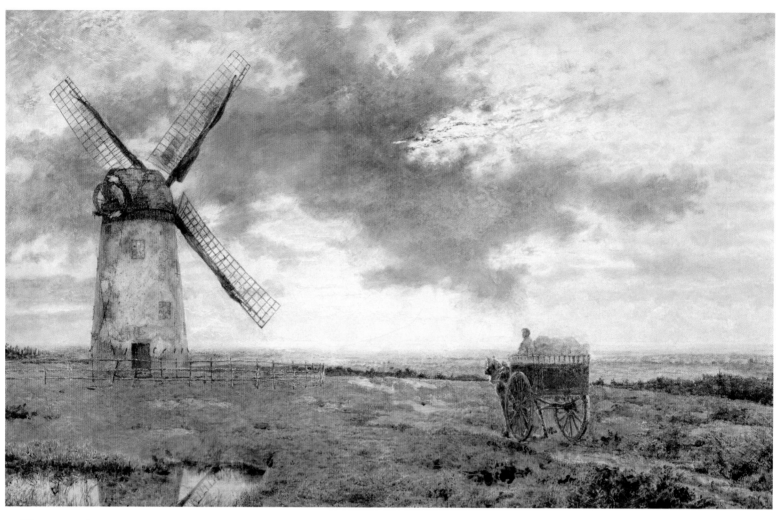

William Davis (1812-73)

Wallasey Mill, Cheshire, about 1856

Oil on canvas, 42 × 66 cm

Private collection

Possibly the painting exhibited at the Liverpool Academy in 1856, from which it was purchased by John Miller

Davis is known to have exhibited several views of Wallasey Mill. Windmills were a favourite subject for him. This painting, which is a particularly good example of his ability to bring natural grandeur to the most humble of scenes, may have been owned by both John Miller and George Rae. The former was Davis's most passionate supporter and patron.

William Joseph Julius Caesar Bond (1833-1926)

Raven's Fall, near Hurst Green, possibly 1856

Oil on panel, 42 × 32 cm

Walker Art Gallery, National Museums Liverpool

Daniel Alexander Williamson (1823–1903)

Morecambe Bay from Warton Crag, 1862

Oil on board, 25.1 × 33.5 cm

Walker Art Gallery, National Museums Liverpool

Exhibited at the Liverpool Academy in 1862 as *Morecome Bay - from Malton Crag.*

For a period in the 1860s Williamson's work showed the influence of the Pre-Raphaelites with brilliant colours and a minute, although slightly thicker, impasto technique. In this painting, the intense glowing colour, the detailed depiction of the sheep and the limestone rocks appear to be influenced by Holman Hunt's painting *Strayed Sheep* (Tate). In later years Williamson's style changed completely and he turned almost entirely to painting impressionistically handled, misty watercolours.

John Edward
Newton (1834–91)

Still Life, 1863

Oil on canvas,
15 × 22.5 cm

Martin Beisly

Possibly *Fruit*, exhibited at the Liverpool Academy in 1864, or *The Forbidden Fruit*, at Liverpool Institution of Fine Arts, 1864

John Edward Newton (1834–91)

The Roadside Pond, 1862

Oil on canvas, 22 × 30.2 cm

Private collection

**Possibly *The Roadside Pond*, exhibited at the
Liverpool Academy in 1862, or *The Dragonfly's
Haunt*, at the Liverpool Institution of Fine Arts,
1863. These two exhibits could also be the same
work**

Newton's landscapes were meticulous in their detail
until, following a move to London in 1866, his style
became looser. The landscape represented in this
scene may be the countryside to the north of
Liverpool. Until 1865 Newton lived near Litherland
and the river shown is perhaps the nearby Alt.

This method conveyed movement and flux in the landscape, analogous to Ruskin's insistence on 'gradation', which was aimed at the avoidance of flat expanses of colour or reliance on mechanically applied, repetitious tints. The same critic, however, warned Davis against 'too great trust to the liquidity of the vehicle in the blending of your colours', explaining his view that although 'good use has been made of this quality by the masters of the Pre-Raphaelite school, [...] it is a dangerous temptation: the highest results in oil-painting depend on judicious and powerful use of dryer, in no wise *floating* colour'.[13] Despite this, Davis was experimental in his use of paint and was a modern figure in his apparent indifference towards what others might regard as a correct method of work.

Some inkling of Davis's personality may be gained from contemporary accounts. A picture emerges of a spiky individual prepared to damage his own interests rather than accommodate himself to others for whom he had no sympathy. He refused to sell works to dealers, who he regarded as parasites. Brown, who could also be curmudgeonly, thought Davis 'one of the most unlucky artists in England [...] crushed by disappointment & conscious dependency of Millar [*sic*] who has entirely kept him for years',[14] but clearly regarded him as a friend. Rossetti, likewise, went to lengths to encourage him – perhaps recognising in him a fellow spirit at odds with the small-mindedness of the Victorian art world.

One can only speculate as to the contact that there may have been between Davis and Daniel Alexander Williamson (1823–1903). The latter was born in Liverpool, and came from a family of artists long established in the city. In the late 1840s Williamson gave up a job with a Liverpool cabinet maker and moved to London, living in Islington and subsequently in Peckham for the following 11 years. In the second half of the 1850s he made a series of drawings and paintings of cattle and sheep on Peckham Common.

These are extraordinary and impassioned works of art in which the artist has paid minute attention to the forms of the animals as they massed together, and with irradiating effects of light casting across and through their shapes and outlines so that the compositions are unified by atmospheric effect. It has been suggested that Williamson may have consciously been emulating the French painter Constant Troyon who in the 1850s also frequently painted flocks and herds with strongly delineated shadows.[15] He could have seen Troyon's work in London or Liverpool.[16] Williamson may not have been fully occupied as an artist during the years that he lived in London and certainly he seems to have made no response to Pre-Raphaelitism until after his return to the North West in 1860. Although never formally connected with the Liverpool Academy, he exhibited there intermittently, with titles of works shown in the 1860s indicating a fondness for ponds, hayfields and furzey wasteland.

From this time forward the artist lived in north Lancashire, for four years at Warton-in-Carnforth, and subsequently in the Duddon valley at Broughton-in-Furness. During the first half of the 1860s Williamson created a series of views of the upland scenery in these two places which allow him to be regarded as one of the most extraordinary of all Pre-Raphaelite landscape painters. At Warton he painted the limestone outcrops and pavements, the forms of which he treated with scrupulous attention to geological accuracy and with a knowledge of the particular locality which can only have been gained by close exploration.

William Davis
(1812–73)

Loch Striven,
about 1860

Oil on board,
21.4 × 32.7 cm
Private collection

Loch Striven is a sea loch lying west of the Firth of Clyde, and north of the Isle of Bute. This was probably painted, therefore, on one of Davis's trips to Bute under the patronage of John Miller, who had a retreat there.

13 *Ruskin: Rossetti: Preraphaelitism*, edited by William Michael Rossetti, London, 1899, pp. 169–70.

14 Surtees, *The Diary of Ford Madox Brown*, p. 190. This misrepresents the pattern of Davis's sales. The list of collectors who lent to the exhibition of Davis's work held after his death includes, in addition to Miller and Rae, the Liverpudlian and Birkenhead patrons Humphrey Roberts and Albert Wood. James Leathart of Gateshead, and Vernon Lushingon, of London (who also spent time in Liverpool) had works by him.

15 See Allen Staley, *The Pre-Raphaelite Landscape*, second edition, New Haven 2001, pp. 200–1.

16 Troyon's work was included in several exhibitions of the French School in London between 1854 and 1857, and in Liverpool in 1857 in an exhibition of French art at the Old Post Office Place exhibition rooms. See: 'French Exhibition of Paintings, 121, Pall Mall', *Morning Post,* Thursday 1 June 1854; 'French School of the Fine Arts', *Morning Post,* Monday 7 May 1855, p.3; 'Exhibition of French Art', *London Evening Standard,* Monday 5 May 1856, p. 1; 'The Fine Arts', *The Examiner,* 17 May 1856, p. 5, 6; 'Second Exhibition of the French School of the Fine Arts', *Liverpool Daily Post*, Monday 16 February 1857, p. 5 (all British Newspaper Archive online) AB.

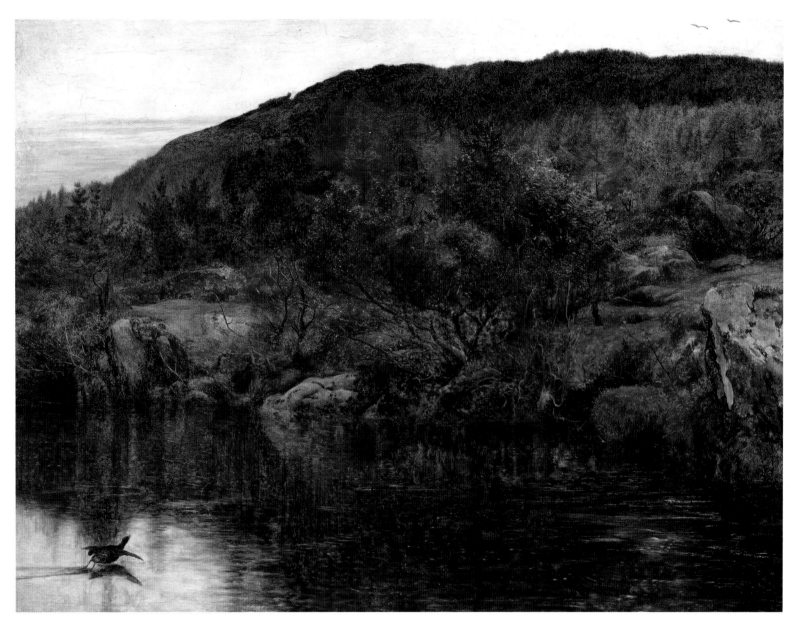

Daniel Alexander Williamson (1823-1903)

The Coot's Haunt, 1863-4

Oil on board, 28 × 36.2 cm

Private collection

Exhibited at the Liverpool Academy in 1864

This atmospheric evocation of an autumn evening represents Williamson's move away from fidelity to nature towards a more poetic interpretation of the countryside.

Daniel Alexander Williamson (1823–1903)

Spring, Arnside Knott from Warton Crag, 1863

Oil on canvas, 27 × 40.6 cm

Walker Art Gallery, National Museums Liverpool

Passed through the ownership of the collectors Edward Quaile and James Smith of Blundellsands

Liverpool-born Williamson came from a family of landscape painters. He spent the years 1849 to 1860 in London but sent pictures back to Liverpool for exhibition. His work of the 1850s shows little awareness of Pre-Raphaelitism. In 1860 he moved to Warton-in-Carnforth in North Lancashire where he painted a series of vibrant small landscapes like this one, remarkable for their luminous colour and showing the influence of Pre-Raphaelitism. The famous landmark the Old Man of Coniston can be seen in the background.

Daniel Alexander Williamson (1823–1903)

Cornfield, late 1860s

Watercolour and bodycolour on paper, 17.1 × 25.2 cm

Williamson Art Gallery & Museum, Birkenhead; Wirral Museums Service

The scene may be the estuary of the river Duddon.

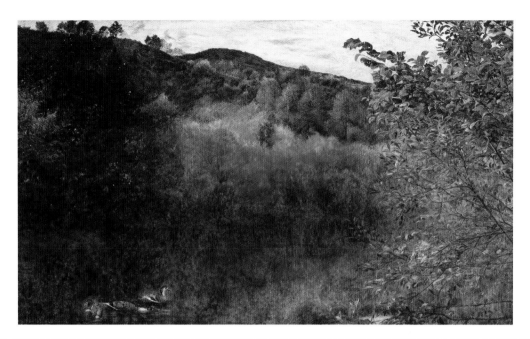

Daniel Alexander Williamson (1823–1903)

Near the Duddon, 1864

Oil on board, 21.6 × 35.6 cm

Williamson Art Gallery & Museum, Birkenhead;
Wirral Museums Service

Formerly in the collection of James Smith.

Williamson moved in 1864 to Broughton-in-Furness in the Lake District. The river Duddon was nearby. In this landscape he alternates between naturalistic detail and impressionistic effects. The painting represents a transitional phase in Williamson's work, which from the mid-1860s was moving away from accurate representation towards a more expressive and intuitive use of colour.

The painting *Spring, Arnside Knot and Coniston Range of Hills from Warton Crag* (pages 98 and 99) shows the wider landscape looking northwards towards the Lakes, but with the carboniferous mass of Arnside Knot forming the immediate horizon. The strength of colour and constant variations of texture make this an immaculate evocation of fine weather but with distant rain. Fissured blocks of limestone are strewn across the foreground among gorse, yews and dead bracken, and fresh grass springs through as gorse continues to bloom. *Morecambe Bay from Warton Crag* (page 93) shows a view towards the west. Sheep shelter among the rocks, the forms of which they seem to echo. A line of Scots pines runs across the width of the composition, while the distant expanse of sea is subtly harmonised with the mauve-grey of a hazy sky. These are extraordinarily literal observations of a familiar landscape which as a series give a complete geographic account of a locality the artist clearly loved.

Williamson had a particular skill in finding pattern in the scenery, simplifying his compositions into bands from foreground to horizon and unifying what he saw so as to make unnecessary the perspectival devices or framing mechanisms of traditional landscape painting. Furthermore, he had a fondness for peculiar tints of colour – russet browns and dense forest greens, purples and mauves – and undoubtedly benefited from newly available and industrially manufactured paints, so that his landscapes have a quality which transcends the naturalistic. The strangeness of the effects he achieved was commented upon in 1862 when *Morecambe Bay* was shown at the Liverpool Academy. The work was disparagingly dubbed 'a decidedly *ante* pre-Raphaelite bit, altogether false to nature'.[17]

After his onward move to Broughton in 1864 Williamson turned increasingly to atmospheric effects and the representation of times of day – a shift of emphasis which put him in step with his contemporaries among advanced landscape painters such as the Leeds artist John William Inchbold (1830–88). *The Coot's Haunt* and *Near the Duddon* (pages 97 and 100) are extraordinary for their manipulation of texture. The artist holds the spectator's attention by allowing the degree of detail to fluctuate across the painted surface – as if simulating the very act of seeing. In the latter work the branches of an alder are treated with delicious crispness and with glinting points of light reflecting from leaves as they twist in the breeze.

17 'The Exhibition of the Liverpool Academy', *Liverpool Mercury,* Thursday 13 November 1862, p. 5 (British Newspaper Archive online).

William Joseph Julius Caesar Bond (1833–1926)

House at Oxton, 1854

Oil on board, 26.3 × 21.2 cm

Walker Art Gallery, National Museums Liverpool

Bond was born at Knotty Ash near Liverpool and was encouraged by the collector John Miller to become an artist. This is one of his earliest known works, painted when he was just 21 years old. It clearly shows the Pre-Raphaelites' influence in its bright colours and sharp detail. Oxton village is a neighbourhood in Birkenhead, across the River Mersey from Liverpool. Research into the exact location of the house is ongoing. It has recently been suggested that it could have been up on the Oxton Ridge.

John Edward Newton (1834–91)

Mill on the Alyn, Denbighshire, about 1861

Oil on canvas, 30.5 × 36.8 cm

Walker Art Gallery, National Museums Liverpool

Exhibited at the Liverpool Academy in 1861 and purchased by George Rae

Newton's view shows a landscape on the river Alyn in Denbighshire, Wales. After decades of remaining unidentified, the mill is now thought to be Wilderness Mill, which was about a mile south-west of Gresford, close to Gwersyllt. The mill no longer exists.

In the foreground ducks float on the still surface of the water, and the far hillside is observed so that it may be explored topographically in the mind of the viewer. In contrast, the composition's central area is a blur of colour with a transition from foxy brown through to ochres and with no clear indication as to where the river's bank lies. Artistically isolated though Williamson may have been (although he was in contact with William Lindsay Windus and made painting expeditions with him in the mid-1860s), and even if pursuing landscape objectives that had been explored by artists such as Brown and Holman Hunt ten years earlier, there is a peculiar inventiveness to his work of the 1860s.

The erratic pattern of Williamson's career took a further change of direction in 1865 when – according to Marillier as a result of an illness which prevented his working in the open air – he adopted watercolour as his principal medium, with ever greater airiness and abstraction. In these works he seems to have adapted to watercolour the method of puddling and floating colour as Davis had done in oil, also using the dampness of the paper as an osmotic medium for colour to spread and coalesce. Davis and Williamson would hardly be recognised as fellow members of a school of artists were it not for their shared tendency to allow colour to melt and fuse in their works.

Marillier regarded the younger painter William Joseph Julius Caesar Bond (1833–1926) as a 'connecting link' between the landscape artists associated with the Liverpool School and described him as a venerated figure in the city.[18] Bond's early studies of foliage and stems of trees are Pre-Raphaelite in inspiration, while the scrupulous observation shown in the painting *House at Oxton* (page 101) is both naturalistic and eccentric. Bond later painted more freely and in a manner dependent upon a somewhat naïve emulation of Turner. The work of John Edward Newton (1834–91) was described by Marillier as 'conspicuous for an exceeding minuteness

18 Marillier, *The Liverpool School of Painters*, p. 74.

Joseph Edward Worrall (1829–1913)

Cobbling, 1871

Oil on panel,
25.5 × 20 cm

Walker Art Gallery,
National Museums
Liverpool

Possibly exhibited in the Liverpool Autumn Exhibition in 1871

The title of this picture, pencilled onto the back of the panel, may be a later, speculative addition – Worrall exhibited a painting entitled *Cobbling* in the 1871 Liverpool Autumn Exhibition. If the title is correct it must relate to 'cobbling' a repair – he mends an 18th-century chair, faithfully painted by the artist. The boy appears in other works by Worrall.

of touch and detail [...] destructive of all effect'.[19] In his still-lifes and landscapes the artist achieved an extraordinary level of realism by manipulation of oil colour but seems to have deliberately avoided any feeling of the transience of weather. In a review of the 1862 Liverpool Academy exhibition, comparison was made between Newton's work and Davis's, concluding that when the former 'paints a tree, one can speak with certainty of its denomination'.[20] This may be taken as an endorsement of a power of observation and a fulfilment of the Ruskinian principle of 'truth to nature'. However, in 1904 Marillier regarded Newton's painstaking attention to detail as grounds for criticism and described his *Old Mill at Gresford* (untraced) as 'cold and uninteresting to the last degree' and this despite 'the painting [being] marvellous as a specimen of skill and minuteness'.[21] Newton sent works to exhibitions from addresses in Litherland and Everton in Liverpool and found subjects in the countryside to the north of the town and in North Wales. His later years were spent in London, as he was one of the many Liverpool artists who migrated southwards in the hope of better professional fortune.

Alfred William Hunt (1830–96) was born in Liverpool's Bold Street where his father Andrew Hunt ran a drawing school. The family subsequently moved to the more fashionable Oxford Street, in the expanding New Town. Hunt attended the Liverpool Collegiate School where the Principal, the Revd William John Conybeare, must have encouraged his interests in the Bible and geology. In 1848 Hunt went up to Oxford University to read Classics, in due course becoming a fellow of Corpus Christi College. Drawing landscape subjects was second nature to him. He accompanied his father on sketching trips from an early age but only slowly moved towards an intensely coloured and detailed style of work. His adoption of a method of painting in oil and watercolour which can be recognised as Pre-Raphaelite was the result, it seems, of reading Ruskin's *Modern Painters* and probably also *The Elements of Drawing* rather than an attempt to match the work of the Pre-Raphaelite landscape painters who were emerging in London in the mid-1850s, such as Inchbold and John Brett (1831–1902).

Hunt exhibited at the Liverpool Academy from 1847, showing views of the Lakes and North Wales. He was elected an associate in 1854 and a full member in 1856. Elsewhere, however, he sold his watercolours through the Oxford print-seller James Wyatt, and exhibited at the Royal Academy from 1854, in which year he showed the oil *Wasdale Head from Styhead Pass* (Harris Museum and Art Gallery, Preston), so from an early stage he was looking to establish his artistic reputation beyond the city of his birth. Nonetheless, it was from his home in Liverpool that Hunt sent works to exhibitions until the end of the 1850s, and it was there that he returned during university vacations. As previously described, Hunt played a leading part in the acrimonious dispute over which painting should be awarded a prize at the 1857 Academy exhibition, approaching Ruskin in the hope that he would offer support for Millais's *The Blind Girl* (inside front cover). Hunt was invited to send to the American touring exhibition of Pre-Raphaelite art in 1857–8 and was subsequently a non-resident member of the Hogarth Club. He was therefore acknowledged as a member of the wider Pre-Raphaelite circle, albeit on its outer fringe. Hunt's friendship with Ruskin survived, perhaps because he put up with the hectoring that other artists had found intolerable. Admiration for Turner was the bond between the two, with Hunt a devoted and inspired interpreter of Turner's method of topographical watercolour painting.

It can be assumed that it was Ruskin's *Modern Painters* IV, published in 1856, that specifically led Hunt to paint a series of mountain subjects in which he paid attention to the mechanisms of physical geography. The most explicit of these in terms of its title is the oil *Track of an Ancient Glacier* (Tate) but this was a reworking of the watercolour *Cwm Trifaen* (page 104) of 1856 in which striations cut by boulders lodged within ancient flows of ice may be seen. Ruskin thought Hunt's 1856 Royal Academy exhibit *The Stream from Llyn Idwal* (untraced) 'the best landscape I have seen in the [Academy] exhibition for many a day – uniting most subtle finish and watchfulness of Nature, with real and rare power of composition [...] the *rents* of cloud, and fading and forming of the hill shadows through them, are magnificently expressed'.[22]

19 Ibid., p. 179.
20 *The Porcupine*, 25 October 1862, p. 234 (quoted Bennett 1978, I, p. 87).
21 Marillier, *The Liverpool School of Painters*, p. 180.
22 Ruskin 1903–12, XIV, p. 51.

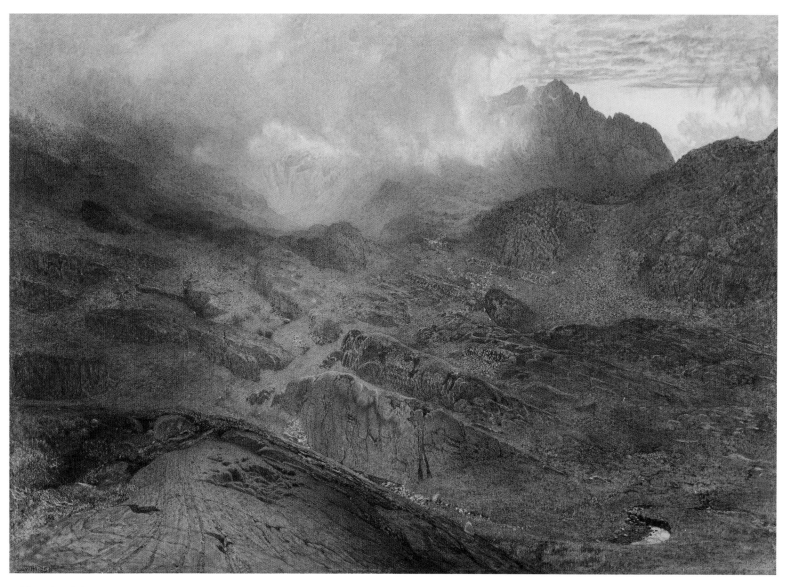

Alfred William Hunt (1830–96)

Mountain Landscape – Cwm Trifaen, 1856

Watercolour and bodycolour on paper, 26.7 × 38.7 cm

Ar fenthyg gan / Lent by Amgueddfa Cymru – National Museum Wales.
Purchased with the assistance of the Art Fund

Hunt was a frequent visitor to North Wales and travelled there in 1855 and 1856, prior to becoming a professional artist in 1861. Bad weather was an ever present challenge for him on these painting expeditions. Mountainous landscapes were a favourite subject. The dramatic geology of this valley in Snowdonia, with its striking granite forms and traces of glacial movement, would have excited his artistic eye.

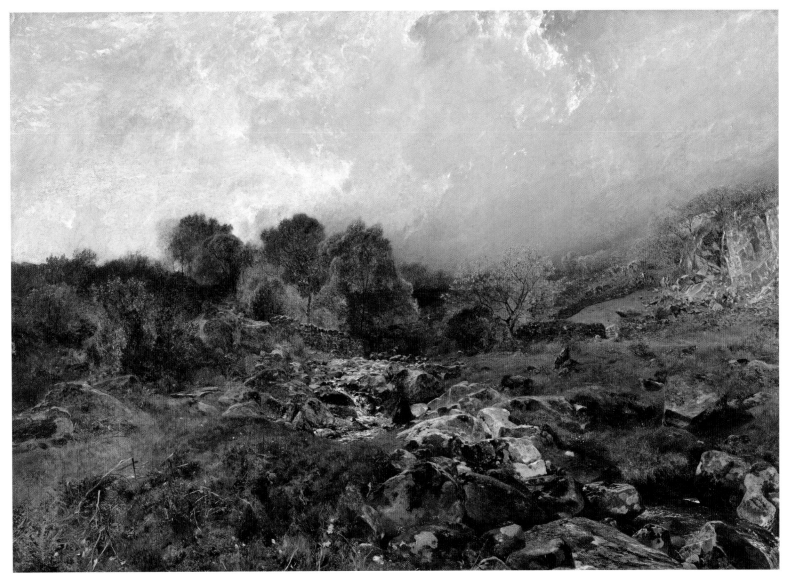

Alfred William Hunt (1830-96)

Cornel Rhos - Spring, 1857

Oil on canvas, 35 × 50.5 cm

Private collection

This vivid evocation of a storm closing in across the Welsh hillside is a testament to the difficulties Hunt experienced in painting outdoors, at the mercy of the elements in Snowdonia. The painting entered the collection of the Gateshead industrialist, James Leathart.

James Campbell (1823–93)

Twilight, Trudging Homeward, about 1857

Oil on canvas, 55.2 × 43 cm

Private collection

**Exhibited at the Liverpool Academy in 1858 as *Trudging Homeward*.
In the collection of John Miller and sold posthumously in 1881**

Campbell's distinctive, linear style is to the fore in this picture. At the 1858 Liverpool Academy, the *Liverpool Mercury* commentator remained dryly unimpressed with the subject: 'Much less pleasing to contemplate [than Campbell's *News from my Lad* (Walker Art Gallery)] – an old English grinder of an Italian organ, his daughter, who plays the tambourine, and their dog, all "Trudging homeward".'

A number of Hunt's Welsh views, presumably from the same trip, were shown at the 1856 Liverpool Academy. The 1857 oil *Cornel Rhos – Spring* (page 105), although not seen in Liverpool until the time of Hunt's memorial exhibition at the Walker Art Gallery in 1897, allows an estimate to be formed of the artist's claim to be regarded as a member of the Liverpool School. The greens of spring foliage are rubbed in and abraded to give texture and allow the luminescent white ground to show; stems of dead bracken and patches of moss and lichen are treated with thread-like linear delineation in the foreground, with points of colour indicating flowers pressing through; the sky swirls with the grey of low cloud but with glistening edges which suggest the sun behind; lichenous rocks with water running between form a confusion which is entirely convincing. This is Hunt's response to the raw elements of nature virtually without indication of human presence (save the dry stone wall that runs across the middle ground), and is a painting as impassioned and single-minded as those of any of his fellow Liverpudlians. *Cornel Rhos* belonged to James Leathart, who was particularly fond of the work of the Liverpool artists, and must have hung in his house in Gateshead in company with paintings by Davis, Bond and James Campbell.[23]

Modern life subjects, as well as landscapes, were treated by three further artists of the Liverpool School, James Campbell (1828–93), Joseph Edward Worrall (1829–1913) and John Ingle Lee (1839–82). Campbell trained at the Liverpool Academy from 1851, often exhibited there, and was evidently a familiar figure in the city – Marillier identified him as a regular at the Saturday-night artistic parties that the patron Miller gave. Works such as *The Wife's Remonstrance* (Birmingham Museums Trust) exemplify the individuality of his style, in which there is no obvious dependence on works by London-based artists.

23 See *Paintings from the Leathart Collection*, exhibition catalogue, Laing Art Gallery, Newcastle upon Tyne, 1968.

Daniel Alexander Williamson (1823–1903)

Driving Sheep, 1865

Watercolour on paper, 18 × 25.8 cm

Private collection

John Ingle Lee (1839–82)

Sweethearts and Wives, 1860

Oil on canvas, 84.5 × 71.3 cm

Walker Art Gallery, National Museums Liverpool

Exhibited at the Liverpool Academy in 1861

'Sweethearts and Wives' is a traditional naval toast.
Scenes showing sailors with their families were popular
in the Victorian period. These men are from *HMS
Majestic*, an ex-Crimea warship anchored in the Mersey
as part of the port defences. Lee has captured the view
across the river towards Birkenhead. St Mary's Church
and Bidston Windmill stand out on the horizon.
Liverpool-born Lee appears as the sailor on the far right
of the canvas. His vivid paint colours and meticulous
detail show his awareness of Pre-Raphaelitism.

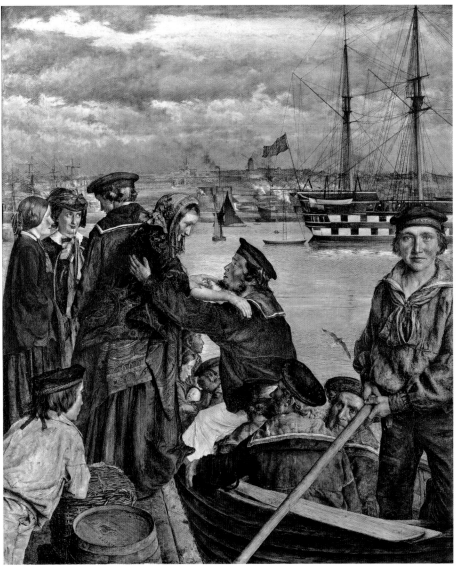

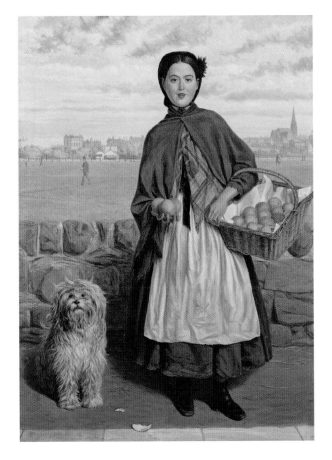

Joseph Edward Worrall (1829–1913)

Three-a-Penny, 1867–8

Oil on panel, 30.5 × 23 cm

Private collection

Exhibited at the Liverpool Academy in 1867

*Not in exhibition

Ruskin regarded this work as 'by far the best picture in the Suffolk Street rooms this year; full of pathos, and true painting', but went on to express regret that the artist was 'unredeemably [*sic*] under the fatal influence which shortens the power of so many of the Pre-Raphaelites – the fate of loving ugly things better than beautiful ones'.[24] Campbell expressed an anguished sympathy for the impoverished, disadvantaged figures who often appear in his paintings. In the subject *Dinner in View* (ex-Christie's, London, 6 November 1995), for example, exhibited at the Liverpool Academy in 1856, he offered an image of hardship which recalls the French 17th-century painter Louis Le Nain. *Trudging Homeward* (page 106), exhibited in Liverpool in 1858 (having previously been shown at the Russell Place Pre-Raphaelite exhibition and then as part of the touring exhibition to America), likewise describes the lives of people engaged in endless struggle.

Joseph Worrall was omitted by Marillier from his index of Liverpool School painters. Recent research has revealed that he was born in St Paul's Square, Liverpool, and trained as a lithographer. He attended life-classes at the Royal Institution in Colquitt Street and was a member of the Liverpool Sketching Club. In addition to exhibiting in Liverpool, he occasionally sent works to the Royal Academy and to Suffolk Street in London in the 1860s.[25] How well Worrall painted is demonstrated by the image of a fruit-seller, wearing a shawl and apron and carrying a basket of oranges, exhibited in 1867 under the title *Three-a-Penny* (formerly with Peter Nahum, London, page 107), and in which the red sandstone wall allows the setting to be recognised as Liverpool. John Ingle Lee, who was likewise excluded by Marillier, became an associate of the Liverpool Academy in 1860 and exhibited there in its last few years. Two paintings by him make clear that he was a remarkable and ambitious artist: *Sweethearts and Wives* (page 107), of 1860, shows a scene of homecoming or departure on the Liverpool waterfront, while the panoramic landscape

Barmouth (Robertson Collection, Orkney), dated 1863–4, in which the foreground rocks are painted with geological precision, demonstrates awareness of Pre-Raphaelite examples, notably – as Allen Staley has suggested – John Brett's *Val d'Aosta* (Lord Lloyd-Webber collection), which had been exhibited at the Liverpool Academy in 1859.[26]

The artist who may be regarded as the foremost figure in the Liverpool artistic sphere, although on the basis of a small handful of paintings, was William Lindsay Windus (1822–1907). Born in the town, the son of a clergyman whose parish was at Halsall near Ormskirk, he attended the Liverpool Academy and a life class established by the brother of the painter JR Herbert. In 1850 Miller sponsored Windus to go to London expressly to see the Pre-Raphaelites' works exhibited that year. The impression made upon him by Millais's *Christ in the House of His Parents – The Carpenter's Shop* (Tate) and, subsequently, Holman Hunt's *Valentine rescuing Sylvia from Proteus* (page 44) was huge, and it was Windus who sought to persuade members of the Liverpool Academy to invite the Pre-Raphaelites and their associates to send their works to the Liverpool exhibitions.

Continuing for a number of years to paint historical and literary subjects, Windus emerged as a distinct artistic personality with *Burd Helen* (page 51) – a work illustrating the Border Ballad 'Child Waters' from Percy's *Reliques of Ancient English Poetry* (1765) – which was shown at the Royal Academy in 1856. Rossetti noticed the work, writing to the Scottish journalist Eneas Dallas to say that although he did not know Windus personally 'the picture has roused my enthusiasm thoroughly, & seems to me in many points the very finest in the Academy. It must have taken many months to paint; the landscape & sky, with the clear outdoor close of day over all, being evidently done every bit from nature'. He went on to praise 'the dramatic expression in the subject [which he found] of a higher & (I think) more successful finish than any other figure picture

William Davis
(1812–73)

Corner of a Cornfield, probably about 1871

Oil on panel,
35.5 × 45.7 cm

Walker Art Gallery,
National Museums
Liverpool

This is a study for a more elaborately finished picture. Contrary to the Pre-Raphaelite commitment to working direct from nature, Davis made several such sketches.

24 Ruskin 1903–12, XIV, pp. 187–8.
25 These biographical details were provided by Mary Bennett and Edward Morris to Christie's and were published in their catalogue entry for the painting *Three-a-Penny*, then called *The Orange Seller* (Christie's, 6 November 1995, lot 126).

26 See Allen Staley and Christopher Newall, *Pre-Raphaelite Vision – Truth to Nature*, Tate Britain, London, 2004, catalogue 98. For new information on Lee, see Ann Bukantas, 'John Ingle Lee (1839–82)', p. 113 in this publication.

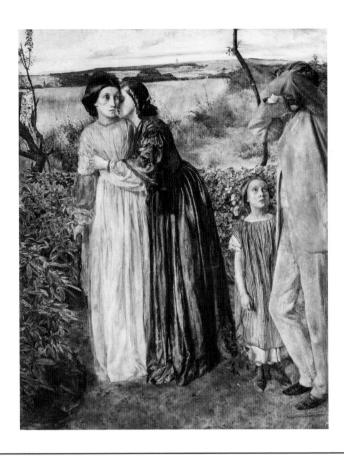

William Lindsay Windus (1822–1907)

Too Late, 1857–8

Oil on canvas, 95.2 × 76.2 cm

Tate: Presented by Andrew Bain 1921

Exhibited at the Liverpool Academy in 1859, and owned by John Miller

*Not in exhibition

[at the Royal Academy in 1856] contains'.[27] Rossetti also drew Ruskin's attention to the painting which the critic had previously missed in his account of the exhibition but which he described in glowing terms in a postscript to *Academy Notes*,[28] reckoning it the second best painting of the season after Millais's *Autumn Leaves* (page 23). Windus wrote a letter of thanks to Rossetti in which he stated that 'you and Mr Ruskin were the two persons in the world whose approbation I most ardently wished and scarcely dared to hope for'.[29] Windus decided not to send *Burd Helen* on to the Liverpool Academy after its first showing in London, as might have been expected (it was eventually seen there in 1864) and confided in Rossetti that he feared the response the painting might receive in the Liverpool press.[30]

Burd Helen was followed by the modern-life subject *Too Late* (page 109), begun in 1857 and exhibited at the Royal Academy and subsequently at the Liverpool Academy in 1859, which shows a man covering his face in distress as he realises the woman he loves is mortally ill. Miller, in a letter to Ford Madox Brown sending art news from Liverpool, of 15 March 1857, reported that 'Mr Windus is going on slowly with his most charming picture and the head of the principal figure is full of that expression of agitated and inward thought at which he had aimed and tells the story of her ruined health and broken heart. He is painting it in sunlight but the sun seldom shines [...]'[31] The landscape setting was the artist's own garden at Liscard on the Wirral, looking towards Bidston Hill and with the Welsh hills seen towards the south-west.

27 Fredeman, *The Correspondence of Dante Gabriel Rossetti II*, p. 123.
28 Ruskin 1903-12, XIV, pp. 85-7.
29 Ibid., n. 1.
30 See Hueffer, *Ford Madox Brown*, p. 110.

31 Ford Madox Brown Family Papers. Quoted *The Pre-Raphaelites*, exhibition catalogue, Tate Gallery, London, 1984, p. 173.

In a further letter, Miller conveyed Windus's self-critical and diffident personality and his hesitancy about what he was doing: 'He has not yet finished the hair [of the figures in *Too Late*], but what he has done is beautiful in all eyes but his own, and it has been in and out, I should think, a hundred times'.[32] Ruskin's carping remarks about the painting in 1859 seem to have contributed to Windus's loss of momentum as an artist and gradually he faded into obscurity. In 1888 Ford Madox Brown mentioned him in an article in the *Magazine of Art* as 'a painter of extreme enthusiasm and very great refinement [who] was a member of the Liverpool Academy and much respected, and what is more, his works were much sought after', but that he had lost his way: 'I saw him a few months ago in Hampstead, where he lives almost by himself. He will not paint; he sometimes begins to do so in the morning, but he invariably rubs out his work in the evening, and contents himself with reading only Latin'.[33]

Windus maintained a close friendship with Daniel Alexander Williamson, with whom, according to James Smith of Blundellsands who compiled notes on the two artists, he made painting expeditions in the Duddon valley (Windus's *The Baa Lamb: View on a Tributary of the River Duddon* (page 111), of 1864, was presumably an outcome of such a stay shortly after Williamson's move to Broughton-in-Furness). Smith broached the question of whether Windus's work might legitimately be regarded as Pre-Raphaelite, expressing the view that his colour was 'truer and less garish than [that of the Pre-Raphaelites]. Probably his work is said to be pre-Raphaelitish because his landscape backgrounds, like theirs, are carefully studied from nature'.[34] Smith is likely to have had Windus's *The Baa Lamb* in mind as he wrote these words, as it was in his collection from 1899. It shows a boulder-strewn river bed with glimpses of wooded cliffs, and the pathetic form of a lost lamb perched on rock. The painting is poignant and lovingly observed and signifies Windus's abandonment of the type of ambitious figurative subject by which he had

previously sought a reputation in London and on which basis he was judged by fellow painters and critics. It represents a move back to the more intimate, privately meditative kind of work which was the essential endeavour of the artists of the Liverpool School.

Landscape painting and modern life subjects set in the open air formed a principal part of the output of those members of the Liverpool School who were influenced by or associated with Pre-Raphaelitism. As has been seen, amongst the different artists there was a wide variation in the degree of proximity to the movement's metropolitan centre, and likewise ideas about landscape painting and the dutiful recording of nature led by John Ruskin were differently interpreted by each one. A refreshing sense of liberty to paint in whatever way seemed to fit with their essential artistic disposition seems to have imbued these artists, with a relaxed attitude as to what constituted a suitable subject for their attention and a feeling that any aspect of an individual's physical surroundings might be regarded as legitimate. Whereas artists in London faced critical disapprobation and the accusation of self-indulgence if they allowed themselves to dwell on aspects of the setting of their lives which were private and personal, in Liverpool there seems to have been a much greater openness and willingness to allow artists freedom of choice as to what they wished to paint. The painters of the Liverpool Academy may have been less ambitious and were certainly less well known in the larger context of 19th-century art than their London contemporaries, but they were able to express their own delight in the actuality of the landscape, producing without inhibition works that were both quirky and individual. As such, they can be upheld as pursuing what Ford Madox Brown, in his account of his own artistic intentions, characterised as painting 'from love of the mere look of things'.[35]

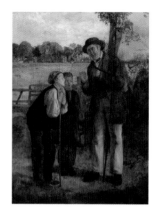

James Campbell (1823–93)

The Fisherman's Lesson, about 1861

Oil on canvas, 57.2 × 44.3 cm

Private collection, on loan to Williamson Art Gallery & Museum, Birkenhead; Wirral Museums Service

Exhibited at the Liverpool Academy in 1861

32 Marillier, *The Liverpool School of Painters*, p. 245, n.1.

33 'The Progress of English Art as *NOT* shown at the Manchester Exhibition', *Magazine of Art*, 1888, pp. 122–4.

34 *Two Liverpool Artists – In Memoriam – D.A. Williamson – W.L. Windus*, anonymously issued by James Smith of Blundellsands, n.d., pp. 17–18.

35 'The Mere Look of Things' was the title given by Allen Staley to the second chapter of the exhibition catalogue *Pre-Raphaelite Vision – Truth to Nature*, Tate Britain, 2004.

William Lindsay Windus (1822–1907)

The Baa Lamb: View on a Tributary of the River Duddon
(also known as '*The Stray Lamb*'), 1864

Oil on board, 21.2 × 30.5 cm

Walker Art Gallery, National Museums Liverpool

Passed through the collections of John Miller, John Bibby and James Smith of Blundellsands

After Ruskin's hurtful criticism of his work in 1858, Windus stopped painting subject pictures and produced small landscapes. This one was painted in north Lancashire on a section of the Duddon in the south western Lake District, near the home of Windus's friend and fellow artist Daniel Williamson. It shows a similarly meticulous approach to rocks and foliage though with a more restrained use of colour. As in Williamson's work, the animal is so delicately painted it is almost indistinguishable from its naturalistic background.

John Ingle Lee (1839–82)

The Gardener's Daughter, about 1868–9

Oil on canvas, 23.2 × 19 cm
Private collection

Lee's pictorial scheme echoes Rossetti's female 'beauties' of the 1860s. The sitter in this portrait is probably Lee's wife, Mary Ann Murdock. She appears in other paintings by him, including *Sweethearts and Wives* (page 107) and *The Book Stall* (page 115).

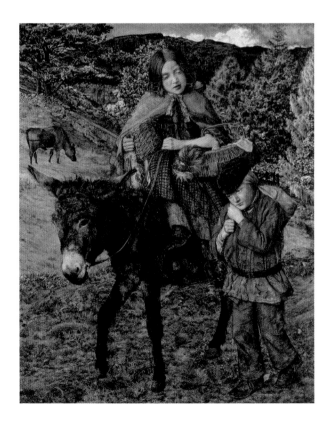

John Ingle Lee (1839–82)

Going to Market, 1860

Oil on canvas, 46.2 × 37 cm
Walker Art Gallery, National Museums Liverpool
Probably *The Young Carriers,* exhibited at the Liverpool Academy in 1860

Lee's sharp-focus technique carefully records the textures of the children's clothing, the basketwork, the chicken feathers and the donkey's coat. Together with the bright colours, the work shows his knowledge of the Pre-Raphaelites. The young artist may also have been influenced by Rosa Bonheur's painting *Landais Peasants Going to Market* which had been exhibited in Liverpool in 1859.

John Ingle Lee

Ann Bukantas

Sweethearts and Wives (page 107) is one of the best known Liverpool Pre-Raphaelite paintings, but the life of its creator has long remained obscure, compounded by the inaccurate recording of his name as John J Lee and owing to name variations in contemporary exhibition catalogues.[1] Following new research for this exhibition, it is now possible to document more fully Lee's career and to expand from 13 to 35 the number of his recorded works.

John Ingle Lee was born in Liverpool in 1839, the third son of Henry Boswell Lee and Emily Sarah Ingle.[2] Lee's father sold straw bonnets and the raw materials for their manufacture. This family business was to become a famous Liverpool department store, George Henry Lee's, the forerunner of John Lewis of Liverpool.[3] By the late 1850s, as Lee was starting his artistic career, his father had retired from the retail trade, having passed the business to his sons George and Henry. In 1857, Henry senior was pursuing a newly fashionable creative venture as a photographic artist with a studio on Church Street in central Liverpool, a

business that Lee's brother Joseph continued.[4] By then, the family had moved across the River Mersey to an affluent part of Rock Ferry occupied by merchants and brokers.[5]

According to the local merchant and art collector James Smith of Blundellsands, John Ingle Lee attended a literary class at Hope Street Church.[6] Between November 1858 and February 1860, Lee's signature appears sporadically in the registration books of the Liverpool Academy.[7] Also attending some of these classes were William JCC Bond (six years Lee's senior) and Joseph Worrall (ten years his senior). William Davis, the Academy's Professor of Drawing from 1856 to 1859, signed in as the tutor on a number of these dates. It is during this period that in 1859, Lee started exhibiting at the Academy, from a Church Street address. His first exhibited work was *Portrait of Mrs*

1 The permutations of Lee's name include: John J Lee (Liverpool Academy - LA); John Lee, John Ingle Lee and J Lee Ingle (Royal Society of British Artists - RSBA); JJ Lee (Royal Academy - RA); J Lee Ingle and JL Ingle (Liverpool Autumn Exhibitions - LAE). NB: A different John Lee who exhibited *Cynthia* at the RSBA in 1891, no. 239, is the probable source of dates sometimes attributed to John Ingle Lee as having worked until 1891.

2 Henry Boswell Lee (1811-1901) and Emily Sarah Ingle (1810-71). Their seven children: George Henry (1830-1913), Henry Boswell (1833-1913), Emily Ann (1835-1923), Ellen (1837-51), John Ingle (1839-82), Joseph (born 1839) and Allen (born 1843).

3 For further information see: Pauline Rushton, *Mrs Tinne's Wardrobe: A Liverpool Lady's Clothes 1900-1940*. National Museums Liverpool, 2012. p. 17-20.

4 *Cartes de visite* were introduced into England in 1857, becoming very popular. HB Lee's address at this time is Parkton Grove, Rock Ferry, and his office is 57 Church Street. *Gore's Liverpool Directory*, 1857, pp. 138, 261. In 1859 his address in Rock Ferry is Green Bank, but he is still operating from Church Street. There is also a listing for a Henry Lee, photographic artist, of The Esplanade, Rock Ferry, also with rooms at 57 Church Street. *Gore's Liverpool Directory*, p. 155. Joseph Lee operated from 1860 to 1865. Henry [Boswell] Lee's dates are given as 1857-59. Gillian Jones, *Lancashire Professional Photographers, 1840-1940*, PhotoResearch, 2004. p. 125.

5 Although his Church Street (presumably studio) address is used for his 1860 LA entry, Lee's 1860 RSBA entry gives his address as Green Bank, Rock Ferry. The family appear in the 1861 Census at 6 George['s] View, New Chester Road, Bebington.

6 Dates unknown. Undated, handwritten note in Walker Art Gallery files headed '(Information given by Mr James Smith, of Blundellsands)', author unknown. Lee is recorded as a 'scholar' in the 1851 Liverpool census. Smith's information may date to around this period.

7 At the age of 19-20, November to December 1858, January to March 1859 and January to February 1860. 'Liverpool Academy of Art Registrations' book, Walker Art Gallery archive, ref 706 ACA 3/3.

Lee (untraced) - possibly his mother, who would have been in her late forties.[8] In 1860 Lee exhibited *The Young Carriers,*[9] (page 112) a stylised interpretation of Pre-Raphaelitism showing two children taking goods to market, and *Grandfather's Comfort*[10] (page 123), a sentimental genre scene. The subject matter in the former of these two works could have been fresh in Lee's mind: in 1859, the French artist Rosa Bonheur's painting *Landais Peasants Going to Market* had been exhibited by Mr Grundy at the Repository of Arts, 26 Church Street.[11]

Sweethearts and Wives was shown in Liverpool and London in 1861.[12] While its heightened colours and attention to detail betray an obvious Pre-Raphaelite influence, Lee would undoubtedly also have seen Henry Nelson O'Neil's popular painting *Eastward Ho!*, 1857 (Museum of London), which was displayed at Grundy's Repository in 1859.[13] Its subject was soldiers departing for the first Indian War of Independence. The theme, O'Neil's vivid colour palette, and the rich degree of activity employed surely influenced the young artist.

A small, circular watercolour and ink self-portrait by Lee (Williamson Art Gallery) confirms that he appears in *Sweethearts and Wives* as the sailor conspicuous in the right-hand foreground of the painting, with his wide face, ruddy cheeks, wavy hair and prominent nose. The woman being held by another sailor, whose likeness appears in other paintings by Lee, may be his wife-to-be, Mary Ann Murdock.[14] A reviewer of the 1861 Liverpool Academy exhibition made cutting remarks about Lee's contribution:

> This picture contains an amount of latent talent, but is one of those works that have brought discredit upon the school they profess to belong to. The title is ambiguous, while the two females in the background - sweethearts, we suppose - are too coarse-looking for a 'prison van'. Mr. Lee should bear in mind that it does not follow because a man has made a sea voyage or two his face should appear as if seen through a prism.[15]

Lee's major work *The Book Stall,* of 1863 (page 115), was also exhibited in London and Liverpool.[16] Lee had married Mary Ann in April 1863 and it seems probable that she is celebrated as the red haired, Pre-Raphaelite beauty given such prominence in this painting.[17] *The Book Stall* and another work, *In a Wood* (untraced), attracted comment in *The Art Journal*:

> 'In a Wood', by John Lee, is a large picture of photographic finish, but not strong enough in the shadows. Another ambitious picture, by the same artist, is entitled 'The Book Stall,' which, though exhibiting the 'leathery' tendency which is a fault of one branch of the Pre-Raphaelites, demonstrates capabilities for better things.[18]

8 Recorded as John J Lee. LA, 1859, no 115. Morris and Roberts, p. 383.

9 Probably *Going to Market* (Walker Art Gallery). RSBA, 1860, no 217; LA 1860, no 160. Mary Bennett, *Merseyside: Painters, People &*, p. 137. Bennett records the artist's monogram as 'JIL'.

10 Liverpool Academy 1860, no 266 (Williamson Art Gallery and Museum, Birkenhead).

11 Together with *Morning in the Highlands*, the original pictures, billed as 'The two last important works completed by Mad'lle Rosa Bonheur'. Advertisement, *Liverpool Mercury*, Friday 27 May 1859, p. 1. British Newspaper Archive [database online].

12 Now in the Walker Art Gallery. Recorded as John J Lee. LA, 1861, no 227. Morris and Roberts, p. 383–4; as John Lee, RSBA, 1861, no 443, p. 383.

13 Advertisement, *Liverpool Mercury*, Monday 25 July 1859, p. 1. British Newspaper Archive [database online]. Two years later, both 'Eastward Ho!', and its partner piece by O'Neil, 'Home Again', 1858 (National Army Museum), were displayed in Liverpool at Mr Griffith's New Gallery (formerly Winstanley's) at 44 Church Street, for a fee of 6*d*. Advertisements, *Liverpool Mercury*, Monday 21 January 1861, p. 1; Saturday 2 February 1861, p. 1; Tuesday 12 February, p. 3. British Newspaper Archive [database online].

14 A woman with similar features appears in *The Book Stall*, 1863; *Home*, 1869; *The Gardener's Daughter*, c. 1868/9.

15 *Liverpool Mercury*, Friday 13 December 1861, p. 6. British Newspaper Archive [database online].

16 In 1863, as JJ Lee, RA, no 637; as John J Lee, Liverpool Institution of Fine Arts, no 459.

17 "April 16th, at Handsworth Old Church, John Ingle Lee…to Mary Ann, only daughter of the late Mr. Wm. Murdock, and grand-niece of the late Mr. John Murdock, of Sycamore-Hill, Handsworth." *Worcester Chronicle*, Wednesday 22 April 1863. [database online] Sourced from Find My Past, British Newspapers 1710–1950 (British Library Documents).

18 'The Liverpool Institution of Fine Arts', *The Art Journal*, 1863, p. 229.

John Ingle Lee (1839-82)

The Book Stall, 1863

Oil on canvas, 101.6 × 81.2 cm

Private collection

Exhibited at the Liverpool Institution of Fine Arts in 1863. In the collection of John Miller and sold posthumously in 1881

*Not in exhibition

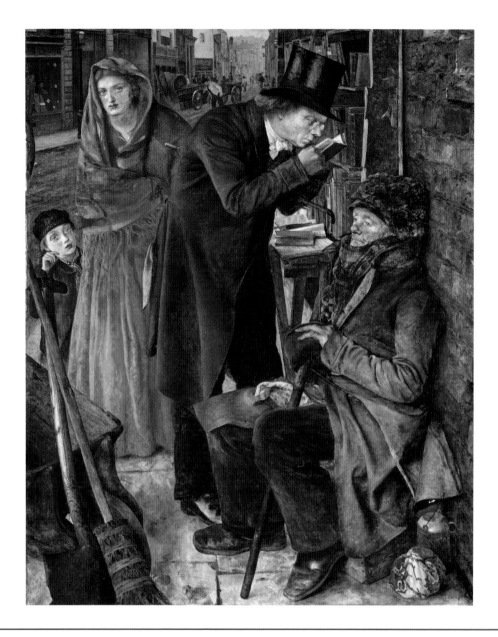

The picture was acquired by John Miller, perhaps from the Liverpool exhibition, and was in the posthumous sale of his collection in 1881 – that Miller did not dispose of it in his lifetime must reflect his admiration for the work.[19]

19 *Catalogue of the extremely Valuable Collection of Pictures and Drawings formed by the Late John Miller, Esq.* Branch & Leete, Liverpool, 4–6 May 1881. No 223. The sale also contained Lee's *Hide and Seek*, no 141. Catalogue in Walker Art Gallery archive.

A landscape now regarded as one of Lee's masterpieces, *Sandbanks on the Murddach, Barmouth* (Robertson Collection, Orkney) was one of two works displayed at the 1864 Liverpool Academy. The *Liverpool Mail*'s dismissive reviewer clearly knew of Lee, and the commentary indicates an incomplete art education that may explain Lee's individualistic painting style:

Of Mr. J. J. Lee's two efforts in the same [Pre-Raphaelite and naturalistic] school, No. 21

"Sandbanks at Barmouth," and 64, "How shall I Look?" [described elsewhere as 'a striking though rather crude half-length figure of a girl'[20]] both lack originality. The first reminds us of A. W. Hunt; the second of more than one of the P.R.B.'s. The incompatibility between the sky and the sandbanks… leads to the inference that the effects must have been got at different times; and there is an absence of beauty as well as interest in the figure, and we civilly suggest to the painter the consideration, with the short and imperfect training he has undergone, is he not too ambitious and too confiding?[21]

Lee's exhibition record suggests a move to London between late 1865 and early 1866, the last exhibited work from a Liverpool address being *Twilight* in 1865.[22] His intention was probably to develop his skills and career in London, but perhaps also to escape the negative critical reception his work received at home. From 89 Queen's Crescent, Haverstock Hill, he exhibited consistently throughout 1866 and 1867 in London, Liverpool and Glasgow, his pictures on offer for up to £100. In 1867 *Evensong* and *Dora* (both untraced) attracted the eye of *The Porcupine*'s reviewer at the Liverpool Academy:

> There is a very pretty little bit of quiet sentiment, "Evening," [Evensong] (29) by J. J. Lee; and there is a much more extensive instalment of florid sentiment, "Dora", (147) by the same hand. The first is full of beautifully-suggestive repose; and the last, from the abundance of a peculiarly angry red in the colouring, would drive a bull to madness. "Evening" represents a band of young girls, their faces and figures rendered softly vague in outline by the tender gloom of evening, standing before an organ and singing… The heroine of Tennyson, on the contrary, has been very badly treated… there appears to be an extensive conflagration going on somewhere in the immediate neighbourhood…In the middle of the

burning glow sits Dora, herself a mass of hottest colour… there is as much of toothache as of the despondency of abandonment in her attitude.[23]

Evensong may be the subject of William Lindsay Windus's remark in a letter to John Miller: 'I am glad to hear that John Lee is likely to succeed with his picture, it has cost him much in labour and money. The figures being all in white will constitute a formidable difficulty, but if he overcomes it the success will be so much the greater.'[24]

Like *Sweethearts and Wives* and *The Book Stall*, two paintings dating from 1868 to 1869 may also include Lee's wife. These are *Home*[25] (private collection) and *The Gardener's Daughter* (page 112). *Home* depicts a man tending ivy around a doorway, his back partially to the viewer. It has been suggested that this too is a self-portrait.[26] In front of him sits a familiar red-haired woman with a baby on her lap. There is a poignancy to the inference that this could be the Lees, since it has not been possible to find evidence that the couple had children, or if they did, that any survived. If *The Gardener's Daughter* is indeed Lee's wife, this full-face portrait provides our clearest image of her. Both paintings bear labels that signal the couple's move to 153 Adelaide Road in Hampstead,[27] from where, between 1871 and 1874, Lee continued to exhibit at the Royal Society of British

20 *Liverpool Daily Post*, Saturday 24 August 1864, p. 5. British Newspaper Archive [database online].
21 *Liverpool Mail*, Saturday 17 September 1864, p. 5. British Newspaper Archive [database online].
22 As John J Lee, LA, no 171 (untraced).

23 *The Porcupine*, 14 September 1867, p. 235.
24 National Art Library. MSL/1995/14/133/8.
25 *Home*, which is signed and dated, has passed through several auctions. Of these, Sotheby's, Belgravia, 30 March 1982, lot 144, interpreted the date as 1868 (record in Witt Library, 1982); Christie's, 24 June 1988, lot 104, give 1869 (record in Witt Library, 1988). The most recent sale was Batemans, Stamford, Lincolnshire, 6 December 2008, lot 287. http://www.batemans.com/lot.php?lot=106287. The latter records the paper label on the verso: No 1. Home, Jno I Lee, 153 Adelaide Road, N6.
26 The original source for the suggestion, which has appeared in auction catalogues, is unknown.
27 On the artist's label attached to the reverse of the frame: 'No. 2 The Gardener's Daughter/John Ingle Lee/153 Adelaide Road/London N.W.' http://www.christies.com/lotfinder/paintings/john-ingle-lee-the-gardeners-daughter-5857448-details.aspx#top The Adelaide Road property no longer exists.

Artists and in the new Liverpool Autumn Exhibitions.[28] The Lees' final move, to 'Sunnycote', an impressive, purpose-built house at Hampstead Hill Gardens, came around 1876 to 1877.[29] An architectural design in *The Building News* illustrated the substantial 'Bijou Residence (with studio) for John Ingle Lee Esq'.[30] Decades later 'Sunnycote' was bought by the critic and poet William Empson, whose biographer records him acquiring in 1946 'the leasehold in Studio House, formerly called 'Sunnycote' – a bright and very commodious house... incorporating a lofty artist's studio (it was built in 1875–6 for the minor painter John Ingle Lee) – on the corner of Rosslyn Hill and Hampstead Hill Gardens.'[31] The property, retaining the name 'Studio House', still exists, with alterations. 'Sunnycote' would be Lee's home for the all too short remainder of his life.

From 'Sunnycote', Lee's steady output of pictures for the Royal Academy and Liverpool Autumn Exhibitions maintained a consistently conservative trajectory, with titles such as *In Arundel Park*, *Contemplation*, and *Idle Moments*. The 1881 census revealed a comfortably middle-class existence, with a cook and housemaid, and, for neighbours, an architect, merchants and the landscape painter Thomas Collier.[32] Furthermore, all of Lee's brothers, and his widowed father, had relocated to London by 1881, suggesting

strong family ties. The following year, Lee found himself in the small village of Dalmally, in the district of Glenorchy, Argyll. A railway station had opened in 1877 and the area was well placed for exploring the scenery around Loch Awe – the likelihood is that Lee was on a painting trip. It was in Dalmally's post office that Lee died in the presence of his brother Joseph on 6 June 1882, aged 43, after a fortnight's illness.[33] The grieving Mary Ann's reaction to this sudden loss appears to have been to sell everything that held painful memories, and by late July, soon after Lee's estate was proved at £6,486 5s., 'Sunnycote', Adelaide Road and two further addresses in the Lees' possession were advertised for sale.[34] This unique insight into their personal circumstances suggests a level of financial stability that could probably only have come through family wealth or investments, rather than from what was surely Lee's modest income through picture sales. But it is the sale by Mary Ann of the entire contents of 'Sunnycote', including everything in Lee's studio – from household furniture and ornaments through to his lay figures, easels, costume props, a modest art collection (with paintings by Richard Wilson and William Etty) and of course Ruskin's *Modern Painters*, that leaves us a window on the taste, lifestyle and occupation of this significant Liverpool Pre-Raphaelite.[35]

28 His pictures ranged in price from £21 to £250 and included *The List of the Killed*, RSBA 1871, no 416 and *Among the Mountains*, LAE 1874, no 42 (all untraced).

29 Ancestry.com. *London, England, Electoral Registers, 1832–1965* (year 1876, London, Ealing) [database on-line]. Provo, UT, USA: Ancestry.com Operations, Inc., 2010. Original data: *Electoral Registers*. London, England: London Metropolitan Archives.

30 The property was built in 1876, in an area where many successful Victorian artists had large studio houses constructed. The design was published in *The Building News,* 23 February 1877. Lithograph (private collection), sourced online via Bridgeman Art Library. Image ref: XJF268024.

31 J Haffenden, *William Empson, Volume II: Against the Christians*, p. 82. Oxford, 2006.

32 Class: *RG11*; Piece: *168*; Folio: *41*; Page: *24*; GSU roll: *1341036*. Ancestry.com and The Church of Jesus Christ of Latter-day Saints. *1881 England Census* [database on-line]. Provo, UT, USA: Ancestry.com Operations Inc., 2004.

33 Lee's name is incorrectly transcribed as John Inglis Lee. 1882 Lee, John Inglis [Statutory deaths 512/00 0007]. Scotland's People [database online].

34 Sunnycote was described as having a 'studio, or music-room, about 46ft. by 20ft., another room of a similar size, and garden with fine old trees.' As well as 153 Adelaide Road, Hampstead, formerly known as No.5 Parkfield Villas, the other properties were No. 20 Eaton Villas, Haverstock Hill and No. 23 Buckland Crescent, Belsize Park. *The Standard,* Saturday 22 July 1882, p. 8. British Newspaper Archive [database online]. Mary Ann's whereabouts between 1882–91 are unclear, but by 1891 the census shows she was living in Oxfordshire with a widowed Aunt. She died in Torquay in 1919.

35 Auction catalogue, Phillips Son & Neale, 26 & 27 September 1882 (327 lots, annotated auctioneer's copy). British Library. Shelfmark 'S.C.Phillips'. Catalogue traced at the time of this exhibition publication going to press, and will be the subject of further research.

Daniel Alexander Williamson (1823-1903)

Winter Evening - Cows going Home,
about 1859

Oil on canvas, 32.5 × 54.7

Private collection

**Possibly exhibited at the Liverpool Academy in
1859 as *Cows Going Home***

Williamson changed his style a number of times. Whilst
living in London between the late 1840s and 1860, he
made a number of paintings and drawings of cattle
which are thought to have been set on Peckham
Common. He returned to the subject of cattle on and
off during his career.

William Davis
(1812-73)

*A Ploughed
Field*, probably
1860s

Oil on canvas,
34 × 50.5 cm

Private collection

William Davis (1812-73)

View of Wallasey, Wirral, about 1856

Oil on board, 30 × 40 cm

Williamson Art Gallery & Museum, Birkenhead; Wirral Museums Service

Davis turned to landscape as a theme following a visit to Ireland with fellow artist Robert Tonge in 1853, and probably also at the suggestion of the collector John Miller. The area around Wallasey provided Davis with much of his subject matter. The view is from near St Hilary's church across Wallasey Village to Mockbegger Wharf.

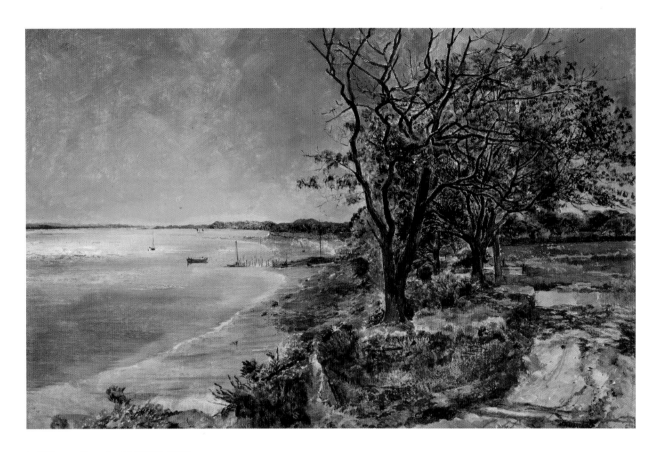

William Davis (1812-73)

Old Eastham Ferry, about 1853

Oil on canvas, 31.7 × 47 cm

Williamson Art Gallery & Museum, Birkenhead; Wirral Museums Service

Probably exhibited at the Liverpool Academy in 1853

Like much of Davis's work, this picture is undated. The loose paint handling suggests his earlier work but it could also be from the later 1850s. Davis exhibited an *Eastham Ferry* in the 1853 Liverpool Academy exhibition but there is no evidence that this is the same piece. Eastham is on the Wirral, across the river Mersey. The site Davis has depicted is that of Job's Ferry, a river crossing dating back to the Middle Ages.

James Campbell (1823–93)

Girl with Jug of Ale and Pipes, 1856

Oil on board, 38.7 × 30.5 cm

Walker Art Gallery, National
Museums Liverpool

**Owned by John Miller, who sold it in
1858**

The view in the background of this scene
appears to be in the Walton or Everton area
looking south across Liverpool. The church
tower is probably that of St Luke's. The girl's
bonnet carries the suggestion of a halo. This
may be Campbell's commentary on the
subject – she is bringing beer and clay pipes
from the local public house.

Joseph Edward Worrall (1829–1913)

Music versus Work, 1864

Oil on canvas, 31.1 × 22.9 cm

Walker Art Gallery, National Museums Liverpool

Worrall attended classes at the Liverpool Mechanics' Institute and later at the
Liverpool Academy. He painted scenes of ordinary Victorian life with minute
attention to detail. The boy's clothes in this picture show that he is a servant.
He has put aside his sweeping brush to play on a tin whistle. When the picture
was shown in London's Royal Academy in 1864 it brought a smile to the face
of one art critic who wrote, 'We are always glad when it is possible to steal a
laugh within the solemn propriety of the walls of the Academy.'

James Campbell (1823–93)

Waiting for Legal Advice, 1857

Oil on board, 77.5 × 63.5 cm

Walker Art Gallery, National Museums Liverpool

This painting has had various titles throughout its history. It shows a Liverpool solicitor's office with a stubborn client waiting, whilst two clerks gossip behind a screen. The little boy is pointing at a spinning top but its meaning is not clear. Although Campbell was influenced by the Pre-Raphaelites, the humorous tone of this picture is in the tradition of Dutch-inspired scenes of everyday life. Such modern subjects were at the height of their popularity in the late 1850s.

William Davis (1812–73)

On the Alt near Formby and Ainsdale, 1853

Oil on board, 30.3 × 45.1 cm

Williamson Art Gallery & Museum, Birkenhead; Wirral Museums Service

An inscription on the reverse of the picture suggests it was once owned by John Miller

This is probably one of Davis's earliest landscape paintings, before the influence of the Pre-Raphaelites took hold. His first landscapes appeared in the Liverpool Academy's exhibitions in 1853. Formby and Ainsdale are to the north of Liverpool.

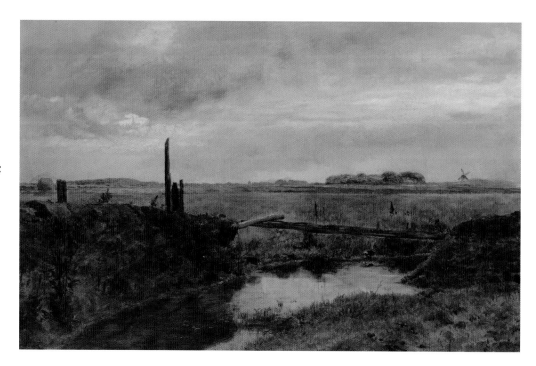

John Ingle Lee (1839–82)

Grandfather's Comfort, about 1860

Oil on board, 46.4 × 38.6 cm

Williamson Art Gallery & Museum, Birkenhead; Wirral Museums Service

Exhibited at the Liverpool Academy in 1860

This was one of Lee's earliest exhibits at the Liverpool Academy, where he was also attending art classes, albeit sporadically. It was painted at around the time the Pre-Raphaelite influence was starting to manifest itself in his work. Genre scenes like this were to become a staple of Lee's work. The models for the painting are unknown.

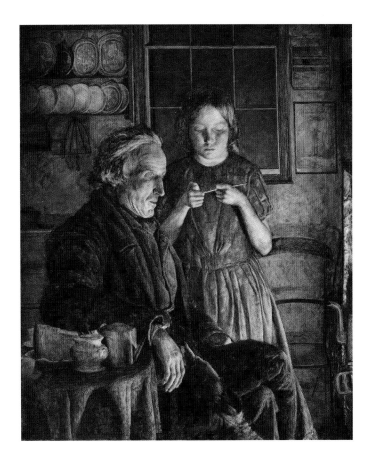

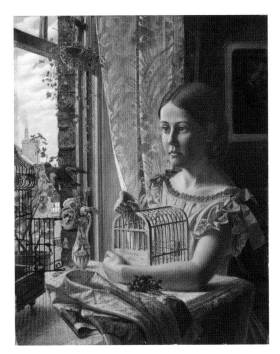

Joseph Edward Worrall (1829–1913)

Escaped, 1865

Oil on paper, on panel, 25.4 × 20 cm

Private collection

Exhibited at Liverpool Institution of Fine Arts in 1865

The setting for this picture is likely to have been Worrall's own house at 231 Upper Parliament Street. The girl shown may have been his eldest daughter Amy. She was six years old when the picture was painted but she died the same year. The title and subject of the picture may have been inspired by her death.

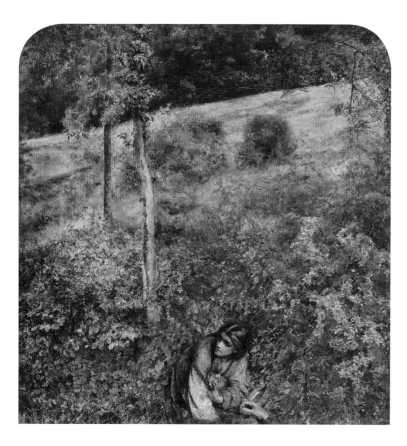

William Lindsay Windus (1822–1907)

The Outlaw, 1861

Oil on canvas, 35.7 × 34.3 cm

Manchester City Galleries

Exhibited at the Liverpool Academy in 1862. In the collection of John Miller and sold posthumously in 1881

Influenced in his work by the Pre-Raphaelites since 1850, having encountered Millais' *Carpenter's Shop* (Tate) at the Royal Academy, as a member of the Liverpool Academy Council, Windus had been instrumental in awarding the Academy prize four times to Hunt and Brown between 1851–8. He worked slowly and was a despondent soul but in his letters, including to Brown, he exhibited a dry wit. *The Outlaw*, his only canvas in the 1862 Liverpool Academy, was not wholly popular with the commentator of the *Liverpool Mercury*: 'This extraordinary picture... does not do justice to his reputation.' The reviewer continued: 'The landscape is of a cold harsh green, and we regret the fame of Windus is not better represented.'

Daniel Alexander Williamson (1823–1903)

The Startled Rabbit, 1862

Oil on board, 26.5 × 39 cm

Williamson Art Gallery & Museum, Birkenhead; Wirral Museums Service

Exhibited at Liverpool Institution of Fine Arts in 1863. Formerly in the collections of John Miller and James Smith

The setting for this scene is Warton Crag, above the Lancashire village of Warton, where Williamson was living. This painting was included in the Liverpool Institution's first exhibition.

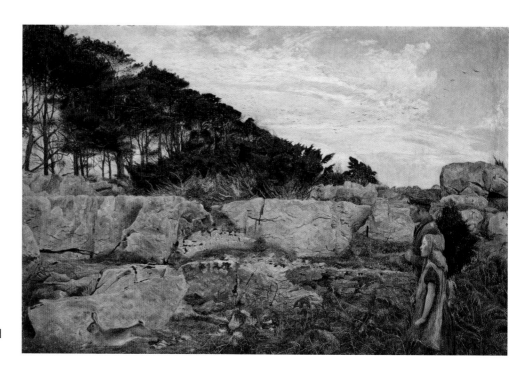

William Davis (1812-73)

Landscape at Bidston, second half of 1850s

Oil on canvas, 22.4 × 31.7 cm
Private collection

The landscape around Bidston Hill and Bidston Common, now part of Birkenhead, was a popular subject with Davis. He represented its ordinariness with affection, familiarity, and fidelity to nature. His meticulous approach was much admired by Brown and Rossetti and, in turn, his style developed under their influence. This view is Bidston Moss.

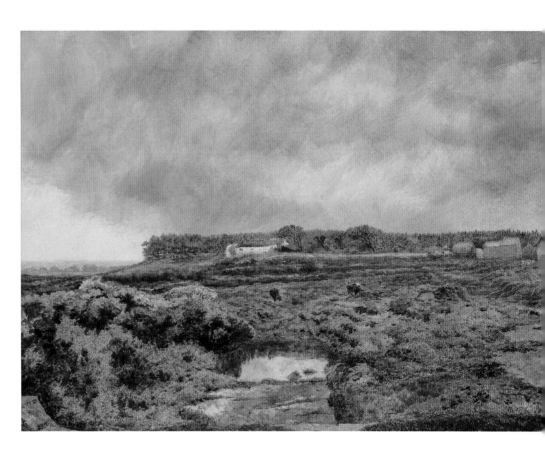

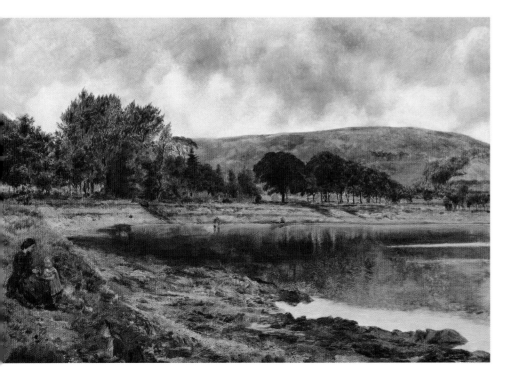

William Davis (1812-73)

Port Bannatyne – Isle of Bute, about 1860

Oil on board, 30.6 × 47.6 cm
Private collection

Probably exhibited at the Liverpool Academy in 1862

Davis visited Bute on more than one occasion. John Miller built a large house there, called 'Ardencraig', which remained with the Miller family until around 1860. Davis exhibited views of Port Bannatyne in the 1855 and 1862 Liverpool Academy exhibitions. John Miller owned what was presumably one of these (larger than the present picture) and which was sold posthumously in 1881. The 1862 painting was praised in the Liverpool Mercury for 'water beautifully liquid and transparent, and the trees and clouds full of real study.' This landscape is a good fit for the description.

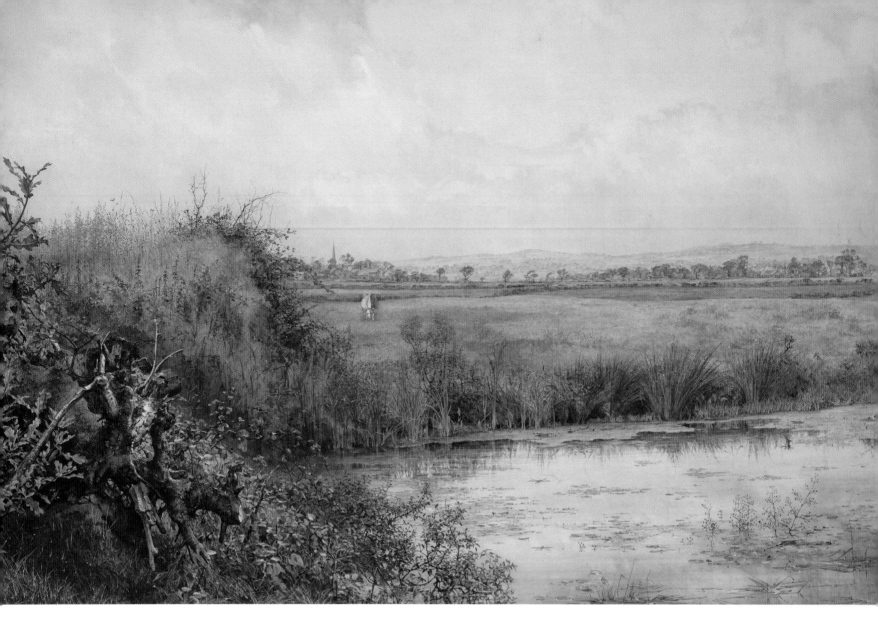

John Edward Newton (1834-91)

View near Sefton, about 1864

Oil on canvas, 56 × 84 cm

Private collection, on loan to Williamson Art Gallery & Museum, Birkenhead; Wirral Museums Service

Exhibited at the Liverpool Academy in 1864

Newton was born in Saint Thomas in the West Indies and may also have lived in Malta. He became a friend of the artist James Campbell and followed him from Liverpool to London in the late 1860s. Newton specialised in still life pictures and landscapes. The level of detail in his early paintings is almost photographic – the foliage in the left-hand foreground here is a good demonstration of his skill. *View near Sefton* was praised in the *Liverpool Mercury* review of the Academy's exhibition for its 'truthfulness' to the locality. The location may be the Alt or the Mill Stream, both flowing near Sefton.

Further reading

Art and the Victorian Middle Class, Money and the Making of Cultural Identity, Cambridge University Press, Dianne Sachko Macleod , 1996

Artists of the Pre-Raphaelite Circle, The First Generation, Catalogue of Works in the Walker Art Gallery, Lady Lever Art Gallery and Sudley House, Mary Bennett, Lund Humphries Publishers Ltd, 1988

Dante Gabriel Rossetti, exhib. cat., Julian Treuherz, Elizabeth Prettejohn, Edwin Becker, Thames and Hudson, 2003

Ford Madox Brown: A Catalogue Raisonné, Mary Bennett, Yale University Press, 2010

Merchant Palaces, Liverpool and Wirral Mansions, Photographed by Bedford Lemere & Co, Joseph Sharples, The Bluecoat Press, Liverpool, 2007

Merseyside Painters, People & Places. Catalogue of oil paintings, Walker Art Gallery, Mary Bennett, Merseyside County Council, 1978.

Pre-Raphaelite Drawing, exhib. cat., Colin Cruise, Thames and Hudson, 2011

Pre-Raphaelite Painting Techniques, Joyce H Townsend, Jacqueline Ridge and Stephen Hackney, Tate Publishing, 2004

Pre-Raphaelite Treasures at National Museums Liverpool, Laura MacCulloch, Liverpool University Press and National Museums Liverpool, 2013

Pre-Raphaelites: Victorian Avant-Garde, exhib. cat., Tim Barringer, Jason Rosenfeld and Alison Smith, Tate Publishing, 2012

Pre-Raphaelite Vision: Truth to Nature, exhib. cat., Allen Staley and Christopher Newall, Tate Publishing, 2004

Pre-Raphaelite Women Artists, Jan Marsh and Pamela Gerrish Nunn, Thames and Hudson, 1998

Reading the Pre-Raphaelites, Tim Barringer, Yale University Press, 2003

The Art of the Pre-Raphaelites, Elizabeth Prettejohn, Tate Publishing, 2000

The Diary of Ford Madox Brown, ed. Virginia Surtees, Yale University Press for the Paul Mellon Centre for Studies in British Art, 1981

The Liverpool Academy and Other Exhibitions of Contemporary Art in Liverpool 1774-1867, A History and Index of Artists and Works Exhibited, Edward Morris, Emma Roberts, Liverpool University Press and National Museums & Galleries on Merseyside, 1998

The Liverpool School of Painters, An Account of the Liverpool Academy, From 1810 to 1867, with Memoirs of the Principal Artists, H.C. Marillier, John Murray, London, 1904

The Poetry of Truth, Alfred William Hunt and the Art of Landscape, Christopher Newall with contributions by Scott Wilcox and Colin Harrison, The Ashmolean Museum and the Yale Center for British Art, 2004

The Pre-Raphaelites, exhib. cat., Tate Gallery / Penguin Books London, 1984

The Pre-Raphaelites, Timothy Hilton, Thames and Hudson, 1970

'Under the Cedar', The Lushingtons of Pyports. A Victorian Family in Cobham – and elsewhere in Surrey, David Taylor, Grosvenor House Publishing, 2015.

Victorian & Edwardian Paintings in the Walker Art Gallery and at Sudley House, Edward Morris, London, 1996.

Victorian Painting, Julian Treuherz, Thames and Hudson, 1993

William Holman Hunt: A Catalogue Raisonné, Judith Bronkhurst, Yale University Press, 2006

Photography credits (by page number)

Index of artworks (by page number)